Patients as Art

Patients as Art

Forty Thousand Years of Medical History in Drawings, Paintings, and Sculpture

PHILIP A. MACKOWIAK, MD, MBA, MACP

EMERITUS PROFESSOR OF MEDICINE
CAROLYN FRENKIL AND SELVIN PASSEN HISTORY OF
MEDICINE SCHOLAR-IN-RESIDENCE
UNIVERSITY OF MARYLAND SCHOOL OF MEDICINE
BALTIMORE, MARYLAND

OXFORD
UNIVERSITY PRESS

OXFORD
UNIVERSITY PRESS

Oxford University Press is a department of the University of Oxford. It furthers
the University's objective of excellence in research, scholarship, and education
by publishing worldwide. Oxford is a registered trade mark of Oxford University
Press in the UK and certain other countries.

Published in the United States of America by Oxford University Press
198 Madison Avenue, New York, NY 10016, United States of America.

CIP data is on file at the Library of Congress
ISBN 978-0-19-085821-6

9 8 7 6 5 4 3

Printed by Sheridan Books, Inc., United States of America

For Connie, wife, mother, and grandmother nonpareil

CONTENTS

There are aspects of sickness and health and life and death that can never be explained by science alone—humanistic aspects of the patient experience that can't be measured or weighed or dissected. Art can help fill in the gaps in what medical science does for our understanding of such things. Art can provide glimpses below the surface of patients' physical ills into the psychology, sociology, and sometimes even the biology of the human condition. This is because artists view the world through a unique lens, one that gives them a more nuanced and richer view of patients and their disorders than scientists. Artists find complexity in simplicity that enables them to endow their depictions of sickness and health and life and death with an authenticity that medical science alone is never quite able to capture.

Art offers an equally compelling perspective on the history of medicine. Long before humans could write, before they had a medical science or possibly even a religion, they had art. Some of the earliest art took the form of stunningly beautiful cave paintings and mysterious stone figures. What the artists' intent was in creating these works is uncertain. Even so, the works have much to say about the artists who created them and the times in which they lived. The works mirror not only the eras in which they were created, but in concert with the works of later artists, mirror all times, as reflections of the dynamic nature of the human condition.

A "work of art" generally implies a certain degree of complexity. In contrast to illustrations, (visual) works of art express something more than the outward appearance of the objects depicted. They reveal unique and private things about the objects' character. Compare, for example, Netter's illustration of acute mastitis with Renoir's portrait of a *Young Girl with the Straw Hat* (Figure 0.1). Both works are beautifully executed. Both depict a young woman with a breast abnormality (note the reddish lump at the lower border of the exposed breast in Renoir's portrait). Netter's illustration is scientifically informative, although impersonal. Renoir's is intimate. It is more pleasing esthetically than Netter's illustration, and although less informative scientifically, raises numerous questions of potential value in expanding the viewer's appreciation of the subject's apparent mastitis beyond those stimulated by Netter's illustration. What, for example, did Renoir make of his model's breast abnormality? Was the abnormality real or simply an artistic distortion added to the portrait for esthetic reasons? And if real, what was its cause? How was the abnormality affecting Renoir's model? How long had it been there, and what became of it? And what was known of the

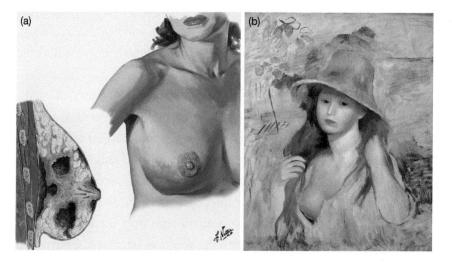

Figure 0.1. *Mastitis (Lactational).* Painted pencil drawing, c. 1970 C.E. by Frank H. Netter, Elsevier Books (a), *Woman with a Straw Hat*, oil on canvass, 1884 C.E. by Pierre August Renoir, private collection (b).

pathophysiology of cystic mastitis in 1884 when Renoir painted the portrait and the seminal work of pathologist luminaries of the likes of Remak, Rokatanski, and Virchow was just beginning to influence medical thought?

Art, in fact, can complement medical science in myriad ways. Art is a universal language capable of communicating ideas beyond the limits imposed by English as the dominant scientific language. Art can inspire those working in the medical field. It can reveal aspects of the mysteries of health and disease yet to be considered by science, and provide a humanizing perspective on the medical profession's struggle to delay death's inevitability and lighten the burden of life's pain and suffering. Art can be a medium for celebrating and preserving medicine's triumphs and follies, as well as for communicating recent advances by the profession to the public. Art can be used to sharpen the observational skills of physicians-in-training; and perhaps most important, art can complement the science of medicine by revealing the ebb and flow of the profession's long history in ways that resonate with the lives, physical struggles, and mortality of ordinary people.

Given tomorrow's uncertainty, the best we can do in contemplating the future is study the past in search of context and perspective. Medicine's history, especially as preserved in art, is a case in point. Hidden among images created by artists, even before the dawn of civilization, are lessons learned and then forgotten that remain applicable today in the ongoing battle with shadowy enemies of health that are forever slain only to rise again. History teaches that time present and times past are inseparable one from the other and also from time future. It shows how closely tied the onward tendency of human accomplishments is to prior generations and, in the words of Sir William Osler, how like the ever-changing waters of a storm-tossed ocean "the philosophies of one age become the absurdities of the next, and the foolishness of yesterday becomes the wisdom of tomorrow." Art reminds us of these things. It impresses upon us the ways in which history is alive in the present. Where medical history is concerned, art humanizes the stark scientific realities of clinical practice by depicting the care of patients through the ages in all its trials and tragedies

and wonder and beauty. And where clinicians themselves are concerned, medical history as revealed in art is an effective antidote to the profession's pride in dogma that refuses to be embarrassed.

In that art is fundamentally a special mode of communication, when a work of art is contemplated, questions naturally arise as to the work's meaning. What is the work's message? What is the artist trying to communicate through the work? These are difficult questions at best, and at worst, ones for which answers can never be known.

The meaning of any work of art is complicated by the fact that great works of art, such as those featured in this book, are intended to stretch the viewer's mind some distance beyond understanding. Sometimes the artist succeeds in doing so consciously and at others intuitively. Moreover, since such works invariably involve outward expressions of artists' innermost feelings and personal prejudices, their interpretation is anything but straightforward. Consequently, all too often one is left with the impression that a work of art simply means whatever the artist intended it to mean. However, the viewer has a role in determining the meaning of a drawing, painting, or piece of sculpture no less important than the artist or, for that matter, a professional critic trained in art history. Each brings a different and equally valuable perspective to the interpretation.

The visual works of art included in this book offer a pictorial review of medical history stretching from Paleolithic times to the present. Each features a patient, some several patients. Most are prominent works that have been analyzed repeatedly by experts as to their outward appearance and inner significance, the extent to which they reflect the ideals and sensibilities of the time in which they were created, and the formal, spiritual, and/or scientific values they appear to communicate. Rarely have experts considered the potential clinical implications of the works or their collective value as an archive of medical history.

A great many prominent works of art have depicted aspects of medicine's long struggle against ignorance, superstition, and religious and political dogma to emerge as one of mankind's greatest achievements. The works included in this book were chosen both for their esthetic appeal and for the skill with which they depict important developments in medicine over

time. In analyzing the works and interpreting their meaning vis-à-vis med-
ical history, I have brought the perspective of an internist with over four
decades of experience caring for patients, teaching doctors-in-training,
and conducting clinical research. I have also brought over twenty years of
experience as a medical historian. Given this background, my particular
focus in analyzing these works concerns what they have to say about the
status of the "art of medicine" at the time they were created and its rela-
tionship to the medicine of today. I also speculate on current diagnoses
that might be applied to the conditions featured in the works. In some
cases, diagnoses are given by artists in the titles of their works. In others,
they are so obvious as to be indisputable, and in others still, necessarily
tentative owing to the absence of critical information, such as the subjects'
medical histories, physical examinations, and diagnostic test results. And
of course, there is the problem of "artistic license." For as Plato observed
in the *Republic* over two thousand years ago: "Artworks present only an
appearance of an appearance of what is really real.

ACKNOWLEDGMENTS

I owe an immense debt of gratitude to a host of friends and associates for giving generously their time and expertise in providing insight and perspective that enhanced my understanding of the artwork presented in this book and helped enrich my brief review of medical history. I am particularly indebted to Dr. Frank Calia (former Vice-Dean and Chairman of Medicine at the University of Maryland School of Medicine), Mrs. Eleanor Herman (*New York Times* best-selling author of *Sex with Kings, Mistress of the Vatican*, and *The Royal Art of Poison*), and Mr. Wayne Millan (classics scholar) for reading every word, analyzing every work of art, and checking every citation in making copious insightful recommendations. Dr. David Nalin (Professor Emeritus, Albany Medical College) offered valuable recommendations that enhanced the Public Health chapter. Dr. Will Carpenter (former Director of the Maryland Psychiatric Research Center) provided a masterful critique of the Mental Health chapter, as did Drs. Miriam Blitzer and Carole Greene (Department of Pediatrics, University of Maryland School of Medicine) the Genetics chapter, and Dr. Dale Smith (Professor of Military Medicine & History at the Uniform Services University of the Health Sciences) and Dr. Edward R. McDevitt CAPT MC USN-R the chapter on Military Medicine. Mrs. Frederic Billings kindly assisted me by translating Spanish phrases into English. Mr. Larry Pitrof (Executive Director of the Medical Alumni Association of the University of Maryland) provided general advice and continued encouragement and

support during the many long months I labored over this project. I am grateful to Mrs. Carolyn Frenkil and Dr. Selvin Passen for the privilege of occupying the history of medicine scholar-in-residence position they endowed at the University of Maryland School of Medicine in 2013 as one of many generous contributions to my medical school. Most of all, I am grateful to my wife Connie for the love, support, and forbearance that has allowed me to pursue my passionate interest in the past, while insulated from the day-to-day necessities of living in the present.

Nutrition

Throughout much of history, humans have struggled to find enough food to grow and to reproduce. We assume that in the distant past, food was scarce but that a meager diet had at least one advantage. That is, if not killed prematurely by infection, a wild beast, accident, or armed opponent, our early ancestors would have avoided the present-day scourges of overnutrition (diabetes, heart disease, cancer, and such). Some of the earliest works of art, however, suggest that the nutritional status of our ancient ancestors might have been more varied and complicated than is generally believed.

OVERNUTRITION

The *Venus of Willendorf,* also known as the *Woman of Willendorf* (Figure 1.1), is an 11.1 cm (4.4 in) high Paleolithic statuette of a massively obese woman discovered in 1908 at an archeological site near the Austrian

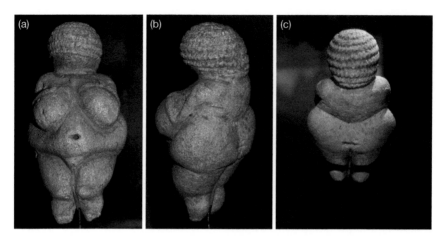

Figure 1.1. *Venus of Willendorf* statuette, oolitic limestone, 28,000 B.C.E. by an unknown artist, Naturhistorisches Museum, Vienna, Austria.
As is typical of primitive works of art, the Willendorf figure lacks important anatomical details (in this case a face, feet, and fully developed arms and hands) possibly to emphasize the figure's symbolic purpose (1). The sculptor's identity and purpose in creating the figure are forever lost in the blur and mists of that long-vanished time. It has been speculated that the statuette served a ritual or symbolic function, was a religious figure, a self-depiction by a female artist, or simply erotic art (2). Whatever its purpose, the statuette's portrayal of massive obesity is so anatomically correct, it seems certain that the artist who created it had seen obesity of such magnitude, and that it existed among Paleolithic peoples, no matter how harsh their lives might have been.

village of Willendorf. The statuette is estimated to have been created between 27,000 and 30,000 years ago during the Paleolithic or "Old Stone" Age (2). If the statuette is realistic, which seems likely, rather than simply symbolic, it raises several interesting questions: Was the Paleolithic diet conducive to a level of obesity that today would be designated "morbid" based on its numerous associated medical complications? Did Paleolithic persons who became as obese as the *Venus of Willendorf,* and whose lives were not cut short by infection, a complication of childbirth, or trauma, develop type 2 diabetes, heart disease, or the various cancers associated with morbid obesity today? And exactly how prevalent was obesity among Paleolithic humans?

Early humans, like today's peoples, consumed an assortment of diets, which varied both over time and among different groups. They were opportunistic omnivores, with some appearing to have consumed large amounts of meat, while others apparently subsisted primarily on a plant-based diet, consisting primarily of carbohydrate-rich tubers. Because the human population of the Paleolithic period was small relative to the biomass of edible fauna, the Willendorf woman's people likely enjoyed an abundance of animal protein. However, the nutritional quality of the animal protein consumed (wild game, especially gregarious ungulate herbivores, such as deer, bison, horses, and mammoths) differed from that found in the modern American supermarket. The latter meat has much more saturated fat, less eicosapentoenoic acid (a fatty acid shown to protect against coronary heart disease), and more calories per unit weight than the meat of wild game. Although the Paleolithic environment almost certainly had a greater abundance both of game and plant foods than current hunter-gatherer environments, Paleolithic humans would have experienced occasional shortages of food sufficient to threaten survival in the absence of adequate adipose reserves. Therefore, consuming excess calories to generate fat stores during times of abundance would have been adaptive (3, 4). Whether the resultant obesity would have been maladaptive then, as it is now, if a person as fat as the Willendorf woman survived beyond her 5th decade, or she would have been spared the adverse effects of morbid obesity because her diet was more wholesome than that being consumed today, is a question whose answer will lie forever lost in the moldering gap between her age and ours.

How prevalent morbid obesity was among pre-historic humans is equally difficult to know. All that can be said is that images with bodies similar to that of the Willendorf woman number in the hundreds, cover a period from 40,000 to 11,000 years ago, and have been uncovered at sites ranging from the Pyrenees to the plains of Siberia (Figure 1.2) (2).

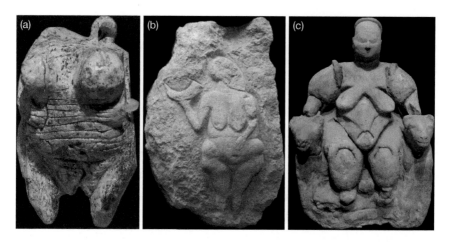

Figure 1.2. *Venus of Hohle Fels* statuette, mammoth ivory, 38,000–33,000 B.C.E. by an unknown artist, University of Tubingen, Germany (a). *Venus of Laussel*, bas-relief, limestone, c. 23,000 B.C.E. by an unknown artist, Musée d' Aquitaine, Bordeaux, France (b). *Mother Goddess of Çatal Hüyük* statuette (with restored head), baked clay, c. 23,000 B.C.E. by an unknown artist, Museum of Anatolian Civilizations, Ankara, Turkey (c).

Images from more recent periods testify to the fact that morbid obesity was also present among residents of some of the earliest civilizations. A bas-relief in Hatshepsut's mortuary temple in Luxor, for example, features the grossly overweight queen of the Chief of Punt (Figure 1.3), who lived during the time of Egypt's 18th dynasty (c. 1543–1292 B.C.E.).

The queen of Punt and the Willendorf woman were both massively obese with what appears to have been similarly elevated body-mass indices (BMI, weight in kg/height in m^2), the screening measurement commonly used today to estimate degrees of obesity. Based on their size, these two ancient women would have had BMIs of at least 40, with normal being 18.5–24.9. The BMI has the advantage of simplicity but, unfortunately, does not distinguish between fat and lean body mass (e.g., muscle), nor does it distinguish between abdominal obesity (so-called apple-shaped obesity) and obesity typified by that of the queen of Punt (so-called pear-shaped obesity). The former, also known as "central obesity," has been more closely associated in some studies, though not all, with cardiovascular

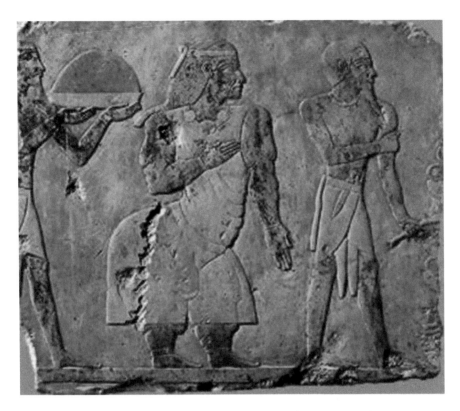

Figure 1.3. *Chief of Punt accompanied by his excessively obese queen,* sandstone bas-relief, c. 1450 B.C.E., Hatsehepsut Mortuary Temple, Valley of the Kings, Egypt. This image is of interest not only because of its antiquity, but also because it depicts a pattern of obesity different from that exhibited by the Willendorf woman—one in which adipose tissue predominates in the hips, buttocks and thighs, rather than the waist. This particular pattern of obesity, called *steatopygia* (from the Greek *stéar,* "tallow" and *pugē,* "rump"), is a genetic characteristic prevalent among women of African origin, most notably those from the Khoisan region (5).

disease and the other complications of morbid obesity than the latter (6). Given these observations, the queen of Punt might have suffered fewer adverse health effects due to her overnutrition than the Willendorf woman if both had survived beyond middle age, even though they had similarly elevated BMIs.

Numerous other stone reliefs, as well as studies of the skin folds of royal mummies, document the presence of obesity among the ancient Egyptian elite, although not its prevalence. Moreover, the Ebers papyrus,

written c. 1500 B.C.E., suggests that physicians of that era recognized the symptoms of diabetes (7). Although there is no evidence that they understood the importance of obesity as a risk factor for the disorder, they did appreciate the influence of diet on health in general. Like the Chinese before them, who devised dietary principles for longevity based on Taoist teachings, the physicians of ancient Egypt advocated a frugal diet of fish, bread, fruits, and vegetables (8).

Two portraits painted 3,000 years later reveal other pernicious aspects of obesity with particular relevance for some modern societies. They are portraits of 5-year-old Eugenia Martínez Vallejo (Figure 1.4) painted by Juan Carreño de Miranda in 1680 C.E. (9). They speak to the physical, social, and psychological burden of childhood obesity, a problem that has reached epidemic proportions in many of today's societies.

Aside from enduring the potential long-term adverse effects of childhood obesity on health, overweight children also face the stigma of being viewed as abnormal by many societies (11, 12). How Eugenia, a poor peasant girl who died when only 25 years old, happened to be so obese at such a young age apparently was of no concern to Charles II of Spain (no less odd in appearance himself, see Chapter 8), who commissioned the portraits. Nor did the medical profession have any knowledge then of the various genetic disorders associated with such early obesity (e.g., Prader-Willi syndrome, Bardt-Giedl syndrome, Cohen syndrome, etc.), or alterations in fetal gene expression caused by maternal malnutrition that are thought to cause a child to become obese, or the myriad ways in which poverty itself predisposes to obesity (13).

One-and-a-half centuries later, William Wadd produced an engraving of a grossly overweight woman, seated in a chair and seemingly about to drift into the arms of Morpheus (Figure 1.5). Although physicians since at least the time of Hippocrates have been concerned with the adverse effects of obesity on well-being, not until the 18th century C.E. did the condition become common enough, especially among the privileged classes, for the medical profession to begin to take notice of it as a serious threat to public health. Wadd, a surgeon, was one

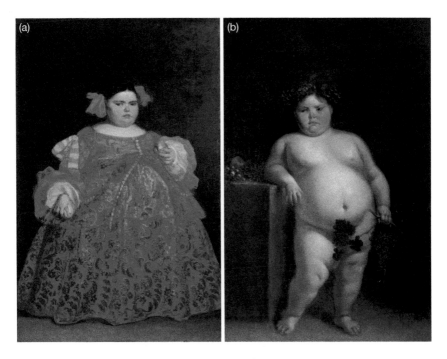

Figure 1.4. *La Monstrua Vestida* (a) and *La Monstrua Desnuda* (b), oil on canvas, 1680 C.E. by Juan Caruño de Miranda, Museo Nacional del Prado, Madrid, Spain.
Caruño de Miranda (1614–1685 C.E.) succeeded Sebastian de Herrera as court painter to the Spanish queen in 1671 C.E. He is known mainly for his portraits of the royal family and court (10).
The two portraits of Eugenia Martínez give subtle expression to the psychological effects of negative stereotyping on the overweight child. On close inspection of the *Vestida* painting, the hint of a tear is visible in the child's right eye. The tear is especially touching, given how young and defenseless she was when Carreño de Miranda saw fit to violate the angelic confidence of a small child without refuge or appeal by portraying her more as an object of derision—a *Monstrua* (Monster) —than a human being.

of the earliest and most influential physicians to do so. He maintained that the cause was obvious—"an over-indulgence at the table"—and the solution simple: "a sensible approach to food" (14). The results of numerous modern investigations argue otherwise. They indicate that the cause of the current obesity epidemic is far from obvious and its solution much more complicated than Wadd or physicians of his era could have imagined.

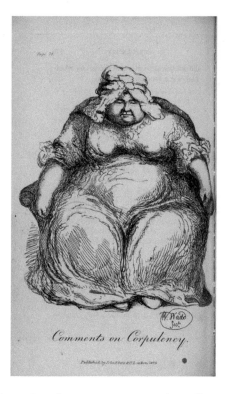

Figure 1.5. *Obese Woman Seated*, engraving, 1829 C.E. by William Wadd, Wellcome
Library, London, England.
William Wadd (1776–1829 C.E.), was a surgeon as well as a skilled draughtsman, who
personally drew and engraved this image and the others featured in his *Comments on
Corpulency* (1829) (14). Wadd's illustration brings to mind Joe, "the fat and red faced
boy in a state of somnolency" in Charles Dickens' *Pickwick Papers*. It further recalls
the association of extreme obesity with uncontrollable sleepiness, hypoventilation, and
right-sided heart failure, which in 1956 C.E. was given the name "Pickwickian syn-
drome" based on Dickens' prescient description of the disorder in his novel. In its ad-
vanced stages, the syndrome is one of the most pernicious complications of extreme
obesity (15).

If a picture is worth a thousand words, Lucian Freud's *Benefits Supervisor
Sleeping* (Figure 1.6) tells a great deal about just how complicated the
causes and control of the current obesity epidemic are. Historically, obese
persons were thought to be low energy expenders, that is to say that they
conserve energy (and thereby calories) to a greater extent than non-obese
persons by moving less (16). This was believed to be the reason, at least in

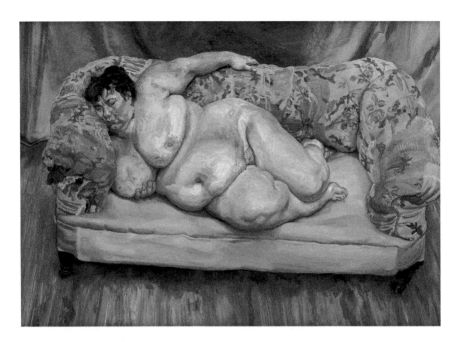

Figure 1.6. *Benefits Supervisor Sleeping*, oil on canvas, 1995 C.E., by Lucian Freud, private collection, Europe.
Lucien Freud (1922–2011, C.E.), a grandson of Sigmund Freud, fled Nazi Germany with his family in 1933 and settled in London. At the time of his death, he was considered Britain's pre-eminent artist, known chiefly for impasto portraits , such as this one with its characteristic thick layers of paint. Like the ideal physician, he spent an inordinate number of hours studying his subjects to detect inner secrets, which he revealed with brutal objectivity in his works (17). *Benefits Supervisor Sleeping* sold for $33.6 million at Christie's in 2008 C.E., setting a world record auction price for a work by a living artist (18).

part, why so often obese persons failed to lose weight when dieting. Freud's portrait of the woman he called "big Sue," and whose body he described as "flesh without muscle" (18), shines a lurid and seemingly confirmatory light on the concept. Although recent evidence fails to support this hypothesis, exercise is, nevertheless, currently considered an essential component of the comprehensive lifestyle modification included in virtually all obesity management programs.

If Freud's "big Sue" were to adhere to the various interventions promoted in current weight loss programs, she might lose weight,

possibly even a substantial amount of weight, but only if she committed completely for an indefinite period to the program. Unfortunately, losing weight is easier for morbidly obese persons than maintaining the weight loss. Few patients of "big Sue's" size succeed over the long-haul. For many, safeguarding one's health at the cost of too strict a diet becomes an illness more tedious than the obesity, and they give up. In others, the battle is lost, in part because their weight loss activates some mysterious internal mechanism that produces a countervailing drop in metabolic rate seemingly designed to pull them back to their original level of obesity (19).

UNDERNUTRITION

There is perhaps no better clinical description of the devastating effects of starvation on the human body than that of the Buddha's condition at the end of his 6-year fast recorded in the *Pali Canon*. According to the account:

> The Buddha, having consumed "as little as one spoonful of bean soup a day, a single sesame seed, and a single grain of rice [became so emaciated his] rib cage was like an old stable with its sides caved in; [his] head withered until it looked old and wrinkled and dry; his eyeballs were sunken, and he had difficulty seeing. When he placed his hand on his abdomen he could feel his spine; when he tried to stand he fell backwards. His beautiful skin turned as black as the color of the madgura fish, and all the hairs came away from his body when the sun fell on him, he did not move into the shade, and from the shade he did not move into the sun. He did not seek refuge from the wind, sun, or rain; he did not chase away horseflies, mosquitoes, or snakes. He did not excrete urine or excrement or spittle or nasal secretions [he became] so weak, so feeble and thin that when they put grass and cotton in the openings of his ears, it came out through his nostrils. (20)

The second-century B.C.E. bronze casting of the *Starving Buddha* by an unknown artist (Figure 1.7) offers an equally arresting image of the ravages of prolonged starvation. However, it tells us nothing about starvation's prevalence in India during the Buddha's lifetime. We can only guess what it might have been based on how common it is today in areas of the Indian subcontinent lacking adequate nutrition.

Today undernutrition no less severe than that resulting from the Buddha's self-imposed fast is a terrifying torture of necessity for some 19 million children under the age of 5 years in certain areas of the world

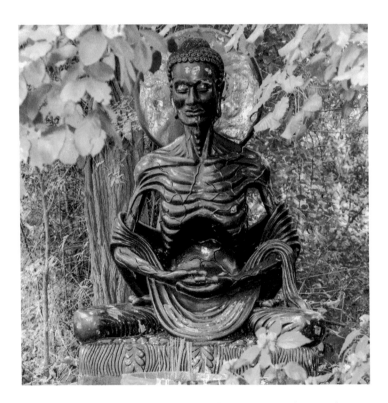

Figure 1.7. *Starving Buddha*, bronze casting, 2nd century B.C.E. by an unknown artist, Lahore Museum, Lahore, Pakistan.
The Buddha was a young man when he resorted to self-mortification through extreme fasting in his quest for perfect enlightenment (20). The effects of prolonged starvation, so graphically illustrated in this bronze casting, gave him the appearance of a man much further along in life's journey than his age would suggest.

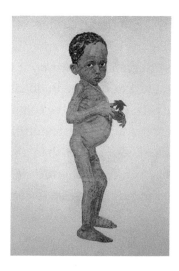

Figure 1.8. *Impact of Malnutrition,* brush pen on cotton, 2016 C.E. by Pierre Mukeba, artist's personal collection.
Mukeba, a self-taught artist, was born in the shadow of civil war in the eastern Democratic Republic of Congo. He had personal experience with food shortages severe enough to cause the signs of starvation exhibited by this child—spindly arms, bloated belly and edematous lower legs. In his works, Mukeba restricts his palette to just three colors—red (for war), blue (piety), and yellow (happiness). The small red flower in this child's hand speaks not to piety or to happiness, but to war's role in creating food shortages responsible for such severe malnutrition (22).

(21). Pierre Mukeba's *Impact of Malnutrition* (Figure 1.8) captures the loneliness, hopelessness, and terror of starvation that has fastened its grip on vast areas of sub-Saharan Africa, as well as places in Asia where the Buddha preached moral enlightenment through selfless endeavor so long ago.

Kwashiorkor

Although the causes of starvation (e.g., war, draught, governmental mis-management) are rarely medical per se, starvation's clinical consequences are profound and highly variable, depending on the age of the victim and the particular nutrient that is most lacking. If the deficient nutrient is

primarily protein, the deficiency is severe, and the victim is a young child, a syndrome known as "Kwashiorkor" can develop. The name, derived from the Ga dialect of West Africa, is shorthand for "the sickness the older child gets when the next baby is born" (23). In certain areas of sub-Saharan Africa, the older child sickens (i.e., becomes profoundly protein deficient) with the arrival of the second child, because he/she is weaned from protein-rich mother's milk to a diet consisting nearly exclusively of carbohydrates. As the deficiency progresses, the older child becomes weak, apathetic, and peevish (Figure 1.8). The child's muscles waste away, growth ceases, and edema and anemia set in. The skin turns dry and scaly. The hair changes from black to red, and the eyes lose their luster. The belly becomes bloated.

Treatment is simple in principle, a nutritious diet containing adequate carbohydrates, fats, and vitamins, along with protein introduced in gradually increasing amounts. Unfortunately, treatment is considerably more complicated in practice than in theory, because Kwashiorkor is a disorder of poor countries whose ability to provide proper nutritional support to their people is compromised further by war, natural disasters, and/or political unrest.

Iodine Deficiency

When iodine is the deficient nutrient, the resulting physiological damage may be relatively minor or catastrophic depending on the extent of the deficiency and the age of the victim. In the adult, the result may be nothing more severe than the prominent goiter (enlargement of the thyroid gland) visible in Albrecht Dürer's portrait of Elsbeth Tucher (Figure 1.9). If, however, the victim is a fetus developing in the womb of a markedly iodine-deficient woman, the effect can be catastrophic. Iodine is essential for the production of thyroid hormone. In its absence, synthesis of the hormone is impaired, resulting in a multisystem disorder known as "hypothyroidism" (25). When severe, the disorder is particularly hard on

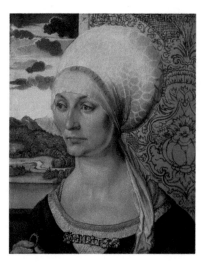

Figure 1.9. *Portrait of Elsbeth Tucher*, oil on wood, 1499 C.E. by Albrecht Dürer,
Staatliche Kunstsammlungen, Kassel, Germany.
Albrecht Dürer (1471–1528 C.E.) is widely regarded as one of the most important fig-
ures of the Northern Renaissance for his work as a painter, printmaker, and theorist (24).
His theories of "ideal beauty" based on variety are reflected in this portrait of a beautiful
woman with a large goiter (note the prominent rounded mass in her neck) and a strange
tubular deformity extending from the left ear to the lower chin for which there is no
anatomical basis.

the developing fetus, producing a concatenation of mental and physical
deformities, known as "cretinism" (Figure 1.10).

The consequences of iodine deficiency (goiter and fetal abnormalities)
have been recognized by physicians since the dawn of the profession and
featured in works of art for nearly as long. Chinese medical writings dating
to approximately 3600 B.C.E. record decreases in the size of goiters with the
ingestion of seaweed and burnt sea sponge. Iodide, the key ingredient of
these foods, was not discovered until 1811, when French chemist, Bernard
Courtois, identified the element while extracting sodium salts necessary
for the manufacture of gun powder. By the 1920s, hypothyroidism due to
iodine deficiency was eliminated in most countries following adoption of
the Swiss practice of adding sodium iodide or potassium iodide to table
salt (27).

Figure 1.10. *Naked Cretin*, bronze figure (a thick plaster covering the back is believed to have represented a device designed as a cure for cretinism), c. 1700 C.E. by an unknown Benin artist, British Museum, London, England.

This dwarf-like figure, with its misshapen head, vacuous expression, coarse facial features, and flaccid-appearing limbs is a stunning representation of a child with classic features of cretinism. The figure was one of many removed from the King of Benin's compound by the British in 1897 C.E. during a punitive expedition. Several of the figures were covered with blood, indicating their use during religious sacrifices. British scholars of the early 20th century speculated that this and other such figures represent an advanced stage of Benin art developed under Portuguese influence during the 16th century C.E. (26).

Scurvy

During the Age of Exploration, the medical profession encountered a previously unknown disorder among sailors forced to subsist on diets devoid of fruits and vegetables during prolonged voyages. The early phase of the disorder was marked by weakness and fatigue. Then victims lost their appetite and began losing weight. Next their muscles and joints began to ache. Small hemorrhages erupted around their hair follicles from which cork-screw shaped hairs emerged. The gums of affected sailors began to swell and bleed; then their teeth loosened and fell out. Their legs swelled; wounds would not heal. The worst affected developed cardiorespiratory failure and died (28, 29). Nikolai Getman captured several of the essential features of the disorder in a painting depicting the suffering of *Prisoners in Forced Labor Camps in Siberia and Kolyma* (Figure 1.11).

The cause of scurvy remained a mystery until 1912 C.E., when Frederic Gowland Hopkins published a landmark paper in the *Journal of Physiology* describing feeding experiments that demonstrated the importance of "accessory" factors other than fat, protein, and carbohydrate in maintaining health (31). That same year Casimir Funk, working at the Lister Institute in London, identified the first such factor—thiamine—and coined the term "vital amine" or vitamin (32). In time, vitamin C, another "accessory factor," was identified as the key ingredient of fruits and vegetables that cure scurvy.

Beriberi

Severe thiamine (vitamin B_1) deficiency causes a different, though equally disabling syndrome known as "beriberi." Western physicians first encountered the disorder in the Far East during the 17th century C.E. among patients having an appearance similar to those featured in Leslie Cole's portrait of starving prisoners of war of the Japanese during World War II (Figure 1.12). The disorder produced swollen feet and

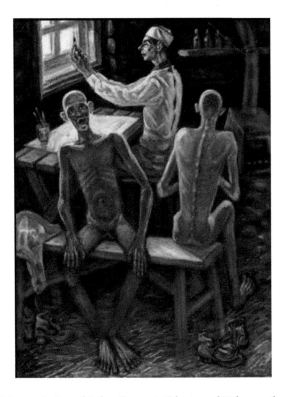

Figure 1.11. *Prisoners in Forced Labor Camps in Siberia and Kolyma*, oil on canvas by Nikolai Getman, the Jamestown Foundation, Washington, D.C., United States. Getman (1917–2004 C.E.), a prisoner of both forced labor camps from 1946 to 1953 C.E., was one of only a few artists who recorded the life of prisoners in the Soviet Gulag. He risked further torture and death to produce works such as this one, "convinced that it was [his] duty to leave behind a testimony to the fate of millions of prisoners who died" (30). Signs of scurvy in the man facing the viewer include his emaciation, absent teeth, gasping respiration (possibly due to a failing heart), and the purple discoloration below his right knee, possibly representing subcutaneous hemorrhage.

caused legs to become so numb and weak that victims walked with an unsteady, tottering gait. Some developed palsies (paralysis), particularly of the legs. In others, their hearts began to fail, occasionally resulting in sudden death. General malnutrition contributed to this host of agonies. However, near total lack of thiamine in a diet consisting almost exclusively of polished white rice was the principal cause, in that the process of power milling involved in the production of white rice robs the grain of most of its content of thiamine and other vitamins (34).

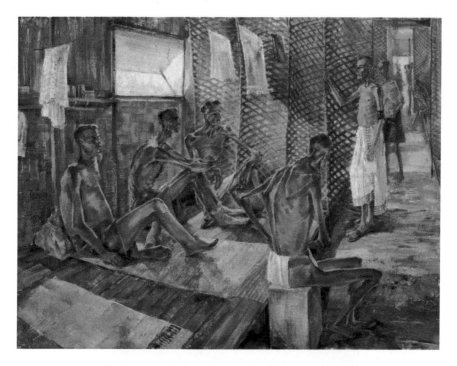

Figure 1.12. *Orderly on his rounds in X ward, Changi Gaol, Singapore, with POW's suffering from starvation and beri-beri,* oil on canvas, 1945 C.E., by Leslie Cole, Imperial War Museum, London, England.
Cole (1910–1976 C.E.) worked for the British military as a war artist during World War II in Burma, Malaya, Normandy, Greece, and Gibraltar. Long after the war he drank heavily in an unsuccessful effort to erase memories of the suffering he saw and recorded in Singapore and the Belsen concentration camp (33). The swollen ankle of the man in the left foreground is typical of the edema that develops as a result of heart failure in cases of "wet" beriberi.

One of the important lessons of World War II was that refeeding prisoners of war and concentration camp survivors suffering from beriberi had to be done cautiously. Feeding carbohydrates to thiamine-deficient patients is especially dangerous, because carbohydrates divert limited stores of thiamine away from the heart and nervous system into glucose metabolism, which can induce potentially fatal diarrhea, heart failure, and neurological dysfunction. Given this knowledge, today patients with known or suspected thiamine deficiency are given large doses of

intravenous thiamine along with other nutrients during the first several days of treatment (34).

Pellagra

During the 18th century C.E., physicians in northern Spain and Italy saw what for them was a new disorder that turned the skin of victims bright red. Initially they called it *mal de la rosa* (the bad rose) and then *pelle ago* (rough skin), from which the present name, "pellagra," is derived. The principal feature of the disorder is a painful, red, crusting eruption of the skin of sun-exposed areas such as the hands, neck, and face (Figure 1.13). In its advanced stage, pellagra produces a host of systemic abnormalities referred to as the "four Ds": diarrhea, dermatitis, dementia, and death. In 1937 C.E., pellagra's cause was identified as a deficiency of niacin (vitamin B_3). Its appearance in 18th century C.E. Spain and Italy and later in the southern United States coincided with the advent of maize as a staple of the local diet. Only later was it learned that the niacin in corn and other cereals linked to outbreaks of pellagra is "bound" niacin, which is biologically inert (36).

THE CANONICAL BODY

Greece's Golden Age lingers to this day in our thought as well as our art. It was then that the concept of beauty was first articulated not just as an ideal physical appearance, but as a whole philosophy of life that exalted all human values and saw humans themselves as the culmination of the process of nature. The human form at its most exquisite dominated the art of that period in works such as the *Apollo Belvedere* and *Venus de Milo*—countless images of mankind that were all perfectly formed, perfectly proportioned, noble, and serene—in a word, more perfect than any actual human body (37).

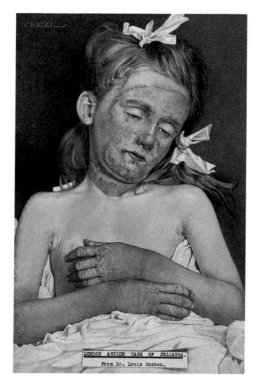

Figure 1.13. *A girl in London Asylum suffering from chronic pellagra,* watercolor on paper, c. 1925 C.E. by Amedeo J. E. Terzi, Wellcome Library, London, England. Terzi (1872–1956 C.E.), an Italian entomologist, is best known for his illustrations of parasitic insects, many of which were commissioned by the renowned pioneer in tropical medicine, Sir Patrick Manson (35). The prominent rash on the young woman's face, neck, and hands is a classic manifestation of pellagra. The coarse rash located on her neck is known as "Casal's necklace" in honor of Casper Casal, who first described the disorder in 1762 C.E. among the peasants of Asturias, Spain.

The urge to emulate the Greek concept finds many young women today struggling daily to achieve superhuman beauty at considerable physical, emotional, and financial cost. The pressure to do so arises in no small measure in response to the societal prejudices already alluded to. Society's interest in physical perfection and possibly its sometimes dire consequence are both captured in Hasselhorst's *The Dissection of a Young Beautiful Woman* (Figure 1.14). The young woman in the chalk drawing was 18 years old when she committed suicide. Her young body

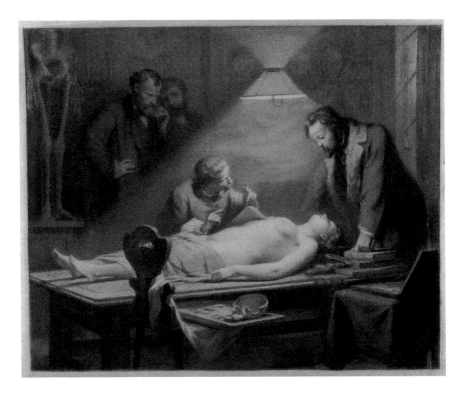

Figure 1.14. *Dissection of a Young Beautiful Woman*, chalk drawing, 1864 C.E. by Johann J. Hasselhorst, Wellcome Library, London, England.
Johann Christian Gustave Lucae, who directed the dissection, is shown leaning over the young woman, staring intently into her face. He was an anatomist as well as a talented illustrator. His apparent preoccupation with the woman's face, as well as the inverted cranium in the foreground and the skulls visible on the shelves of the back wall, reflect his special interest in craniology, which was the focus of his most important work. One of the two men observing the procedure in the background is the artist, Hasselhorst. The surgeon, J. P. Sälzer, performing the dissection, is pulling back a flap of skin from the right chest wall that appears to have a layer of fat not nearly as thick as that of the woman who was the model for the *Venus of Willendorf* but more prominent than that of the *Venus de Milo* model (37).

was taken apart to determine the *ideal* measurements of the female form (38). What criteria Johann Christian Gustave Lucae, the anatomist who supervised the dissection, used to determine that his subject had the ideal female body is unknown. Possibly he chose her because of her likeness to the *Venus de Milo*? We do not know the results of Lucae's analysis. It's not likely that they enhanced our understanding of beauty. For

beauty is a changing and fitful thing, which like health, has its season. In both cases, science is better at analyzing the parts than in understanding the whole.

REFERENCES

1. Read H. *The Meaning of Art*. London: Faber and Faber; 1972: 72.
2. Dixson AF, Dixson BJ. Venus figurines of the European Paleolithic: symbols of fertility or attractiveness? *J Anthropol.* 2011; 2011: 1–11.
3. Konner M, Eaton SB. Paleolithic nutrition. Twenty-five years later. *Nutrition Clin Pract.* 2010; 25: 594–602.
4. Eaton SB, Konner M. Paleolithic nutrition. A consideration of its nature and current implications. *N Engl J Med.* 1985; 312: 283–289.
5. *Webster's Ninth New Dictionary.* Springfield, MA: Merriam-Webster; 1985
6. Bray GA, Frühbeck G, Ryan DH, Wilding JPH. Management of obesity. *Lancet* 2016; 387: 1947–1956.
7. Loriaux DL. Diabetes and the Ebers papyrus 1552 B.C. *Endocrinologist* 2006; 16: 55.
8. Daumas F. *La Civilization de l'Egypte Pharaonique.* Paris: Artaud; 1965: 424.
9. Bordin G, D'Ambrosio LP. *Medicine in Art*, (trans. Hyams J).Los Angeles: Getty Publications; 2010; 34–35.
10. http://www.spainisculture.com/en/artistas_creadores/juan/carreno_de_miranda. html (accessed December 27, 2016).
11. Grant SL, Mizzi T, Anglim J. "Fat, four-eyed and female" 30 years later: a replication of Harris, Harris and Bochner's (1982) early study of obesity stereotypes. *Australian J Psychol.* doi: 10.111/ajpy.12107.
12. Minor T, Ali MM, Rizzo JA. Body weight and suicidal behavior in adolescent females: the role of self-perceptions. *J Mental Health Policy Econ.* 2016; 19: 21–31.
13. Bukvic N, Elling JW. Genetics in the art and art in genetics. *Gene* 2014, http://dx.doi. org/10.1016/j.gene.2014.07.073.
14. http://rcpilibrary.blogspot.com/2012/08/book-of-month-william-wadds-comments-on_31.html (accessed on July 7, 2016).
15. Miller A, Granada M. In-hospital mortality in the Pickwickian syndrome. *Am J Med.* 1974; 56: 144–150.
16. Carneiro IP, Elliott SA, Siervo M, et al. Is obesity associated with altered energy expenditure? *Adv Nutr.* 2016; 7: 476–487.
17. Spurling J. Profile: Lucien Freud: portrait of the artist as a happy man. *The Independent*, Saturday December 12, 1998.
18. National Portrait Gallery, Exhibition booklet for *Lucian Freud Portraits*, 1012, Section VII.
19. Kolata G. After "the biggest loser," their bodies fought to regain weight. *NY Times*, May 2, 2016.

20. Mackowiak PA. *Diagnosing Giants. Solving the Medical Mysteries of Thirteen Patients Who Changed the World*. New York: Oxford U. Press; 2013:18–30.
21. Black RE, Victora CG, Walker SP, et al. Maternal and child undernutrition and overweight in low-in-come and middle-in-come countries. *Lancet* 2013; 382: 427–451.
22. http://gagprojects.com/index.php/artists/pierre-mukeba/ (accessed April 20, 2018)
23. MacKay DM. Kwashiorkor. *East Pakistan Med J.* 1963; 7: 1–8.
24. Panofsky E. *The Life of Albrecht Dürer*. Princeton, NJ: Princeton U. Press; 1945; ISBN 0-691-00303-3.
25. Ingbar SH, Woeber KA. Diseases of the thyroid, in Thorn GW, Adams RD, Braunwald E, et al. (eds.), *Harrison's Principles of Internal Medicine* (8th ed.). New York: McGraw-Hill Book Co.; 1977: 508–510.
26. Pitt-Rivers, AHL-F. *Antique Works of Art from Benin*. The Project eBook #44014, October 22, 2013: 4–5.
27. Leung AM, Braverman LE, Pearce EN. History of U.S. fortification and supplementation. *Nutrients* 2012; 4: 1740–1746.
28. Hirschmann JV, Raugi GJ. Adult scurvy. *J Am Acad Dermatol.* 1999; 41: 895–906.
29. Dunn PM. James Lind (1716–94) of Edinburgh and the treatment of scurvy. *Arch Dis Child Fetal Neonatol Ed.* 1997; 76: F64–65.
30. Getman, N. *The Gulag Collection: Paintings of the Soviet Penal System*, The Jamestown Foundation, 2001: 131. ISBN 0-9675009-1-5.
31. Hopkins FJ. Feeding experiments, illustrating the importance of accessory factors in normal diets. *J Physiol.* 1912; 44: 425–460.
32. Funk C. The etiology of the deficiency diseases. *J State Med.* 1912; 20: 341–368.
33. https://arts.brighton.ac.uk/alumni-arts/cole-leslie-1910-1976 (accessed July 36, 2016).
34. Van Itallie TB. Thiamine deficiency, ariboflavinosis and vitamin B_6 deficiency. *Harrison's Principles of Internal Medicine* (8th ed.). New York: McGraw-Hill Book Co.; 1977: 455–457.
35. Mattingly P. Amedeo John Engel Terzi, 1872–1956. *Mosquito Systematics* 1976; 8: 114–120.
36. Mann GV, Van Itallie TB. Pellagra, op. cit. *Harrison's Principles of Internal Medicine* (8th ed.). New York: McGraw-Hill Book Co.; 1977: 452–455.
37. Read H. *The Meaning of Art*. London: Faber and Faber; 1972: 21.
38. http://catalogue.wellcomelibrary.org/record=b1183379 (accessed December 27, 2016).

Diagnostics

L ittle has changed in the initial evaluation of the patient for over 4000 years. The principles underlying today's concept of a proper medical history and physical examination were clearly articulated in nine Egyptian papyri, some of which were written as early as c. 1950 B.C.E. In the Ebers papyrus (c. 1550 B.C.E.), the longest and most edifying of the surviving medical papyri of the ancient Egyptians, we learn that physicians of that era began their examination of patients by obtaining a detailed history through pre-specified questions designed to elicit as many signs and symptoms as possible. Like today's physicians, those of ancient Egypt saw symptoms as the cry of suffering organs, although their understanding was limited by their rudimentary knowledge of anatomy and physiology (1).

The medical history obtained by these early physicians was followed by a careful physical examination employing many of the same maneuvers used by physicians today (1):inspection (to assess the patient's general appearance and search for focal abnormalities pointing to the

seat of the illness), palpation (of the radial pulse, the temperature of the skin, and abnormalities detected during inspection), and auscultation (of the lungs and abdomen in search of disordered breathing or abnormal bowel sounds). The odor of sweat, breath, and wounds was noted in search of further clues to diagnosis, much as astute clinicians do today in predicting the presence of kidney failure, liver failure, a lung abscess, or a bed sore harboring particular bacteria based on their distinctive smell.

Ancient physicians had none of the vast array of sophisticated laboratory tests that are so important today in diagnosing diseases. Nevertheless, they did conduct crude examinations of blood, urine, stool, and other body secretions in rendering diagnoses. Ultimately, however, most diagnoses proved no more edifying than the words patients used to describe their illnesses (2).

THE MEDICAL HISTORY

An early 20th century C.E. painting by Édouard Vuillard (Figure 2.1) says a great deal *sub specie aeternitatis* about the art of obtaining a medical history. In Vuillard's portrait, Dr. Henri Vaquez gazes directly into his patient's eyes with a look of compassion and concern during the interview. He has his hand on her shoulder. As reflected in the intimacy of the interaction taking place between doctor and patient in the portrait, the art of history taking involves a conversation concerned not just with the collection of clinical information, but one also intended to allay the patient's anxiety, build confidence, and ensure cooperation during interventions to come.

The information obtained by Dr. Vaquez during the interview would have been recorded by hand in a document much like the notebook tucked under the arm of the attendant to the patient's left in Vuillard's painting; the patient's vital signs (to be further discussed) would have been recorded on a clipboard like the one in the hand of the nurse on the painting's far left. Although the ancient Egyptians recorded a succession

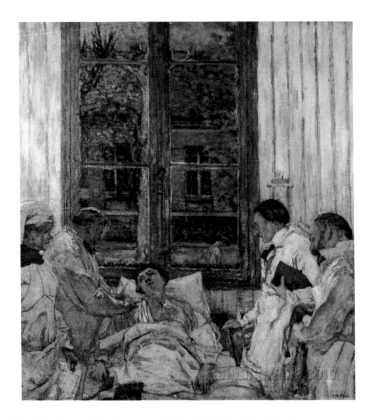

Figure 2.1. *The Doctor Henri Vaquez (1860–1936,) Cardiologist*, distemper on canvas, 1921 C.E. by Édouard Vuillard, Académie Nationale de Médicine, Paris, France.

Dr. Vaquez, a French internist, is remembered for having provided the first description of polycythemia rubra vera (3), a disorder of the bone marrow resulting in an excess of circulating red blood cells that gives patients' complexions a red or bluish-red hue. The hands and face of the patient in this painting are noticeably redder than those of the two attendants to her left, suggesting that she might have been suffering from the disorder. However, Dr. Vaquez's face and that of the man visible through the window are equally red, implying that Vuillard gave the patient a rubious complexion simply for harmonic reasons.

of brief remarks about various diseases, clinical records of individual patients were not kept until much later by Hippocratic physicians in the 4th and 3rd centuries B.C.E. (4). Several of these appear in *Epidemics*, one of numerous treatises in a collection of works composed by disciples of Hippocrates known as the Hippocratic Corpus. Over the course of many centuries, paper records gave way to electronic documents in

which, sadly, patients' medical histories have been transformed from personalized stories of the travails of their illnesses to ones composed largely of auto-populated fields offering scant insight into the actual patient experience.

THE PHYSICAL EXAMINATION

Although an increasingly complex array of laboratory tests and imaging procedures would seem to indicate otherwise, the bedside physical examination remains one of the cornerstones of today's patient evaluation. When combined with information obtained from the medical history, the physical examination points to the correct diagnosis in most patients, and in all patients it provides information that is essential in guiding the use of riskier and more expensive laboratory and imaging evaluations. Moreover, the intimacy of the physical examination (Figure 2.2), like that of the medical interview, reinforces as powerfully as any interaction in the doctor/patient relationship the trust that is essential in defining mutual expectations and conveying to the patient a physician's sense of caring.

A complete physical examination traditionally begins with assessment of the patient's "vital signs"—temperature, pulse, respiratory rate, and blood pressure. The examination then progresses from head to toe in an orderly fashion that has changed little over thousands of years.

As recorded some 3000 years ago in the *Sushruta Samhita*, Ayruvedic medicine's ancient Sanskrit text:

[In undertaking the physical examination] The physician should view the body of the patient, palpate it with his hands, and inquire about his complaint the five sense organs of hearing, touch, sight, smell and taste, as well as oral inquiry, materially contribute to a better diagnosis. By the sense of hearing we can . . . determine whether the contents of an abscess are frothy and gaseous, for the

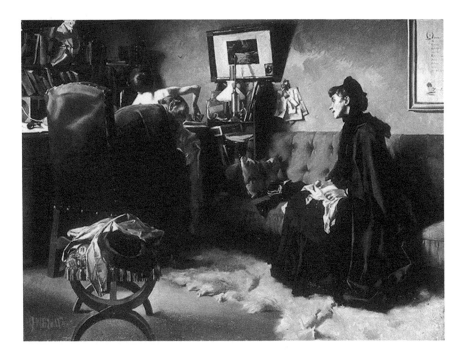

Figure 2.2. *A Delicate Child [Ein Sorgenkind],* oil on canvas, 1886 C.E. by Baron Hugo von Habermann. Staatliche Museen zu Berlin-Pruessicher Kulturbesitz, Nationalgalerie, Berlin, Germany.
This sensitive study of the doctor-patient relationship captures in near photographic realism the vulnerability of the seriously ill patient and the extent to which patients will expose themselves to physicians in search of a cure for their illnesses. The "direct auscultation" of the child's bare chest by the doctor points to a pulmonary disorder as her problem. Given the anxiety and profound fatigue visible in the mother's face, combined with the child's pale and emaciated appearance, the pulmonary disorder is likely chronic and relentlessly debilitating, in which case, tuberculosis would be an important consideration.

emptying of such is attended with noise. By the sense of touch we may know whether the skin is hot or cold, rough or smooth By the sense of sight we can determine corpulence or emaciation, vital power . . . and change of colour. By the sense of taste we can assure ourselves concerning the state of the urine in diabetes And by the sense of smell we can recognize the peculiar perspiration of many diseases. (5)

The fact that physicians today follow much the same format in performing a complete physical examination makes the rapidly changing world of modern medicine seem strangely static.

For as long as humans have committed thoughts to tablets, papyrus, or paper, body temperature has been monitored as a means of distinguishing health from disease. Although a crude forerunner of a thermometer might have been invented by Philo of Byzantium as early as the 3rd century B.C.E., not until the 17th century C.E. was such an instrument put to clinical use. In 1612 C.E., Santorio Santorio (Sanctorius), a colleague of Galileo, described the first device known to have been used to measure a person's temperature. Two more centuries would pass before the thermometers we use today would be perfected (6).

The pulse and respiratory rate have also been monitored as part of the physical examination in nearly every medical tradition. Western physicians, such as the one featured in Picasso's *Science and Charity* (Figure 2.3), typically examine a patient's pulse by palpating the radial artery in the wrist, taking note of both the rate and the rhythm of the pulsations being transmitted from the beating heart. In the normal, resting adult, the pulse rate varies between 60 and 100 beats per minute with a regular rhythm that varies only slightly with respiration.

Practitioners of traditional Chinese medicine, such as the one featured in Figure 2.4, have a considerably more complex scheme for evaluating a patient's pulse. The scheme, formulated in the 16th century C.E. by physician Li Shizhen, involves no fewer than 12 basic pulses, each linked to a specific organ. Physicians, such as the one featured in this figure, perform the examination on both wrists, ideally early in the morning, when Yin and Yang are believed to be in balance. In differentiating one disease from another, the physician looks for characteristic qualities of the pulse, not just its strength, rhythm and pace, but also its depth, volume, shape and size. In ancient India, a similarly complex scheme was employed in evaluating a patient's pulse (8).

Although palpation of a patient's pulse has been an integral part of the physical examination since antiquity, knowledge of the mechanisms responsible for arterial pulsations awaited the work of William Harvey in

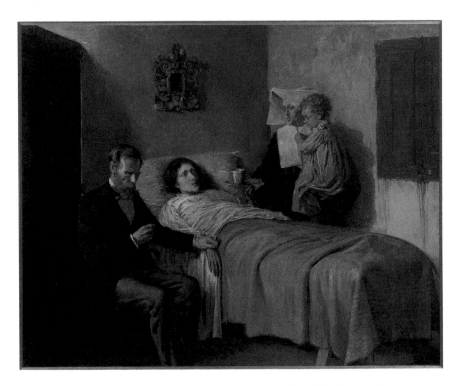

Figure 2.3. *Science and Charity*, oil on canvas, 1897 C.E. by Pablo Picasso, Museu Picasso de Barcelona, Barcelona, Spain.
The "patient" featured in this work is a beggar Picasso hired off the street to pose for him for 10 pesetas. Her desperately ill appearance, therefore, is likely imaginary, reflecting Picasso's later comment that "Art is a lie that makes us realize the Truth." Possibly the medical truth revealed in the painting is the cardiovascular collapse that takes place during the terminal phase of fatal diphtheria—as evidenced by the bed-bound patient's blue (i.e., cyanotic) right hand and pale face—which carried off Picasso's beloved 7-year old sister, Conchita, in 1895 C.E. (7).

the 17th century C.E., which established the relationship of the pulsations with contraction of the left ventricle of the heart. In time, instruments capable of recording the hemodynamic characteristics of arterial pulsations were developed, including the Kymograph featured in Figure 2.5. However, not until 1896 C.E. did clinicians have a simple, reliable way to measure the force of such pulsations—the blood pressure (the 4th vital sign). That was the year Scipione Riva-Rocci introduced the inflatable cuff that would give rise to the modern sphygmomanometer (9).

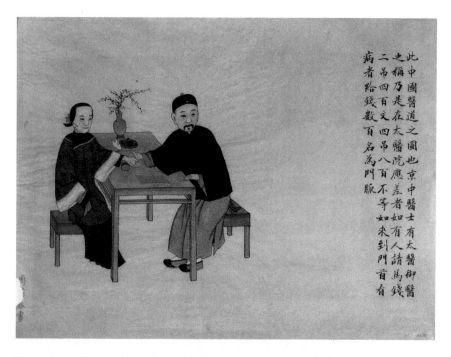

此中國醫道之圖也京中醫士有太醫御醫
之稱乃是在太醫沈應羞者如有人請馬錢
二弔四百文四弔八百不等如來到門首看
病者給錢數百名為門脈

Figure 2.4. *A Doctor Taking the Pulse of a Woman Seated at a Table*, watercolor, c. 1890 C.E. by Zhou Pei Chun, Wellcome Library, London, England.
In this typical Chinese painting devoid of chiaroscuro, the physician is examining a patient's left radial pulse, which according to traditional Chinese medical precepts, is the one most closely linked to the status of the heart (8). The physician has no watch. Nevertheless, given the position of his left hand, he appears to be using it to tap out the cadence of the pulse. All that can be said of the patient is that she appears pale though not otherwise ill.

Inspection, palpation, and auscultation during the physical examination also have long been featured in works of art. Figure 2.6 shows Rhazes, a 9th century C.E. Persian physician, inspecting a young boy's throat. Like the Hippocratic physicians who preceded him by over a thousand years, Rhazes used what was perceptible not just to his sight, but to all his senses in arriving at a diagnosis and predicting prognosis (10). However, patients' exterior appearances would provide only limited insight into their disorders until many centuries later when physicians gained the ability to perceive the condition of the body's invisible interior.

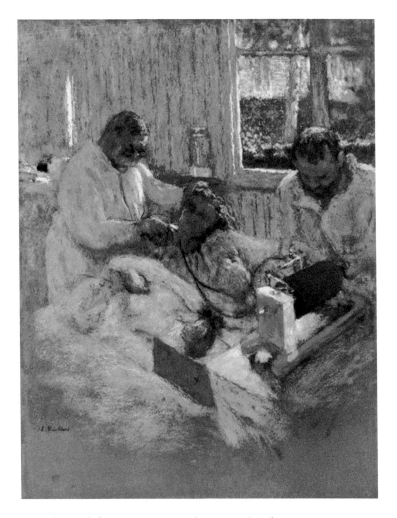

Figure 2.5. *The Cardiologist Henri Vaquez (1860–1936) and His Assistant, Dr. Parvu,*
distemper on canvas, c. 1918–1921 C.E. by Édouard Vuillard, Musée de l'Assistance
Publique, Paris, France.
Vuillard was friends with many physicians who, like Dr. Vaquez, were passionate art
collectors. Vuillard portrayed several of them engaged in professional activities, such
as in this painting in which Dr. Vaquez, with Dr. Parvu's assistance, is examining blood
flow in the arteries and veins of a patient's neck using Ludwig's drum kymograph (wave
writer). Given Dr. Vaquez's interest in cardiac arrhythmias, it is likely that the elderly pa-
tient being examined suffered with some form of heart disease (3).

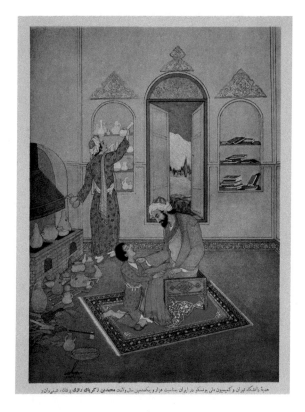

ه‌دیهٔ دانشگاه تهران و کمیسیون ملی یونسکو در ایران بمناسبت هزار و یکصدمین سال ولادت محمدبن زکریای رازی و شاک، شیمی‌دان و

Figure 2.6. *Rhazes, a Physician, Examines a Boy,* color press print, c. 1960 C.E. after Hossein Behzad, Wellcome Library, England.
Behzad, a modern artist, is known for producing miniatures in the 10th century C.E. Persian style (11). In this one, he created an image of Rhazes (Abu Bakr Mohammad Ibn Zakariya al-Razi) examining the throat of a young boy. Rhazes is credited with distinguishing measles from smallpox, which had previously been lumped together as a single disease with a pleomorphic rash (10). Although both infections produce lesions in the throat during their course, the boy being examined by Rhazes lacks the blistering eruption of smallpox and does not appear ill enough to be suffering with full-blown measles.

Every aspect of the external manifestations of disease was noted by Hippocratic physicians in search of the smallest detail that might reveal the patient's diagnosis and likely prognosis. William Orpen's *A Mere Fracture* (Figure 2.7) captures the intensity with which the dedicated clinician searches for such clues. The young physician depicted in the painting

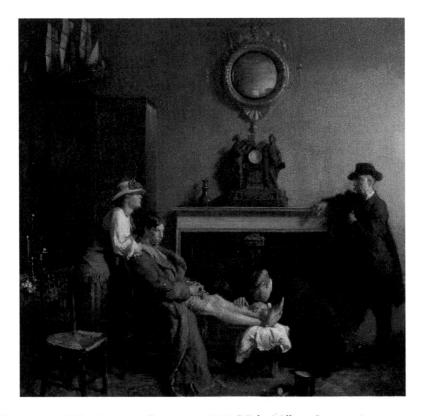

Figure 2.7. *A Mere Fracture,* oil on canvas, 1901 C.E. by William Orpen, private collection.

The doctor featured in this portrait was modeled after William Compton Gore, a fellow student of Orpen's at the Slade School of Art and a physician who gave up medicine for painting the year Orpen produced this work (12). The title of the work, "A Mere Fracture," belies the probable existence of a complication of the fracture, perhaps an infection, that can be read, as if printed in bold letters, in the patient's gravely ill-appearing countenance. In contrasting the physician's pre-occupation with what the painting's title implies he considers a routine fracture, while apparently ignoring the patient's ghastly visage, Orpen gives artistic expression to the difference between inspection and observation—the difference between looking and seeing during the physical examination.

appears to be using not just sight in inspecting the patient's wound, but also touch and likely smell.

As noted previously, palpation, yet another point on the compass physicians employ while navigating the physical examination, has been used since time immemorial to assess a patient's pulse and temperature.

Palpation has also been used to discern the status of organs hidden within the abdomen, such as the liver, spleen, kidneys, and intestines (Figure 2.8), and to evaluate physical abnormalities found elsewhere for warmth, tenderness, and texture.

Percussion, a maneuver first described by Leopold Auenbrugger in *Inventum Novum* in 1761 C.E., is a relatively recent addition to the physical examination. After watching his father determine the amount of wine remaining in barrels by repeatedly tapping them to detect the level at which the pitch of reverberations changed, Auenbrugger found that the same technique could be used to determine the size of the heart and detect the presence of fluid in the chest (14).

Auscultation, the fourth point of the physical examination compass, also has been used since antiquity to evaluate patients. According to a passage in the Hippocratic Corpus treatise *In the Surgery*, which almost certainly describes the auscultatory findings in a patient with pneumonia: "If you apply your ear for a long time and listen to the sides [of the chest], it seethes inside like vinegar" (15).

In 1816 C.E., René Théophile Hyacinthe Laënnec (Figure 2.9) greatly enhanced physicians' capacity to hear patients' internal sounds with his invention of the stethoscope [derived from the Greek *stethos* (chest) and *skopein* (to explore)]. His first version of the instrument was nothing more than a sheet of paper rolled into a tube. A later version consisted of a hollow wooden cylinder that was held against the ear, with a cone at the other end that was placed against the patient's chest. Although modern versions of the instrument have achieved the status of the physician's badge of office, the device was initially viewed with skepticism. Henry Halford, who was then president of the Royal College of Physicians, wrote Laënnec: "I am sorry to observe that you have much employed yourself with this new-fangled device" (16). Today a nearly endless array of highly sophisticated "new-fangled" devices, such as ultrasound machines, PET scans (positron-emission tomography), and the like continue to generate skepticism as well as hope (to be discussed).

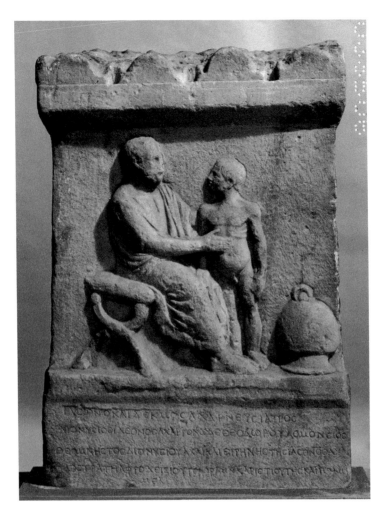

Figure 2.8. *Tombstone Stele of Jason, an Athenian Physician, Examining the Swollen Belly of a Child*, 2nd century C.E. by an unknown artist, British Museum, London, England. The distended abdomen, swollen lower legs, and prominent ribs of the child being examined by Jason reflects the progressive physical wasting, abdominal fluid, and lower extremity edema that are encountered in any one of a number of chronic disorders of the heart, liver, and kidneys. Physicians of Jason's era attached great importance to the area of the abdomen being palpated by Jason—the area just under the ribs known as the "hypochondrium." In the Hippocratic Corpus, the author of *Prognostics* devotes a longer section to the examination of the hypochondrium than any other area of the body. According to the author: "A swelling in the hypochondrium that is hard and painful is the worst. . . . Swellings that are soft and painless, yielding to the finger, cause the crises to be later, and are less dangerous" (13).

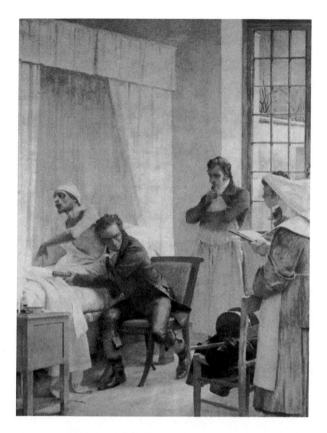

Figure 2.9. *Laënnec at the Necker Hospital Auscultating a Tuberculosis Patient in Front of His Students*, oil on canvas, c. 1890 C.E. by Theobald Chartran, US Natural Library of Medicine, Bethesda, Maryland, United States.

For reasons known only to Chartran, the artist has Laënnec performing *direct* auscultation with his ear placed directly on the patient's chest, rather than *mediate* auscultation with the stethoscope he holds in his left hand. Thanks to his stethoscope, Laënnec became one of the leading experts of his day on diseases of the chest. Many of the auscultatory findings used today to distinguish one cardiopulmonary disorder from another were first described by Laennec with the help of his "new-fangled" instrument. Laënnec saw many patients in his practice who were dying of tuberculosis. The one depicted in this portrait has the classic appearance of just such a patient. Laënnec died of the infection at age 45.

LABORATORY INVESTIGATION

Myriad tests are performed on the blood of patients today as a standard component of the medical evaluation. These vary from simple "blood counts" to high-tech genetic assays. The ancients bled patients (performed phlebotomy) more for therapy than diagnosis (Figure 2.10).

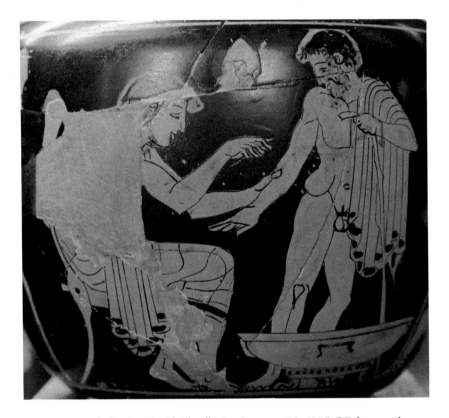

Figure 2.10. *Aryballos (vase) with Bloodletting Scene*, c. 488–470 B.C.E. by an unknown artist, Louvre, Paris, France.
According to art historian Herbert Read, pottery is among the earliest art forms, the classical harmony of which is exemplified by the Greek vase (18). This particular vase depicts a physician about to bleed a patient, whose diagnosis cannot be discerned from his appearance. The physician holds the patient's arm with his left hand, while preparing to take blood from the bend of the elbow—precisely the site at which blood is taken for analysis from patients today. On the floor beneath the patient's arm is a metal basin positioned to collect the blood. For the next 2000 years, physicians throughout the globe would perform the same procedure on patients innumerable.

Nevertheless, as already noted, they were keen observers who looked for clues to the nature of illnesses not just in the outward appearances of patients, but also in the character of their blood, urine, feces and other secretions. In *Epidemics,* information of value in determining diagnosis and prognosis was said to include "touching, smelling, or tasting . . . the things from blood, the intestines, belly, bile, [and] the other humors" (17).

The character of the urine was no less important. Hippocratic physicians, as well as Ayurvedic and Chinese practitioners, searched urine's color, transparency, sediment and other features to determine what was happening inside patients (Figure 2.11). Bubbles persisting on the surface of urine, according to a passage in *Aphorisms,* another Hippocratic text, indicated diseased kidneys (19). Today such bubbles alert clinicians to the presence of excess albumen in the urine due to a variety of kidney disorders. Microscopic and chemical analyses of urine specimens have become so informative that today the urinalysis is sometimes referred to as the "poor man's kidney biopsy."

During the Middle Ages, examination of the urine (urinoscopy) was a mainstay of diagnosis for physicians, as well as quacks. Divining diagnoses from the urine was routinely practiced until the 19th century C.E. (Figure 2.12), when a gradual decline in belief in humoralism as espoused by Galen (see Chapter 3) and the emergence of modern concepts of kidney function finally led to more enlightened methods of diagnosis.

Internal imaging of the human body (Figure 2.13) was not possible until 1895 C.E. when German physicist Wilhelm Konrad Röntgen discovered x-rays (20). Since then, imaging science has evolved rapidly with the introduction of standard radiography, ultrasound, radionuclide tracers, contrast agents, computed tomography, and magnetic resonance imaging. Each new technique has enhanced medicine's capacity to visualize disease processes, customize treatments, and understand pathophysiology. These advances have been accompanied by an expanding array of genetic assays, driven largely by the Human Genome Project, that are being used to determine the susceptibility of patients to specific diseases and to individualize their treatments.

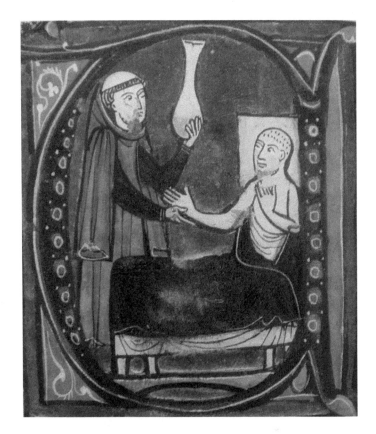

Figure 2.11. *European Depiction of the Persian Doctor al-Razi,* colored woodcut, c. 1250–1260 C.E. by an unknown artist, in *Receuil des Traités de Médicine* by Gerardus Cremonensis.

The surgeon depicted in this medieval woodcut is examining urine contained in a "matula," while apparently feeling the pulse of the bed-bound patient who produced the specimen. The matula was a common piece of equipment used by physicians (as well as quacks) to collect and examine urine. The bladder-shaped glass container was designed to be large enough to accommodate the entire content of an adult's bladder when first emptied in the morning. A companion piece known as the "urine wheel," consisted of a round color chart used to correlate different colors of urine with possible diagnoses. Medieval physicians distinguished 20 colors of urine and also considered the quality, clarity, deposits, and density of urine, along with the frequency of urination in arriving at a diagnosis (19).

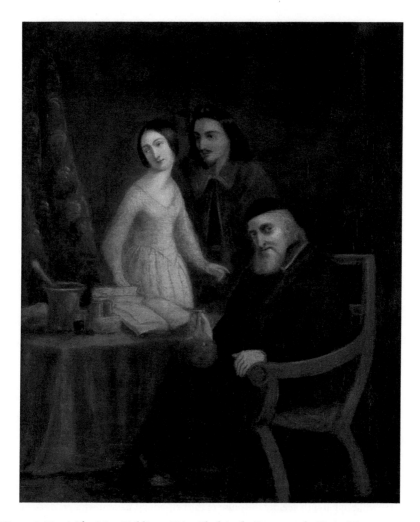

Figure 2.12. *A Physician Holding a Urine Flask in the Presence of a Young Woman and Man,* oil on canvas, c. 19th century C.E. by an unknown artist, Wellcome Library, London, England.

The physician in this painting looks knowingly at the viewer with a flask of urine in hand, while a young man gazes upon his demur partner with the loving concern of an expectant father. One surmises from the physician's expression that urinoscopy has confirmed the couple's suspicion—the young woman is pregnant. Urinoscopy of sorts is used to this day to determine if a woman is pregnant. However, today the presence of the sex hormone, human chorionic gonadotropin (hCG), in a woman's urine (or blood), rather than the urine's color, clarity, density, and so on is the finding indicative of pregnancy.

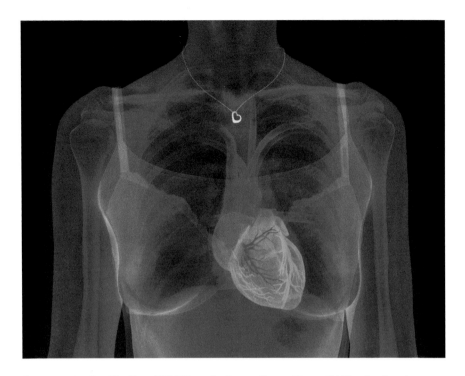

Figure 2.13. *Can You Even Tell Where the Breast Cancer Tumor Is?* Hand-colored x-ray, c. 2009 C.E. by Hugh Turvey, British Institute of Radiology, London, England.
Most people would not consider an x-ray image a work of art. However, the definition of art is open, subjective, and changeable. If art's purpose was once to create beauty and to imitate nature, the concept is constantly changing, thanks to radical innovations such as those of artists like Turvey. His works combine x-ray imagery with shadow photography techniques, hand coloration, and other manipulations. They reflect the tone, tempo, and intensity not only of the society in which he lives, but given his medium, also of current medical practice. The "patient" presented in this image appears to be a healthy young woman.

Such advances have generated hope for an increasingly bright future in the management of human disease but also concerns similar to those of a century ago that accompanied the introduction of Laennëc's stethoscope. Many fear that direct contact with the patient and the art of physical diagnosis, which underwent an explosion in the 19th century C.E. and continues to reveal patients' diagnoses in more than 80% of cases (21, 22),

are being replaced today by a reliance on vastly more expensive, invasive, and impersonal diagnostic testing.

THE AUTOPSY

From a purely technical point of view, the modern practice of post-mortem examination for anatomical demonstration (dissection) and de-termining the cause of death (autopsy) originated with the embalming practices of ancient Egypt (Figure 2.14). Embalming human cadavers, which appears to have begun around 2600 B.C.E. during Egypt's 4th or 5th Dynasty, provided the earliest objective knowledge of human anatomy (23). The first systematic dissection of the human body, how-ever, is credited to the Greek anatomist Herophilos during the 3rd cen-tury B.C.E. Herophilos' contributions to our understanding of human anatomy rivaled those of Andreas Vesalius 1800 years later, but received

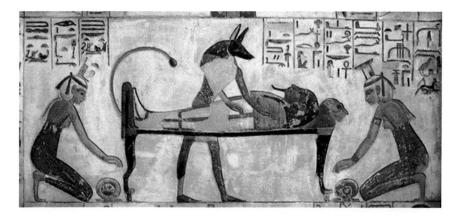

Figure 2.14. *Ancient Egyptian Funerary Scene,* wall painting in the tomb of Siptah, XIX Dynasty, c. 13th century B.C.E. by an unknown artist, Valley of the Kings, Egypt.
The man in the jackal-headed mask is a living image of Anubis (god of embalming and the dead), who directed the embalming of the recumbent mummy. The two kneeling women participating in the mourning rite are living images of Isis (goddess of fertility) and Nephthys (twin sister of Isis and protector of the dead).

only grudging recognition due to accusations that he and a contemporary, Erasistratus, vivisected condemned criminals during the course of their anatomical studies (24).

Dissection of the human body seems to have been abandoned in the aftermath of the indictment of Herophilos until the 14th century C.E., when Italian medical professors resumed the practice. Within a short time, dissections and, to a lesser extent, autopsies were being performed by enthusiastic medical faculties throughout northern Italy (23). Leonardo da Vinci reportedly performed dissections of over 30 cadavers in his effort to spell out in art what nature has written in the human body (Figure 2.15) (25). However, Andreas Vesalius is given singular credit as the father of modern anatomy for the revolutionary dissections he performed (and had illustrated) while at the University of Padua. His work shifted the focus of the knowledge of anatomy from the written authority of Galen to direct observations of the structure of the human body.

Vesalius' dissections were public theater transformed into fine art (Figure 2.16) (25). The public nature of his dissections and those of later eras differed strikingly from autopsies. The former were didactic exercises conducted for the benefit of doctors and their students (Figure 2.17), the latter private affairs conducted primarily for the benefit of the families (Figure 2.18). The first unambiguous record of an autopsy dates from 1286 C.E. That crude examination was performed by a doctor in Cremona, Italy, who was "enquiring into the nature of a mysterious epidemic" (23).

Perfection of the microscope by Dutch lens maker Antony van Leeuwenhoek in the 17th century C.E. set the stage for the era of cell biology and presaged that of molecular biology. Today these advances have given autopsies, the ultimate diagnostic examinations, a view inside the human body not just of its organs, its cells, and their molecular structure, but also the genetic codes that determine health and susceptibility to particular diseases.

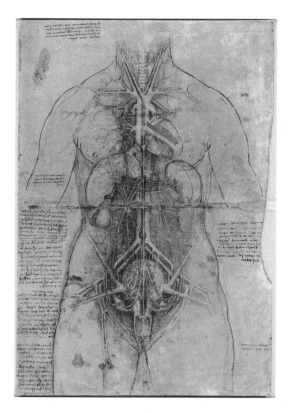

Figure 2.15. *Dissection of the Principal Organs and Arterial System of a Woman,* pen and ink sketch, c. 1490 C.E. by Leonardo da Vinci, Royal Library, Windsor Castel, England.

In 1489 C.E., da Vinci began a series of human anatomical drawings based on dissections of over 30 human specimens. Although an astute observer and superb illustrator, his naturalistic depictions of human anatomy were not always true to the object being represented. In this particular drawing, much of the female anatomy is fanciful or based on animal anatomy (25). The cause of the woman's death is a mystery for which the drawing offers no solution.

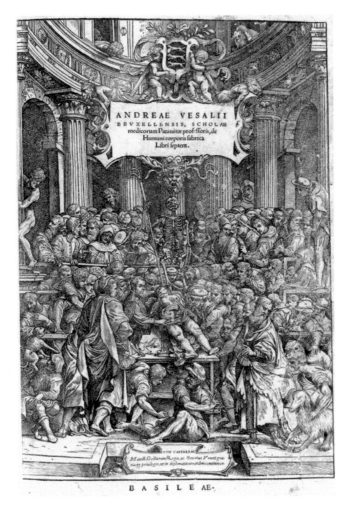

Figure 2.16. Title page of Andreas Vesalius' *De humani corporis fabrica*, woodcut, 1543 C.E. by Jan Stephan van Calcar.

This woodcut depicts Vesalius conducting a public dissection of a young woman. The two men represented immediately behind Vesalius, who is performing the dissection, are Galen and Hippocrates. The robed man just in front and to the right of the dissecting table is Aristotle.

In these dissections, Vesalius insisted that the body presented be the type against which one could compare other bodies, as one did with the statue of Polycleitus (25). Therefore, the well-proportioned young woman being dissected in this woodcut likely died of an acute disorder, rather than a chronic debilitating one.

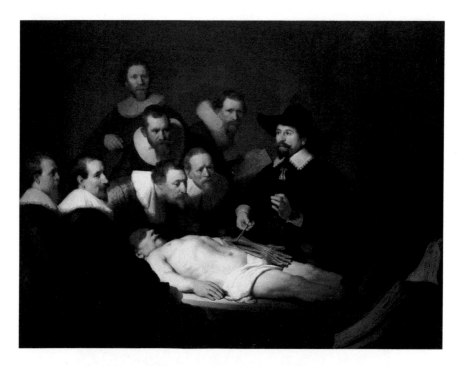

Figure 2.17. *The Anatomy Lesson of Dr. Nicolas Tulp.* oil on canvas, 1632 C.E. by Rembrandt van Rijn, Mauritshuis, The Hague, The Netherlands.

This is among Rembrandt's best-known paintings. It is one of nine paintings of anatomy lessons commissioned by the Amsterdam Guild of Surgeons between 1603 C.E. and 1925 C.E. still found in Dutch museums. The patient on whom Dr. Tulp is demonstrating the muscles of the forearm was convicted of armed robbery and executed by hanging. Anatomy lessons were social events in the 17th century C.E., which took place in theaters attended for a fee by students, colleagues, and the general public. This painting was not intended to give an authentic picture of an actual dissection, but to portray important members of the Guild of Surgeons (26).

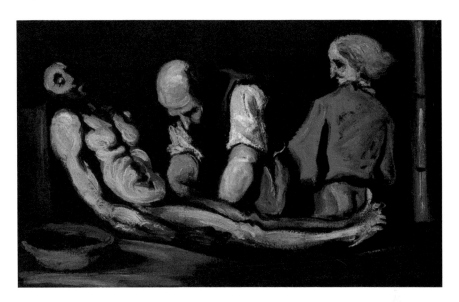

Figure 2.18. *L'Autopsie*, oil on canvas, c. 1868 C.E. by Paul Cézanne, private collection. Aside from its chilling tone and the presence of a cadaver, there is little in this thick impasto "couillarde" painting to indicate that it depicts an autopsy. In fact, the painting also has been called *La Toilette Funeraire*, a title, perhaps, more appropriate, given the absence of dissecting instruments or even a scalpel. Cézanne was notably reticent about his works and left no information regarding the dead patient depicted or the actions of the two attendants. The second half of the 19th century C.E. was a time of momentous advances in pathology, which might have motivated Cézanne to create this *memento mori* (27).

REFERENCES

1. Ghaliougui P. *Magic and Medical Science in Ancient Egypt*. London: Hodder & Stoughton; 1963: 188.
2. Mackowiak PA. *Diagnosing Giants. Solving the Medical Mysteries of Thirteen Patients who Changed the World*. New York: Oxford U. Press; 2013: 3.
3. O'Brien S, Vose JM, Kantarjian HM (eds.), *Management of Hematologic Malignancies*. London: Cambridge U. Press; 2011 : 141.
4. Jouanna J. *Hippocrates* (trans. DeBevoise MB), Baltimore: Johns Hopkins U. Press; 1999: 303–304.
5. http://collectmedicalantiques/quotes (accessed February 12, 2016).
6. Wright WF, Mackowiak PA. Origin, evolution and clinical application of the thermometer. *Am J Med Sci*. 2016; 351: 526–534.
7. Katz JT, Khoshbin S. Picasso's *Science and Charity*: paternalism versus humanism in medical practice. *Open Forum Infect Dis*. 2016; 3: 1–2.

8. Ghasemzadeh N, Zafari AM. A brief journey into the history of the arterial pulse. *Cardiol Res Pract*. 2011; 14: 1–14.
9. Postel-Vinay N. A Century of Arterial Hypertension (trans. Edelstein R, Coffin C). New York: John Wiley & Sons; 1996: 35, 57, 158.
10. Tibi S. Al-Razi and Islamic medicine in the 9th century. J R Soc Med. 2006; 99: 206–207.
11. http://catalogue.wellcomelibrary.org/record=b1179125 (accessed October 18, 2016).
12. http://www.tate.org.uk/artist/sir-william-orpen-1725 (accessed October 18, 2016).
13. Op. cit. (Jouanna) p. 298.
14. Jütte R. Auenbrugger, in Bynum WF, Bynum H (eds.), *Dictionary of Medical Biography*, vol. 1. London: Greenwood Press; 2007: 137–138.
15. Op. cit. (Jouanna) p. 299.
16. Newman JS. A newfangled column. *ACP Hospitalist*, September 2016; 25.
17. Op. cit. (Jouanna) p. 292.
18. Read H. *The Meaning of Art*. London: Faber and Faber; 1931: 41.
19. Bynum B, Bynum H. Object lessons. The matula. *Lancet* 2016; 387: 638.
20. The Editors. Looking back on the millennium in medicine. New Engl J Med. 2000; 342: 42–49.
21. Hampton JR, Harrison MJG, Mitchell JRA, et al. Relative contributions of history-taking, physical examination, and laboratory investigation to diagnosis and management of medical outpatients. Brit Med J. 1975; 2: 486–489.
22. Peterson MC, Holbrook JH, Hales, VD, et al. Contributions of the history, physical examination, and laboratory investigation in making medical diagnoses. West J Med. 1992; 156: 163–165.
23. Park K. The life of the corpse: division and dissection in late medieval Europe. J Hist Med Allied Sci. 1995; 50: 111–132.
24. Bay N S-Y, Bay B-H. Greek anatomist Herophilus: the father of anatomy. Anat Cell Biol 2010; 43: 280–283.
25. Kusukawa S. The uses of pictures in the formation of learned knowledge: the cases of Leonhard Fuchs and Andreas Vesalius. In Kusukawa S, Maclean I (eds.), *Transmitting Knowledge. Words, Images, and Instruments in Early Modern Europe*. London: Oxford University Press; 2006: 73–96.
26. http://.academia.dk/blog/anatomy-5-rembrandts-the-anatomy-lesson-of-dr-nicolaes-tulp (accessed October 31, 2016).
27. http://clockwork.photography/paul-cezanne-murder-death (accessed October 5, 2016).

Therapeutics

C reation of burr holes in the skull, a surgical procedure known as trephination, is the earliest documented form of medical therapy (1). Archeological evidence establishes its use as far back as the Cro-Magnon period (50,000–10,000 B.C.E.; see Chapter 4). Drug therapy has only a moderately shorter history. Written records of the use of salicylates, cannabis, mandrake, and opioids as anesthetics and analgesics in ancient Egypt, Greece, and China attest to the fact that some of the earliest physicians administered drugs that were both effective and surprisingly modern (2). However, lacking knowledge of the mechanisms responsible for human diseases, physicians prior to modern times rarely had more to offer seriously ill patients than crude attempts to assist the healing power of nature and the compassionate vigilance so poignantly depicted in Sir Luke Filde's iconic image of *The Doctor* (Figure 3.1).

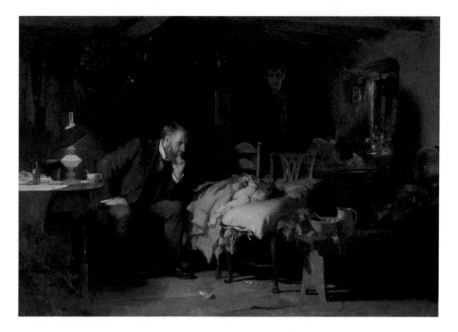

Figure 3.1. *The Doctor*, oil on canvas, c. 1891 C.E. by Sir Luke Fildes, Tate Gallery, London, England.
Fourteen years before Fildes painted this masterpiece, his son Philip died in a similar fashion of diphtheria on Christmas morning. Like "the doctor" depicted in this painting, physicians of Fildes' era had little to offer desperately ill children (or their parents) other than themselves in addressing the ravages of diphtheria, scarlet fever, meningitis, and the other infections that carried off so many children (3). Although medical science has largely eliminated the threat of these diseases in much of the world, others persist for which a comforting presence remains the most a physician has to offer a patient.

RITUALS

In that archaic concepts commonly attributed diseases to demonical forces invading patients from without, some of the oldest treatments consisted of expiatory rituals designed to expel disease-producing demons. The existence of Nkisi power figures among the Kongo peoples (Figure 3.2) and similar ritualistic sculptures discovered among other traditional societies of Sub-Saharan Africa (4) suggest that the use of rituals in efforts to cure disease probably extends back along the arc of human history to its very beginning.

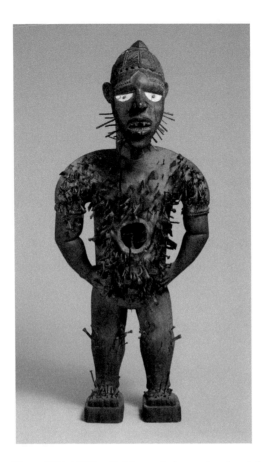

Figure 3.2. *Power Figure* (Nkisi N'Kondi: Mangaaka), wood and metal sculpture, c. 19th century C.E. by an unknown artist, Metropolitan Museum of Art, New York, United States.

Wooden figures of this sort, representing either a human or an animal, were carved under the divine authority of a nganga or spiritual authority, who activated the figures through chants, prayers, and sacred substances aimed at curing physical, social, or spiritual ailments. Europeans likely encountered such figures as early as the 15th century C.E., which they confiscated as objects of heathenism and destroyed. Vestiges of medicinal matter have been detected in the abdominal cavities of these figures. The various metals embedded in the torso sealed vows, consecrated treaties, and served to eradicate evil (4). While not a representation of a particular patient or specific disorder per se, through repeated use in attempts to cure the illnesses of many patients, the figure is a representation of many patients in one.

With the rise of civilizations, expiatory rituals involving increasingly sophisticated and elaborate ceremonies continued to be used therapeutically. The ancient cultures of Egypt and Greece both combined prayer with herbal medicines and other interventions in attempts to cure disease. Isis and Osiris were two gods commonly invoked by the Egyptians for such purposes. Imhotep (c. 2700 B.C.E.), ancient Egypt's most renowned physician, also became the focus of these rituals following his posthumous elevation to a god of medicine (Figure 3.3) (5).

The medicine of Hippocrates drew important elements of its inspiration from the Egyptians in combining religion and science in confronting illness. The early Christian church appropriated many of their principles in its own therapeutic rituals, including a belief in the curative power of

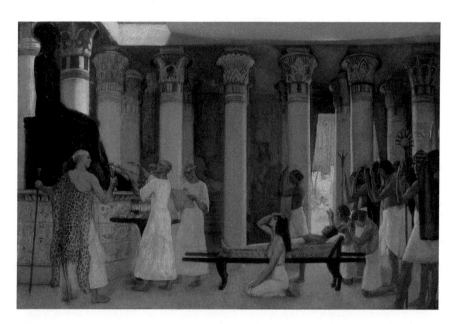

Figure 3.3. *An Invocation to I-em-hetep, the Egyptian Deity of Medicine,* oil on canvas, c. early 20th century C.E. by Ernest Board, Wellcome Library, England.
Evidence gleaned from skeletal and mummified remains and various medical manuscripts documents a wide range of disorders among the ancient Egyptians, including eye diseases, scorpion and serpent bites, kidney stones, tuberculosis, polio, and parasitic infections (6). A patient like the one depicted by Board resting on the stretcher in this painting could have been a victim of any one of these.

divine intervention, which involved replacing Asclepius with Jesus as the god of healing (7). Although following the fall of Rome, medicine was heavily influenced by the Church's conviction that healing required the assistance of God, physicians never completely abandoned their commitment to the profession's secular tradition based on ancient Greek texts (8, 9).

Realizing that, ultimately, all clinical successes are temporary and cannot escape the triumph of death over life, those given to religious cures endeavored to save not just the body, but also the soul. The power of such interventions, celebrated in myriad medieval miracles, nearly always involved some therapeutic marvel (8). Figure 3.4 is just one of many works produced by Renaissance artists commemorating the triumph of religion over disease.

Belief in spiritual cures remained strong despite advances in medical science well into the 19th century C.E. (12). Even today, claims continue to be made of links between spirituality and physical health in light of the existence of modest (13), although also conflicting (14), scientific evidence of such links.

CORRECTING HUMORAL DISPROPORTIONS

Modern medicine generally traces its origin to the teaching of Hippocrates and his disciples, although Hippocratic concepts were derived, at least in part, from ones promulgated over a thousand years earlier by the Egyptians and possibly even earlier by the Assyrians (15). The ancient Greeks believed that while nature tends to cure itself, sometimes it has to be forced to cooperate (16). In such cases, specific interventions were undertaken to correct disproportions of vital bodily substances thought to be responsible for ill health.

According to Hippocratic doctrine, there were four such vital substances (or humors)—blood, phlegm, yellow bile, and black bile. The ancient Egyptians believed there were three—*st. t* (mucus), *rwt* (bile) and *whdw* (alimentary residues) (17). No single humoral theory reflected the

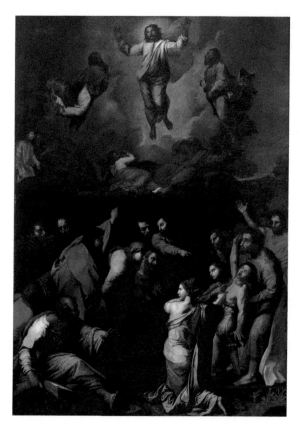

Figure 3.4. *The Transfiguration*, oil on canvas, 1517 C.E. by Raffaello Sanzio (Raphael),
The Vatican, Rome, Italy.

The theme of this Raphael masterpiece comes from Mathew 18:15 (10), which harkens
back to pre-Hippocratic Greece, when both charlatans and physicians postulated a di-
vine origin for epilepsy (the disorder of the boy at the lower right of the painting), which
they called the "sacred disease" (11). The belief surrendered to Hippocratic concepts
favoring natural causes for diseases, only to reemerge during the Medieval period, when
poverty, despotism, and religion combined to inhibit rational thought. Under the influ-
ence of the Church, many during the Middle Ages believed that diseases in general, and
epilepsy in particular, were the work of the devil, and that cures came only from God
through Christ. Such themes abounded in the works of many of the greatest artists of
the era.

beliefs of all Hippocratic physicians (18). However, of the many theories promulgated, the most enduring is articulated in *The Nature of Man*, one of the 60 known treatises of the Hippocratic Corpus. According to the treatise,

> The human body contains blood, phlegm, yellow bile and black bile. These are the things that make up its constitution and cause its pains and health. Health is primarily that state in which these constituent substances are in the correct proportion to each other, both in strength and quantity, and are well mixed. [Disease] occurs when one of the substances presents either a deficiency or an excess, or is separated in the body and not mixed with the others. It is inevitable that when one of these is separated from the rest and stands by itself, not only the part from which it has come, but also that where it collects and is present in excess should become diseased (19)

Correcting humoral disproportions involved a variety of interventions, which varied according to the disorder being treated and the practitioner's preference.

One logical approach to treatment (even by today's standards) was based on the "principle of opposition." According to the principle as articulated in *The Nature of Man*,

> Diseases caused by over-eating are cured by fasting; those caused by starvation are cured by feeding up. Diseases caused by exertion are cured by rest; those caused by indolence are cured by exertion. . . . (20)

Another approach intended to correct presumed disproportions of the humors and to ensure that the humors were well-mixed involved various procedures that we now know violated Hippocratic

medicine's most sacred tenet, *primum non nocere* (first not to harm). Such treatments held sway for over 2000 years, largely due to the prolific writings of Galen of Pergamum, who was the sun soaring in the heavens of medical thought from the 2nd century C.E., until finally challenged by Paracelsus in the 16th century C.E. (21). There is no more convincing evidence of the long reach of Galen's influence on medical practice [Western, Arab, and possibly also Asian (22)] than the use of bloodletting as a treatment for diseases ranging from smallpox to acne well into the 19th century C.E.

The origin of "bloodletting," bleeding patients to cure or prevent illness (Figure 3.5), is uncertain, although it is known to have been practiced by the ancient Egyptians as early as 1000 B.C.E. (23). Bloodletting was the principal means by which Hippocratic physicians corrected humoral imbalances responsible for illness. The two most common methods used to bleed patients were venesection (often called "breathing a vein") and the application of leeches. As often as not, venesection involved the removal of massive amounts of blood by opening a superficial vein with a lancet—5 pints over 16 hours in the case of America's first president, George Washington, which almost certainly hastened his death from a complicated throat infection (24). Because fainting was considered a beneficial effect of bloodletting, sessions frequently ended only when the patient began to swoon (25).

The popularity of bloodletting finally waned in the mid-1800s C.E. after Pierre Charles Alexandre Louis demonstrated its total lack of efficacy against pneumonia and a variety of other febrile illnesses (26). Nevertheless, even today, phlebotomy, the modern version of bloodletting, continues to be used as a treatment for polycythemia rubra vera (a disorder involving excessive production of red blood cells) and hemochromatosis (a derangement of iron metabolism leading to the accumulation of excessive amounts of iron within the body).

Cupping (Figure 3.6) was a gentler method of managing disproportions of the blood. The procedure, which is used to this day by practitioners of

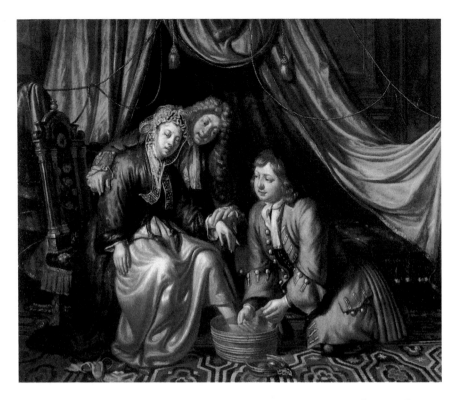

Figure 3.5. *A Physician and a Surgeon Attending to a Woman Patient,* oil on wood,
c. 1700 C.E. by Matthijs Naiveu, Wellcome Library, England.

The disorder for which the deathly pale woman is being bled in Naiveu's painting cannot
be determined from her appearance. The only clue to a possible diagnosis is the bluish
discoloration of her finger tips (i.e., cyanosis) visible on close examination, suggesting
that she was suffering from congestive heart failure. If she was an actual patient, and not
simply a product of Naiveu's imagination, bloodletting might have been beneficial by
reducing pulmonary congestion due to heart failure and thereby alleviating her shortness
of breath. In fact, until the availability of potent diuretic drugs in the 1960s C.E., blood-
letting (i.e., phlebotomy) was an accepted treatment of pulmonary congestion.

Though bloodletting was often prescribed by physicians in pre-modern times, the pro-
cedure was typically carried out by barber/surgeons (25). Thus, in Naiveu's painting, the
bewigged *physician* is depicted taking the patient's pulse, while the less elegantly attired
surgeon lets blood from her foot.

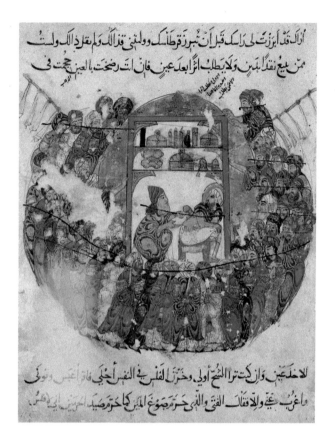

Figure 3.6. *A Doctor Venesects a Patient,* painting on paper, 1240 C.E. from the *Maqama* of Abu Mohammed al-Kasim Hariri, Institute for Asian Studies, St. Petersburg, Russia. *Hijama* (Arabic for "sucking") is a term for "wet cupping," during which blood is drawn by vacuum from a small skin incision for therapeutic purposes. In this image of daily life in ancient Iraq, a healthy-appearing patient is being treated with Hijama for reasons known only to the artist. This form of *wet* cupping or *scarification* has been used for thousands of years—first by the Chinese, then by the ancient Egyptians, Greeks, Romans, Persians, and Arabs—to draw out stagnant or morbid humors. After falling out of favor for a time, cupping is enjoying a resurgence in popularity among holistic health care practitioners (27).

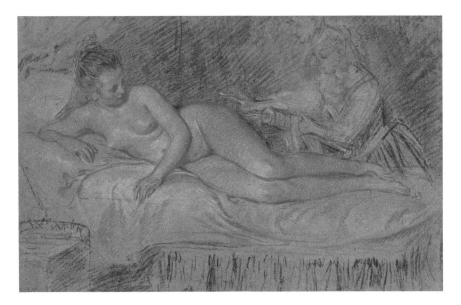

Figure 3.7. *The Remedy*, chalk drawing, 1716–1717 C.E. by Jean-Antoine Watteau, J. Paul Getty Museum, Los Angeles, California, United States.
Watteau's style is typical of the Rococo period—elusive, delicate, and also amusing (28). He leaves it to the viewer to imagine why such a robust-appearing, young woman would need "the remedy" she is about to receive. Her remedy, also known as a clyster (enema), has been used since antiquity to cleanse the colon of toxins formed as a result of decomposition of food (29). In the 19th century C.E., biochemical and microbiological studies seemed to support the concept. Ilya Ilyich Metchnikoff (1845–1916 C.E.), the father of cellular immunology, went so far as to propose that these toxins had a role in aging, which led mainstream physicians to recommend periodic colonic cleansing to prevent "auto-intoxication" (30). Despite a lack of recent scientific evidence supporting Metchnikoff's theory of auto-intoxication, colonic cleansing continues to be promoted as one of many alternative medical treatments.

alternative medicine for a variety of complaints, involves heating a cupping glass and placing it on a patient's skin, generally over a diseased internal organ. As the cup cools, a vacuum is created, bringing blood to the surface to act as a counterirritant (27).

Emetics, purgatives, clysters (Figure 3.7), and moxibustion (therapeutic scalding of the skin to invigorate the flow of vital fluids to dispel certain pathological influences; Figure 3.8) were the other principal treatments

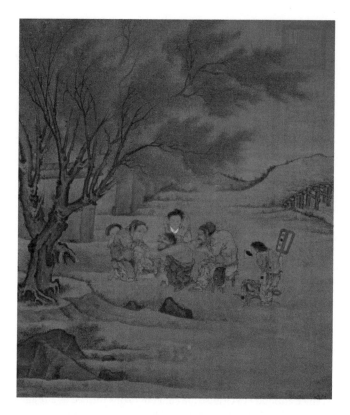

Figure 3.8. *Chinese Doctor Treating a Man by Burning Herbs on his Back*, brush and ink on silk, c. 950 C.E. (Song dynasty) by an unknown artist, National Palace Museum, Taiwan.

Moxibustion, which creates blisters on the skin surface as a "counter-irritation" intended to promote drainage of internal toxins, has been used therapeutically in China since at least the 14th century B.C.E. The disorder for which this screaming patient is being treated is a mystery that cannot be solved based on the information provided by the artist in the work. If the patient had been seen by a practitioner of alternative medicine today, his treatment might have been to promote health rather than to cure an illness, based on several investigations demonstrating a range of potentially beneficial immunological and psychological responses to moxibustion (31).

used by many cultures to correct humoral disproportions. According to the author of *Aphorisms,* another work in the Hippocratic Corpus, the relative values of the treatments were as follows:

Those diseases that medicines [i.e., emetics and purgatives] do not cure are cured by the knife [i.e., bloodletting]. Those that the knife does not cure are cured by fire [i.e., moxibustion]. Those that fire does not cure must be considered incurable. (29)

To these treatments, the Chinese added yet another procedure designed to correct humoral disproportions—acupuncture. In combination with herbal medicines and moxibustion, acupuncture has been used for millennia to restore the balance between the *Yin* and *Yang,* the Chinese corollaries of the four humors (32).

PHARMACEUTICALS

Archeological evidence suggests that hunter-gatherers as far back as Paleolithic times were knowledgeable of the medicinal properties of plants, which were used by shamans to treat a variety of illnesses (Figure 3.9) (34). With the rise of civilizations, interest in the medicinal properties of plants increased. Two thousand years ago Han dynasty scholars compiled and perfected herbal remedies for malaria similar to artemisinin, a modern anti-malarial drug that earned its developers the 2015 C.E. Nobel Prize for Medicine (35). Although medical texts cataloging herbal remedies were long featured in Indian and Chinese cultures, the best known, early Western text, *De materia medica,* was compiled in the 1st century C.E. by Dioscorides, a Greek surgeon in the army of Rome's Emperor Nero (36). For a millennium and a half, Dioscorides' text served as the basis for the pharmacopeia of Western medicine. The work was translated into Arabic in the 9th century C.E. and for many centuries thereafter was also the basis for Arab pharmacology (37).

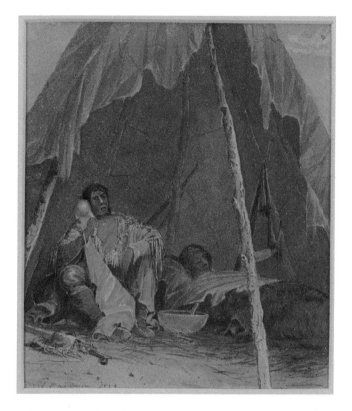

Figure 3.9. *Medicine Man Curing a Patient,* color lithograph, 1850 C.E. after a drawing by Captain Seth Eastman in the book by H. R. Schoocraft, The Indian Tribes of the United States, Philadelphia, 1851.
The drawing is of a scene witnessed by the artist while among the Dakota Indians (33). A witch doctor, mirroring a tradition of hunter gatherers reaching back beyond the twilight time of memory, treats an elderly patient with incantations and herbal medicine contained in the bowl sitting near his left foot. If the patient was cured, as implied by the title of this work, he or she was not likely a victim of small pox, measles, tuberculosis or any of the other deadly infections brought to the New World by Europeans, which decimated native populations.

With the dawning of the Age of Enlightenment, men of science assumed the role of the shaman in overseeing the discovery and application of plant-derived medicines (34). By the mid-1800s C.E., apothecaries, long having prepared and dispensed botanical medications (Figure 3.10), began the wholesale manufacture of drugs such as morphine and quinine. Later that

Figure 3.10. *A Medical Practitioner Taking a Lady's Pulse in a Pharmacy,* oil on canvas, c. 1882 C.E. by Emili Casals i Camps, Wellcome Library, England.

By the time Casals i Camps produced this work, polypharmacy was so prevalent among patients in most developed countries that Sir William Osler was moved to remark, "A desire to take medications is, perhaps, the greatest feature which distinguishes man from other animals" (38). Osler's words are reflected, as if in a fitting monument, in the wondrous array of polychromic drug jars so neatly arranged on the shelves of this pre-Napoleonic Spanish pharmacy.

When offered for sale at Christie's in London in 1916 C.E., the painting was titled "Malade au Coeur," implying that the disorder affecting the two fashionable ladies is lovesickness (39). Although the ladies, the physician, and especially the pharmacist on the right appear anxious to begin treatment, this time at least, the viewer is not taken in by the pharmaceutical industry's promise of a "cure" for a normal life event.

century, German dye manufacturers, such as the Merck Company, discovered medicinal properties of by-products of their dye stuffs, and began marketing them as pharmaceuticals, thereby initiating a golden age of drug development (40). Progress in the manufacture of new drugs by the pharmaceutical industry accelerated thereafter to the point that by 1998 C.E., the United States was spending $335 per person on prescription

drugs per annum (41), and as of 2016 C.E. over 10% of the US population was being prescribed 5 or more medications (42).

The effect of the explosive growth of the pharmaceutical industry on human health has not been entirely beneficial. In fact, as early as 1860 C.E., Oliver Wendell Homes, Sr. was moved to remark that: "If the whole *materia medica*, as now used, could be sunk to the bottom of the sea, it would be all the better for mankind—and all the worse for the fishes" (43). A century later, physician-demographer Thomas McKeown argued that modern therapeutics had been falsely credited with public health improvements that were better explained by improvements in nutrition and standard of living (44). Others warned that gains in life expectancy in the United States (and likely elsewhere) were being eroded, at least in part, by the use and misuse of prescribed medications (42).

The ancient Greeks were acutely aware of this Janus-faced character of medications (Figure 3.11). Their term for medicines, *pharmakon*, from which "pharmacist" is derived, was applied to both poisons and medicines, reflecting the fine line that even today separates medicines from poisons (46). The pharmaceutical industry has saved countless lives with its ever-expanding array of drugs. However, adverse reactions to drugs are also a leading cause of hospitalization and death today in countries such as the United States (47).

NURSING

The word "nurse," derived from *nutrire* (Latin for "to suckle") reflects nursing's long tradition of both nourishing the sick and caring for sick people by first caring about them as persons. Phoebe, who is called a "deaconess" in Romans 16:1, is generally regarded as the first Christian nurse. Rafaidah bint Sa'ad, a follower of Mahammad, the founder of Islam in the early 7th century C.E., is believed to have been her Muslim counterpart (48). Given their historical prominence, it appears that from

Figure 3.11. *Bitter Medicine,* oil on wood, c. 1630/40 C.E. by Adriaen Brouwer, Stadelsches Kunstinstitut, Frankfurt, Germany.

The unpleasant taste of certain medicines so graphically communicated in the mute facial expression of this patient is the least of drugs' potential for harm, one nearly as great as that for benefit. So prevalent is the former, and so enthusiastically touted by industry is the latter, that when contemplating drug treatments physicians have been urged to regularly apply a reduction to the reported benefits of the drug, while routinely assuming that the drug's harms are more serious and frequent than reported (45).

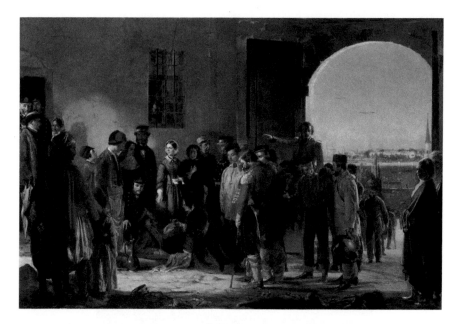

Figure 3.12. *The Mission of Mercy: Nightingale Receiving the Wounded at Scutari*, oil on canvas, c. 1857 C.E. by Jerry Barrett, National Portrait Gallery, London, England.
Barrett's work exemplifies the idealistic artistic mode—presenting a subject in a form more perfect than the original (49). Barrett uses light not just to illuminate Nightingale as the fulcrum of the painting, but also to endow her face with an image of charity and compassion that the wounded veteran at her feet seems to drink from her eyes as a hope fulfilled. Although no other nurse in history reached a summit of glory as high as that of the Nightingale depicted in this portrait, her triumph at Scutari had less to do with her care of the wounded than in correcting the unsanitary conditions in the hospitals there that were responsible for the deaths of over a thousand British soldiers during the first months of the Crimean War (50).

the earliest days of both religions, devotees were committed to caring for the sick.

Florence Nightingale (Figure 3.12) has been credited with inaugurating the modern age of nursing with her founding of the school of nursing at St. Thomas' Hospital in London. Although modern historians are inclined to minimize the importance of Nightingale or her school in establishing nursing as a modern profession, her accomplishments as a nurse (during the Crimean War), nurse administrator, and nurse educator were, nevertheless, extraordinary (50).

HOSPITALS

Originally, "hospitals," a term derived from Medieval Latin, were places of rest and entertainment for pilgrims. They were hostels or hotels of sorts, rather than institutions devoted to the care of the aged or the infirm. Although the old and the sick sought help at temples devoted to Asclepius and Roman "Valetudinaria," these were not, strictly speaking, hospitals or nursing homes. The first hospitals in a modern sense were probably those that began to appear in the Arab world in the 9th century C.E. and in Europe several hundred years later (Figure 3.13). Initially, they

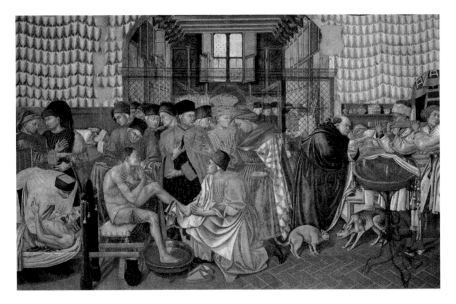

Figure 3.13. *Care of the Sick in the Pelleginaio* (Pilgrim's Hall), fresco, 1440 C.E. by Domenico di Bartolo, Ospedale di Santo Maria dell Scala, Siena, Italy.
Ucello is often credited with "discovering" perspective (52). However, as is evident in this fresco, di Bartolo and other contemporaries of Ucello had simultaneously discovered the capacity of perspective to enhance the verisimilitude of their works. This is just one of many frescoes commissioned by the Ospedale to narrate the progressive practices being carried out by its staff (53). Three patients are featured in the fresco. One has a nasty thigh wound that is likely infected, given the fact that the patient appears to be shivering. The other two are bed-ridden and presumably also seriously ill. The one on the left is being comforted by an attendant, while a disinterested priest hears the confession of the one on the right. In that the Ospedale staff could do little for serious illnesses, all three patients would probably have died. Because of the high mortality of patients admitted to hospitals at the time di Bartolo painted this fresco, those who could afford it, received their medical care at home (54).

were ecclesiastical institutions. Then in the 14th century C.E., lay hospitals began to be established. Today public and private hospitals far outnumber those directed by the Church (51).

When medicine had only its art to offer the sick, hospitals provided little more than food, warmth, and spiritual support. Today advanced medical techniques performed in hospitals are saving the lives of patients with disorders that only a short time ago were nearly uniformly fatal (Figure 3.14). The modern intensive care unit (ICU), with its advanced monitoring and life-support, has been especially important in this regard. However, the care given in such units is expensive and in a disturbing number of cases, unnecessary, futile, or even harmful (56) (Figure 3.15).

QUACKERY

Unproven, potentially harmful treatments have been peddled throughout history by quacks as well as physicians. Even today, the First ("free speech") Amendment of the US constitution protects the sales pitches of representatives of the pharmaceutical industry that substitute marketing for science in promoting potentially ineffective and sometimes dangerous, off-label use of their products (58). In such cases, it is nearly impossible to distinguish quacks (Figure 3.16) from physicians who abuse their position of power and prestige to promote treatments of dubious efficacy.

The term "quack," derived from *quacksalver*, is an archaic Dutch term for a boisterous "hawker of salve." In practical terms, such persons are pretenders of medical skill, who aggressively hawk questionable diagnoses along with baseless treatments, especially for serious diseases against which traditional medicine has limited efficacy (60). Physicians, too, occasionally find themselves promoting questionable diagnoses and ineffective treatments for serious disorders as victims of the current limitations of medical science, publication bias favoring treatment over watchful waiting, and unrealistic patient expectations.

Figure 3.14 *The First Attempt by Dr. Chicotot to Treat Cancer with X-Rays*, oil on canvas, 1907 C.E. by Georges Chicotot, Musée de l'Assistance Publique-Hopitaux de Paris, France.

Chicotot was an artist as well as a physician, who produced a number of paintings dealing with the history of experimental medicine (55). This one is a self-portrait, featuring Chicotot's use of an early form of radiation therapy on a patient with breast cancer. In his left hand, he holds a watch to time the exposure to x-rays. In his right, he grasps a sort of Bunsen burner spouting a flame from its tip that is heating an x-ray-generating Crookes tube. No effort is being made to shield either Chicotot himself, or parts of the patient's body not involved by the cancer from the damaging effects of the radiation. Only later would the deleterious effects of such exposure on both the patient and the therapist be appreciated.

Figure 3.15. *La Flebo* (The Drip), watercolor, c. 2002 C.E.by Giancarlo Vitali, property of the artist.

When asked for his definition of the perfect physician, Herophilus, one of the two most renowned anatomists of Greece's Golden Age, replied: "He who is capable of distinguishing between the possible and the impossible" (57). In this painting, one of many created by Vitali as visual commentaries on his own confinement to a hospital bed, a frail, elderly patient is being supported in what appears to be an intensive care unit with a multitude of intravenous fluids. Although modern intensive care brings many such patients back from the brink of death, other wholly hopeless cases are sustained in a living death while gasping out the last remnant of an exhausted life. The object suspended above this patient like a piece of decaying meat on a skewer, suggests that the artist believes the patient belongs to the latter category, and that his struggling spirit yearns to free itself from its earthly bonds.

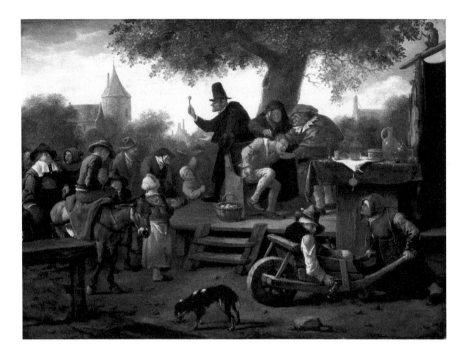

Figure 3.16. *The Quack*, oil on panel, c. 1650–1660 C.E. by Jan Steen, Rijksmuseum Amsterdam, the Netherlands.

Steen, a Dutch painter of his country's Golden Age, produced works known for their psychological insight, humor, and abundance of color (59). This one is typical. The scene is lively to the point of chaos and teaming with symbolism. There is the quack, so richly clothed in a priestly black frock and seemingly anointing a group of onlookers with a kind of aspergillum, while hawking his "salve" with a mixture of fiction and fact, and devils and angels. His assistants appear to be lancing a boil on the back of the neck of one of the villagers, showing the viewer that not everything a quack, or for that matter a physician, has to offer is necessarily useless or harmful. And above it all, a monkey looking down from a roof at the far right of the painting provides symbolic commentary on acts of human folly taking place below.

REFERENCES

1. Restak R. Fixing the brain. *Mysteries of the Mind*. Washington, DC: National Geographic Society; 2000: ISBN 0-7922-7941-7. OCLC 43662032.
2. The Editors. Looking back on the millennium in medicine. *N Engl J Med*. 2000; 342: 42–49.
3. Nuland SB. *Medicine. The Art of Healing*. Boston: Beaux Arts Editions, 2000: 94.
4. http://www.metmuseum.org/toah/images/h3/h3_2008.30.jpg (accessed November 28, 2016).

5. Byyny RL (ed.). Editorial: The Pharos of Alpha Omega Alpha. *The Pharos*;2016; Summer: 3–8.
6. http://www.ucl.ac.uk/museums-static/digitalegypt/age/disease.html. (accessed December 3, 2016).
7. Nuland SB. *Medicine. The Art of Healing*. Boston: Beaux Arts Editions, 2000: 38.
8. Bordin G, D'Ambrosio LP. *Medicine in Art* (trans. Hyams J). Los Angeles: J. Paul Getty Museum; 2010: 330.
9. Anderson J, Barnes E, Shackleton E. *The Art of Medicine*. Chicago: U. Chicago Press; 2011: 85.
10. Nuland SB. *Medicine. The Art of Healing*. Boston: Beaux Arts Editions, 2000: 38.
11. Jouanna J. *Hippocrates* (trans. DeBevoise MB). Baltimore: Johns Hopkins U. Press; 1999: 182.
12. Anderson J, Barnes E, Shackleton E. *The Art of Medicine*. Chicago: U. Chicago Press; 2011: 89.
13. VanderWeele TJ, Balboni TA, Koh HK. Health and spirituality. *JAMA*. 2017; 318(6): 519–520.
14. Powel LH, Shahabi L, Thoresen CE. Religion and spirituality. Linkages to physical health. *Am Psychologist* 2003; 58: 36–52.
15. New sources of medical history (1910 C.E. editorial), *JAMA*. 2010; 304(18): 2072.
16. Jouanna J. *Hippocrates* (trans. DeBevoise MB). Baltimore: Johns Hopkins U. Press; 1999: 346.
17. Mackowiak PA. *Diagnosing Giants. Solving the Medical Mysteries of Thirteen Patients Who Changed the World*. New York: Oxford U. Press, 2013: 4.
18. Jouanna J. *Hippocrates* (trans. DeBevoise MB). Baltimore: Johns Hopkins U. Press; 1999: 316.
19. Ibid. 326.
20. Ibid. 342–343.
21. Ibid. 353.
22. Ibid. 362.
23. Seigworth GR. Bloodletting over the centuries, *NY State J Med*. 1980; 80: 2022–2028.
24. Wallenborn WM. George Washington's terminal illness: a modern medical analysis of the last illness and death of George Washington. http://gwpapers.virginia.edu/history/articles/illness/ (accessed January 11, 2016).
25. Greenspan RE. *Medicine*. Perspectives in History and Art. Alexandria:Pontevedre Press; 2006: 85–106.
26. Morabia A. Pierre-Charles-Alexandre Louis and the evaluation of bloodletting. *J Roy Soc Med*. 2006; 99: 158–160.
27. http://www.greekmedicine.net/therapies/Hijama_or_Cupping.html (accessed November 29, 2016).
28. Reed H. *The Meaning of Art*. London: Faber and Faber; 1972: 151.
29. Jouanna J. *Hippocrates* (trans. DeBevoise MB). Baltimore: Johns Hopkins U. Press; 1999: 156.
30. Mackowiak PA. Recycling Metchnikoff. Probiotics, the intestinal microbiome and the quest for long life. *Frontiers Inf Dis*. doi:10.3389/fintm.2013.0004.

31. http://www.Kenkoucare.com/foreign_english_information02.html. (accessed March 10, 2016).

32. Anderson J, Barnes E, Shackleton E. *The Art of Medicine*. Chicago: U. Chicago Press; 2011: 144.

33. Zigrosser C. *Ars Medica*. Philadelphia: Edward Stern & Co.; 1955: 6.

34. Anderson J, Barnes E, Shackleton E. *The Art of Medicine*. Chicago: U. Chicago Press; 2011: 144.

35. George DR, Edris W, Hanson T, Gilman F. Medicinal plants—the next generation. *Lancet* 2016; 387: 220–221.

36. Leuver ME. How we cured cancer: cancer therapies before the age of imaging. *Medicine Bull.* (of the University of Maryland) 2016; Fall: 16–17.

37. Nuland SB. *Medicine. The Art of Healing*. Boston: Beaux Arts Editions, 2000: 18.

38. Tibis S. Al-Razi and Islamic medicine in the 9th century. *J Roy Soc Med.* 2006; 99: 206–207.

39. Lewis JD, Strom BL. Balancing the safety of dietary supplements with the free market. *Ann Intern Med.* 2002; 136: 616–617.

40. From the "Full Bibliographic Record," Wellcome Library no. 44588i (accessed November 28, 2016).

41. Emergence of pharmaceutical science and industry: 1870–1930. *Chemical & Engineering News* [https://pubs.acs.org/cen/conservatory/83/8325/8325emergence.html. (accessed February 23, 2016)].

42. Lichtenberg FR. Are the benefits of newer drugs worth their cost? Evidence from the 1996 MEPS. *Health Affairs* 2001; 20: 241–251.

43. Kessler C, Ward MJ, McNaughton DC. Reducing adverse drug events. The need to rethink outpatient prescribing. *JAMA.* 2016; 316: 2092–2093.

44. Greene JA, Jones DS, Podolsky SH. Therapeutic evolution and challenge of rational medicine. *N Engl J Med.* 2012; 367: 1077–1082.

45. McKeown T, Record RG. Reasons for the decline of mortality in England and Wales during the nineteenth century. *Popul Stud.* 1962; 16: 94–122.

46. Jureidini J. Antidepressants fail, but no cause for therapeutic gloom. *Lancet* 2016; 388: 844–845.

47. Jouanna J. *Hippocrates* (trans. DeBevoise MB). Baltimore: Johns Hopkins U. Press; 1999: 130.

48. Kaufman DW, Kelly JP, Rosenberg L, et al. Recent patterns of medication use in the ambulatory adult population of the United States. The Slone survey. *JAMA.* 2002; 287: 337–344.

49. Jan R. Rufaida al-Asalmiya: the first Muslim nurse. *J Nursing Scholarship* 1996; 28: 267–268.

50. Reed H. *The Meaning of Art*. London: Faber and Faber; 1972: 224.

51. Mackowiak PA. *Post Mortem. Solving History's Great Medical Mysteries*. Philadelphia: ACP Press; 2007: 277–304.

52. Zigrosser C. *Ars Medica*. Philadelphia: Edward Stern & Co.; 1955: 22.

53. Reed H. *The Meaning of Art*. London: Faber and Faber; 1972: 134.

54. Baron H. The hospital of Santa Maria della Scala, 1090–1990. *Brit Med J.* 1990; 301: 22–29.

55. Nuland SB. *Medicine. The Art of Healing.* Boston: Beaux Arts Editions, 2000: 63.
56. Bordin G, D'Ambrosio LP. *Medicine in Art* (trans. Hyams J). Los Angeles: J. Paul Getty Museum; 2010: 282.
57. Agnus DC. Admitting elderly patients to the intensive care unit—Is it the right decision? *JAMA.* 2017; 318: 1443–1444.
58. Jouanna J. *Hippocrates* (trans. DeBevoise MB). Baltimore: Johns Hopkins U. Press; 1999: 109.
59. Robertson C, Kesselheim AS. Regulating off-label promotion—a critical test. *N Engl J Med.* 2016; 375: 2313–2315.
60. Walsh J. *Jan Steen: The Drawing Lesson.* Los Angeles: Getty Museum Studies on Art; 1996: 43 ff.
61. Zigrosser C. *Ars Medica.* Philadelphia: Edward Stern & Co.; 1955: 52.

4

Surgery

Although surgery's history is nearly as old as the human species, the practice as we know it today did not exist before the 19th century C.E. Until then, except for some daring operations performed during remote periods, surgery was restricted to external manipulations and efforts to address traumatic injuries (1).

Trephination, creation of a burr hole in the skull, is one of the oldest known surgical procedures. The intervention was practiced over a wide geographic area as early as the Cro-Magnon period (50,000–10,000 B.C.E.), and although believed to have originated in the Mediterranean basin, was commonly practiced by pre-Inca peoples throughout most of Central and much of North America (Figure 4.1). Trephination's purpose varied from magical to relief of the after-effects of traumatic injury. Although principles of asepsis lay thousands of years in the future, many of the ancient patients subjected to trephination appear to have recovered from the surgery without evidence of infection of the bone surrounding the burr hole (4).

Figure 4.1. *Inca Trephination Mural,* oil on canvas, 1966 C.E. by Alton S. Tobey,
Smithsonian Institution, Washington, D.C., United States.
According to Herbert Read: "The kind of art which we might call *realistic* would be one
that tried by every means to represent the exact appearance of objects"(2). Tobey did
extensive research in preparing for his work on this mural. How successful he was in
representing the exact appearance of trephination performed by an Inca priest-surgeon
will never be known. What we do know, based on the discovery of numerous ancient
skulls with tell-tale burr holes, is that trephination was not only performed many times
in the ancient Inca city of Macchu Picchu, but that many of the warriors on whom
the procedure was performed survived long enough for their surgical wounds to heal
without evidence of infection (3).

Long before Hippocrates' lifetime, medical papyri reveal that the
ancient Egyptians were skilled at manipulating and splinting simple
fractures and dislocations of long bones and mandibles, as well as at
incising abscesses and cauterizing tumors (5). Amputations and attempts
to surgically manage head injuries, remove urinary stones, and evacuate
abdominal and thoracic fluid were innovations introduced later by the
Greeks (5). The Romans contributed early plastic procedures (e.g., re-
pair of ears, lips, and the nose) to the practice of surgery. Surgery among
the ancient Asians, particularly those in India, evolved as a result of the
eastward diffusion of operative techniques closely resembling those of

the Greco-Romans for abscesses, urinary stones, fractures, hernias, nasal deformities, amputations, and removal of foreign bodies (6).

The 19th century C.E. marked the first major advances in surgery after the time of Hippocrates, thanks, in large part, to improvements in general anesthesia and aseptic techniques based on concepts promulgated by the emerging science of bacteriology (7).

CHALLENGES

Of the many challenges that confronted early surgeons, the three greatest were bleeding, infection, and pain. Much credit has been given to Ambroise Paré (1510–1590 C.E.) for solving the problem of surgical hemorrhage by introducing the use of ligatures and by performing amputations through healthy, rather than necrotic, tissue. However, these *innovations* were actually *revivals* of Greco-Roman techniques developed more than a millennium earlier. Paré's principal attribute as a surgeon, according to historian Cecilia C. Mettler, was his remarkably good judgment (8).

Surgeons have long recognized the importance of cleanliness in performing operations. Hippocratic physicians maintained that wounds should never be irrigated except with clean water or wine, and that the water used for irrigation should be either very pure or else boiled. Surgeons were instructed to cleanse their hands and nails and to conduct their work in operating rooms that were clean, well-illuminated and staffed by capable assistants (9). Sushruta, a Hindu surgeon active around 800 B.C.E., gave similar instructions to his disciples in ancient India (6).

Following the fall of Rome, the concept of "laudable pus" pre-empted cleanliness as a guiding principle of wound management. According to the concept, the presence of pus in a wound (i.e., suppuration) (Figure 4.2), is necessary for drying and proper healing of a wound, and also the prevention of tetanus and gangrene. Although attacked by some early authorities, notably Paracelsus (see Chapter 3), the concept held sway among many

Figure 4.2. *Hospital Gangrene of an Arm Stump,* water color, 1863 C.E. by Edward
Stauch, National Museum of Health and Medicine, Silver Spring, United States.
Stauch used color and shade with great skill in giving expression to both the physical and
emotional suffering of Private Milton E. Wallen of Company C, 1st Kentucky Cavalry.
Private Wallen was wounded by a Minié ball while imprisoned in Richmond on July 4,
1863 C.E. When sketched by Stauch, his amputated right arm was being treated for gan-
grene. Incredibly, Wallen survived the infection and was furloughed from the hospital in
October of 1863 C.E. (10).

prominent surgeons until the work of Pasteur and others provided incon-
trovertible evidence of the bacterial etiology of wound suppuration and its
relationship to surgical sepsis (11).

British surgeon Joseph Lister (Figure 4.3) is generally credited with
introducing the principles of asepsis in surgery that were to save innu-
merable lives (12). However, like Paré, Lister deserves only partial credit
for solving one of surgery's greatest challenges. While quick to appreciate
the importance of Pasteur's work in explaining wound infection, Lister's
attempts to interdict the process with carbolic acid washes and aerosols
proved far less effective in preventing sepsis or tetanus than in producing
fatal intoxication. Lister's principal contribution to the practice of surgery

Figure 4.3. *Joseph Lister*, panel 4 of the great bronze doors of the John B. Murphy Memorial Building, 1925 C.E. by Tiffany artist Charles Keck, American College of Surgeons, Chicago, Illinois, United States.
Lister's image appears on the façade of the great bronze doors along with those of Asclepius, Pasteur, Ephraim McDowell, Sir William Osler, and William Crawford Gorgas in recognition of "their contributions to medical science that paved the way to modern 'medical miracles.'" (12). Lister's contribution, carbolic acid-decontamination of surgeons' hands, is shown being performed in this panel. His use of a carbolic acid aerosol to decontaminate the surgical environment is not shown. Although Lister sipped the enlightening wine of many others in developing his aseptic method, a method more toxic than effective, he is widely regarded as the father of aseptic surgery (13).

was to draw attention to the practical application of the findings of Pasteur and other early bacteriologists to surgical practice (13).

It is widely believed that until October 16, 1846 C.E., surgical procedures were of necessity crude, quick, and excruciatingly painful (Figure 4.4) (14). On that day, a tumor was removed from the jaw of a young man while

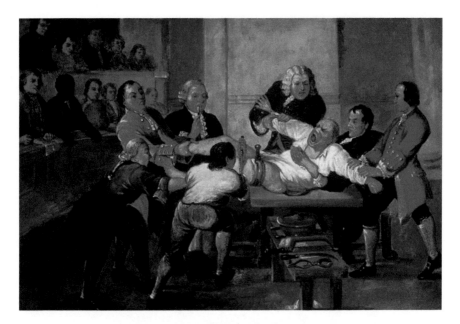

Figure 4.4. *Dionis' Choice of Assistants*, oil on canvas, mid-19th century C.E. by an unknown artist, St. Thomas' Hospital, London, England.
French surgeon Pierre Dionis (1643–1718 C.E.) gave the following description of the assistants needed to perform a proper amputation: "We are to cause the Patient to be . . . held up by a Servant, who kneels behind him, and on whose stomach he leans; we cause a Servant to sit also on the side of the Patient on which we are to perform the Operation, who grasping with his two Hands the lower part of the Thigh, draws the skin upwards as much as possibly he can, whilst the Operator [surgeon] is fixing on ligatures . . . The Incision . . . [is] to be Held by a third Servant placed directly opposite the Patient, kneeling on one knee , , , A fourth Servant is charged with instruments . . . and the Apparatus for the dressing is held by another Servant; Nor can we be without a sixth, who is to obey the Order of the Operator" (15).
The painting's emotional energy captures far better than words the pain, suffering, and chaos of surgical procedures performed before the advent of effective general anesthesia.

under ether anesthesia in the amphitheater at the Massachusetts General Hospital in Cambridge, MA (Figure 4.5), an event since trumpeted as "one of the first significant medical discoveries to cross the Atlantic from west to east" (18). However, ether anesthesia was just one of many examples of "how the commonplace of the past becomes the vaunted discovery of the present" (19).

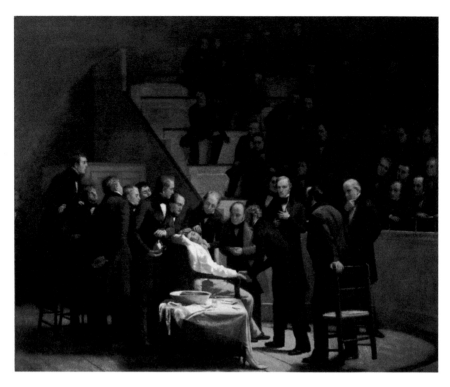

Figure 4.5. *First Operation Under Ether*, oil on canvas, 1886 C.E. by Robert C. Hinkley, Francis A. Countway Library of Medicine, Boston, Massachusetts, United States. According to 18th century C.E. English artist Sir Joshua Reynolds, artists who create *idealistic* representations of nature "distinguish the accidental deficiencies, excrescences, and deformities of things, from their general figures [to make] out an abstract idea of their forms more perfect than any one original" (16). And so it is with Hinkley's portrayal of the "first operation under ether." The operation performed by John C. Warren on October 16, 1846, C.E. with ether anesthesia provided by dentist William T. Morton was not the *first* such operation. Crawford W. Long (1815–1878 C.E.) administered ether to patients during eight operations performed in Jefferson, Georgia prior to September 1846 C.E., and also administered ether to his wife at the birth of their second child a year before the operation celebrated in Hinkley's painting (17). Moreover, although the throng of onlookers in Hinkley's work appears as if those present might live a thousand years and never see so glorious an event again, like so many medical "discoveries," the one they are witnessing was but one step along the tortuous path of progress in the practice of surgery.

In the 1st century C.E., Dioscorides alluded to the use of mandragora to produce anesthesia when patients were cut or burnt (19), and according to Galen, hypnotic drugs were used liberally in conjunction with surgery during the 2nd century C.E. (17). In the 15th century C.E., William Bullein described a concoction of an herb, "which bringeth sleep . . . and casteth man into a trance until he shall be cut out of the stone" (19). As for ether, Paracelsus is believed to have used it to anesthetize animals as early as the 15th century C.E. (20). Thus, the use of anesthetics in surgery was not a 19th century C.E. discovery. Rather, its use reaches far back into antiquity. Moreover, according to Mettler, the absence of the agonizing screams previously heard in operating rooms was not the principal function of general anesthesia in bringing surgery into the modern age. General anesthesia, she maintained, has had less to do with the much-vaunted humanitarian one of alleviating pain than that of rendering the patient inert during surgical procedures (21).

SURGEONS

Modern day surgeons trace their origin to the barbers of antiquity, who were called upon to perform more than simple haircuts. During the Egyptian era, throughout Roman times and in the Middle Ages, barbers bled patients, extracted teeth, and performed a wide range of surgical procedures. In that these tasks were considered a lesser art than that performed by physicians, when Galen arrived in Rome in the 2nd century C.E., public sentiment and upper-class bias prevented him from practicing both medicine and surgery. Although he knew how to perform trephining and other surgical procedures, he generally deferred such work to the Roman equivalent of the medieval barber-surgeon (Figure 4.6) (22).

Incorporation of barber-surgeons into the hierarchy of medicine occurred around the 7th century C.E., when ecclesiastic custom required their service in shaving monks' heads to create the tonsured sign of religious devotion and humility; and in the 12th century C.E., when the famed

Figure 4.6. *The Surgeon and the Peasant*, engraving, 1524 C.E. by Lucas van Leyden, Metropolitan Museum of Art, New York, New York, United States.
The procedure being performed by the [barber] surgeon in van Leyden's famous engraving is a mystery. The patient's raised right hand suggests that he is anticipating something more painful than a close shave, perhaps incision of a boil behind his ear. Van Leyden's surgeon has a heavy purse and attire much more elegant than his patient, implying an undue preoccupation with money, which artists of that era were prone to associate with "surgeons," no less than with quacks (23).

medical school in Salerno recommended periodic (prophylactic) bloodletting in *Regime sanitati*, barber-surgeons were the ones who performed the procedure (24). Given this responsibility, barber-surgeons began advertising their presence in the marketplace, just as today's barbers do, with a red and white striped pole, originally meant to signify the red blood and white rags involved in bloodletting.

Surgery emerged as a separate profession in the mid-13th century C.E., with the granting of the privilege of licensing barber-surgeons to the Collège de St. Côme in Paris. Professional jealously and fear of losing control over the activities of barber-surgeons caused physicians to oppose the move, leading to the creation of two classes of surgeons— those licensed by the Collège of St. Côme, known as "surgeons of the long robe" and the non-licentiates, known as "surgeons of the short robe" (25). Dishonest practitioners populated both groups, making it difficult for the public to distinguish surgeons from quacks (see Figure 3:16). Not until 1745 C.E. were the barbers' and surgeons' corporations in England legally separated (26). Although less committed to a research culture seeking conversion of intellectual curiosity into sound science than medicine (29), surgery advanced rapidly thereafter under the leadership of surgeons equal in stature to that of their physician counterparts (Figure 4.7).

SPECIALISTS

According to Herodotus, medicine was already teeming with subspecialists by the 5th century B.C.E. "Each physician," he wrote, "applies himself to one disease only, and not more. All places abound in physicians; some physicians are for the eyes, others for the head, others for the teeth, others for the parts about the belly, and others for internal disorders" (30).

In early times, obstetrics was the purview of midwives rather than physicians (Figure 4.8). When attendance by physicians became the norm in "lying-in" hospitals in Europe during the 19th century C.E., epidemics of puerperal fever (i.e., nearly invariably fatal infections associated with childbirth) raged until brought under control by chlorine disinfection of surgeons' hands—an innovation generally credited to the Hungarian physician, Ignaz Philipp Semmelweis (Figure 4.9) (32).

Numerous references to Cesarean-section (Figure 4.10) exist in early Egyptian, Greek, Roman, Hindu, and Chinese documents. Although

Figure 4.7. *The Gross Clinic*, oil on canvas, 1875 C.E. by Thomas Eakins, Philadelphia Museum of Art, Philadelphia, Pennsylvania, United States.
Professor Samuel Gross of Philadelphia's Medical College was an autocrat, a skeptic and a surgery colossus of the 19th century C.E. His disdain for Lister's doctrine of antisepsis is reflected in his bloody bare hand and ordinary frock coat in Eakins' masterpiece, a disdain echoed by a former student, who wrote: "I have seen more than once, my old teacher, Professor S.D. Gross, give a last touch to his knife on his boot – even on the sole – and then at once use it from the first cut to the last" (27)." Gross' patient is already infected. He has osteomyelitis of his left femur (28), a devastating infection, even today, which tends to respond poorly to treatment, including surgery performed under aseptic conditions.

commonly believed to have been the manner of the birth of Julius Caesar, for whom the procedure is named, this is unlikely, in that Caesar's mother, Aurelia, survived long enough after the surgery to hear of her son's invasion of Britain decades later. Prior to the modern era, the purpose of Cesarean-sections was to retrieve infants from dead or dying mothers in

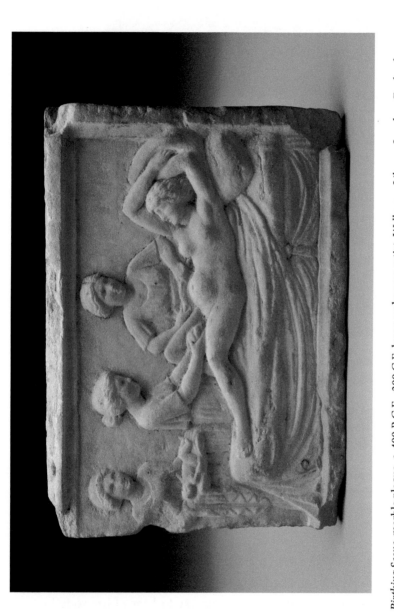

Figure 4.8. *Birthing Scene*, marble plaque, c. 400 B.C.E.–300 C.E. by an unknown artist, Wellcome Library, London, England. The exact age of this beautifully executed marble plaque is uncertain. Excavated at Rome's Ostia Antica, it depicts a recently delivered woman reclining on a couch covered with drapes. The mother is attended by three women dressed in classical Roman robes, one of whom is holding the newborn baby. No doctor is present. In ancient Rome, only mothers of high status were typically attended during delivery by a physician (31).

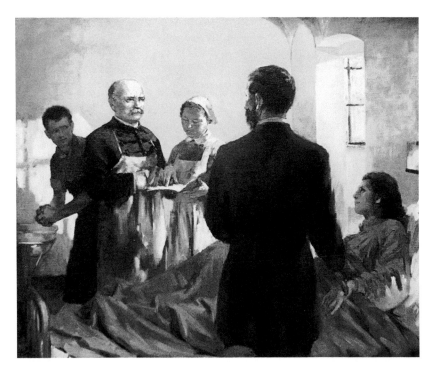

Figure 4.9. *Semmelweis*, oil on canvas, 1953 C.E. by Mária Túry, private collection. According to medical lore, Ignaz Philipp Semmelweis stepped onto medicine's stage, briefly played his part in ending the tragedy of puerperal sepsis, and then died rejected and despised in a Vienna mental institution. The "inconvenient truth" that Semmelweis supposedly discovered, and for which he was persecuted—that "contagion" carried on the hands of surgeons from the morgue to the delivery room was responsible for the 19th century C.E. epidemics of sepsis among pregnant women—was known to the medical profession well before he made his historic "discovery." Moreover, his innovative intervention, hand sanitation with chlorinated lime solution, was already being employed in Scotland at the time he first proposed it (33).

the desperate hope of saving the baby's life, or so that the mother and child might be buried separately (36).

The earliest visual representation of urological surgery is a relief depicting circumcision in a tomb at the Sakkara cemetery in Memphis, Egypt created nearly five thousand years ago (Figure 4.11). The ancient Egyptians also inserted catheters into the urinary bladder (5). However, extraction of urinary stones was not performed until later by Hippocratic and Roman specialists (38). The first description of suprapubic cystotomy

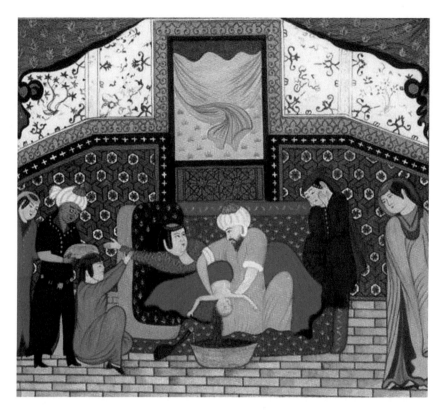

Figure 4.10. *Rustam's Birth*, watercolor on paper, 1498 C.E. by an unknown artist, *Shahnamah Firdaws* (Book of Kings of Firdaws), Topkapi Museum Library, Istanbul, Turkey.

The *Shahnamah* is an epic poem written between 977 C.E. and 1010 C.E. by Persian poet Ferdowsi. It tells of the mythical, and to a lesser extent, historical past of the Persian Empire from the beginning of the world until the Islamic conquest of Persia in the 7th century C.E. The 14th, 15th, and 16th century C.E. editions of the work contain beautiful miniature illustrations like this one of the miraculous birth by Cesarean-section of Rustam, one of the principal figures of the poem's heroic age. In that Rustam's mother is said to have recovered from the procedure (34), Rustam's birth by Cesarean-section, like that of Julius Caesar's, is much more likely mythical than historical. The remote, impersonal expressions of the participants in this illustration are typical of Persian works of that period (35).

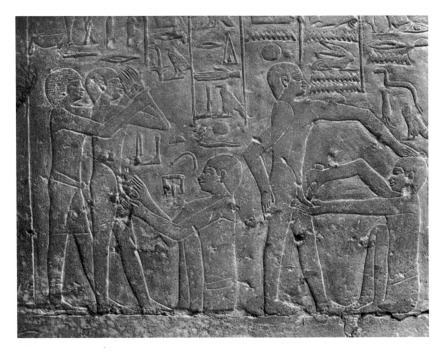

Figure 4.11. *Egyptian Circumcision Scene*, stone relief, c. 2625–2475 B.C.E. by an
unknown artist, tomb at the Sakkara cemetery in Memphis, Egypt.
This ancient relief attests to the fact that the practice of circumcision predated the Bible's
religious commandment by over a thousand years. The procedure's original purpose is
uncertain. Possibly, it had a ritual function related to the attainment of manhood, was
performed for hygienic reasons, or had some other religious purpose (37).

(entering the urinary bladder through the anterior abdomen; Figure 4.12)
as the operation of choice for removing bladder stones was by Francois
Rousset in 1590 C.E. (39).

The ancients possessed limited expertise in the area of otolaryngology.
References to disorders of the ears, nose, and throat in the *Hippocratic
corpus* are brief and mostly appear as incidental remarks included in
discussions of other topics (40). Tonsillectomies (Figure 4.13) were
performed, although they were cruder than those of modern times, often
consisting simply of attempts to remove tonsils by scratching them with a
finger nail (43). Foreign bodies were removed from the upper respiratory
passage, and tracheostomies were also preformed (44). In the 9th century

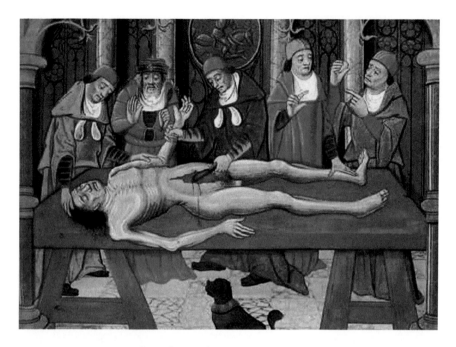

Figure 4.12. *Dissection of a Cadaver*, velum print, 15th century C.E. by an unknown artist, in *De proprietatibus rerum* (BNF Fr. Fol. 56), Bibliothèque Nationale, Paris France. Numerous odd details of this work serve to invite a lingering examination rather than a quick glance. Although the title implies that the patient is dead, the "prosector" and his assistants appear to be restraining him, with hands on his head, arm, and leg, suggesting that he is alive, anesthetized, and undergoing surgery rather than a dissection. The location of the incision (over the urinary bladder) and the object being examined by the two figures on the right suggest further that the procedure being performed is a lithotomy and that the object being held aloft by the man at the far right is a bladder stone.

C.E., the Persian physician Rhazes even predicted the advent of the otoscope with early attempts to direct light into the ear canal (45).

Sushruta performed the first known cataract operation in India in around 800 B.C.E., making him history's earliest known ophthalmologist. Whereas he apparently succeeded in extracting the cataract from a patient's eye (46), surgeons of Sushruta's era generally managed cataracts using a procedure called "couching," in which the diseased lens was dislocated within the eye away from the pupil rather than being removed (Figure 4.14) (47).

Figure 4.13. *Dr. Péan Operating*, oil on cardboard, 1891–1892 C.E. by Henri de Toulouse-Lautrec, Sterling and Francis Clark Institute, Williamstown, Massachusetts, United States.

Toulouse-Lautrec gives a wonderfully vivid picture of a late 19th century C.E. surgeon at work. He follows one of his favored compositional arrangements in having the surgeon's assistant appear in the immediate foreground, inviting the viewer to lean forward for a better look at the operation being performed (41). As to the reason for the surgery, one can only guess, given the limited information provided in the portrait. The painting has been called "Une Opération de Trachéotomie," implying that Péan is inspecting the patient's throat prior to performing a tracheostomy, possibly in a patient with diphtheria, given his "bull neck," which is typical of the infection. Other possible diagnoses include tuberculosis or cancer of the larynx, an abscess or tumor of the tonsils, or a salivary stone (42).

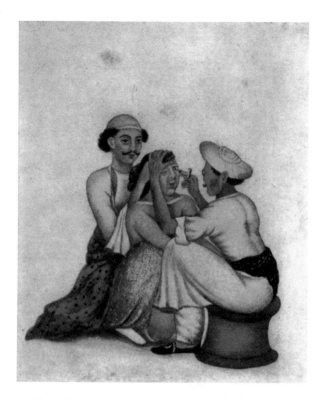

Figure 4.14. *Couching for Cataract*, colored engraving, c. 1760 C.E. by Thomas Jefferys, Wellcome Library, London, England.

"Couching," a treatment for cataracts first performed in India during the 9th century B.C.E., involved insertion of a sharp, but not too slender, needle into the eye, and when resistance was met on contact with the lens, gently working the lens downward away from the pupil. If the lens did not stay down, it was broken into pieces and the fragments were depressed below the pupil. Although the procedure might have improved vision in the affected eye, post-operative complications such as infection and retinal detachment would have been common (46).

Until recently, surgical extirpation was the only option available to patients suffering with cancers. Archigenes of Apamea, who practiced in Rome around 100 C.E., performed one of the earliest known mastectomies for cancer of the breast (48). Until the late 19th century C.E., it was customary to remove the skin with the entire breast followed by application of a simple dressing in managing such patients (Figure 4.15) (49).

乳岩之圖

Figure 4.15. *Excision of a Cancerous Growth*, colored woodcut, 1851 C.E by an unknown artist, in Geka Kihai, a surgical treatise by Kamata Keishu, Wellcome Library, London, England.
This woodcut depicts the 1804 C.E. operation by Hanaoka Seishu to remove a cancerous growth from his wife's breast. There is profuse hemorrhaging from the incised breast in spite of an attempt by Seishu to staunch the bleeding with his bare hands. The patient is unconscious, having been placed under general anesthesia by Seishu (50) over four decades before Morton and Warren performed the operation under ether (Figure 4.5) that earned them credit for "the invention of anesthesia . . . [that has been acclaimed as America's] greatest gift to the art and science of medicine" (51).

Plastic surgeons have long specialized in the repair of defects and malformations in attempts to restore function and improve the appearance of affected patients. During the 9th century B.C.E., Sushruta helped found the discipline by introducing a method for repairing noses that had been cut off as punishment for adultery (52). In recent times, the role of

plastic surgeons in the relief of pain and deformity, and in the restoration of function and the ability to earn a living, has expanded greatly into the area of cosmetics (Figure 4.16).

Christian mythology credits two 3rd century C.E. brothers, Saints Cosmas and Damian, with having performed the first transplant—that

Figure 4.16. *Visit to the Plastic Surgeon*, oil on masonite, 1960 C.E. by Remedios Varo, private collection.

Varo's art has been called metaphysical, symbolic, allegorical, and surreal (53). This work is all of these. From a clinical standpoint, the grotesquely enlarged nose of the young woman about to enter the plastic surgeon's clinic symbolizes a traditional focus of plastic surgery—relief of the pain and stigma of physical deformity. The surreal model in the display case with wildly exaggerated feminine features is a mocking metaphor for both society's concept of the desirable woman and the idea of plastic surgery done for purely cosmetic reasons. A translation of the clinic's motto appearing in the window is: "Overcome nature. In our glorious era. Plasticnylon (sic). There are no limitations. Audacity. Good taste. Elegance and swelling is our motto. French spoken."

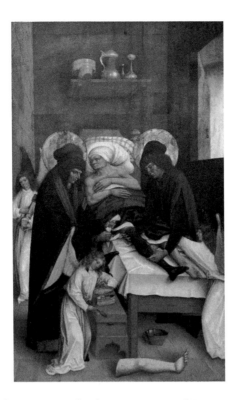

Figure 4.17. *Transplantation Miracle of Saints Cosmas and Damian,* wood
panel painting, c. 1500 C.E. by an unknown Swabian master, Würtembergisches
Landesmuseum, Stuttgart, Germany.
The 3rd century C.E. miracle attributed to twin brothers Cosmas and Damian in nu-
merous works is just one of many instances throughout history in which fiction has
anticipated reality. In this case, Christian legend anticipated the advent of transplant sur-
gery by nearly two thousand years (54).

of the leg of a healthy, black Ethiopian onto a white bell tower attendant
(Figure 4.17) (54). The first actually successful transplant of a human
organ, a kidney (from one identical twin to the other), was performed
at the Brigham Hospital in Boston in 1954 C.E. Successful liver, heart,
and pancreas transplants followed in the late 1960s C.E., and lungs
and intestines in the 1980s C.E. As of 2017 C.E., surgery's newest
subspecialists are either performing or contemplating transplantation
of nearly every organ, cell, and subcellular structure in the human body
(55, 56).

REFERENCES

1. Mettler CC, *History of Medicine*. Philadelphia: Blakiston Co.; 1947: 793.
2. Reed H. *The Meaning of Art*. London: Faber and Faber; 1972: 137.
3. http://www.altontobey.com/treph.html (accessed December 29, 2015).
4. Mettler CC, *History of Medicine*. Philadelphia: Blakiston Co.; 1947: 794.
5. Saber A. Ancient Egyptian surgical heritage. *J Invest Surg*. 2011; 23: 327–334.
6. Nutton U. *Ancient Medicine* (2nd ed.). London: Routledge; 2012: 87–103, 160–173.
7. Mettler CC, *History of Medicine*. Philadelphia: Blakiston Co.; 1947: 890.
8. Ibid 844–848.
9. Mackowiak PA. *Post Mortem. Solving History's Great Medical Mysteries*. Philadelphia: ACP Press; 2007: 75.
10. https://www.flikr.com/photos/medicalmuseum/337270955 (accessed May 17, 2017).
11. Magner LN. *The Art and Science of Surgery. A History of Medicine*. New York: Marcel Dekker; 1992: 279–305.
12. https://www.facs.org/about%20acs/archives/pasthighlights/bronzedoors. (accessed January 5, 2017).
13. Mettler CC, *History of Medicine*. Philadelphia: Blakiston Co.; 1947: 896.
14. The Editors. Looking back on the millennium in medicine. *N Engl J Med*. 2000; 342: 42–49.
15. http://www.piratesurgeon.com/pages/surgeon_pages/amputation3.htm (accessed March 10, 2016).
16. Reed H. *The Meaning of Art*. London: Faber and Faber; 1972: 223.
17. http://www.anb.org/articles/12/12-00544-article.html. (accessed January 2, 2017).
18. Greene JA, Jones DS, Podolsky SH. Therapeutic evolution and the challenge of rational medicine. *N Engl J Med*. 2012; 367: 1077–1082.
19. JAMA 100 Years Ago. Medical history and non-medical writers. *JAMA*. 1909; 52: 1041.
20. http://www.histansoc.org.uk/timeline.html (accessed January 2, 2017).
21. Mettler CC, *History of Medicine*. Philadelphia: Blakiston Co.; 1947: 891.
22. Ibid 817.
23. https://www.vialibri.net/item_pg_i/454062-1524-lucas-van-leyden-the-surgeon-and-the-peasant (accessed March 10, 2016).
24. Mettler CC, *History of Medicine*. Philadelphia: Blakiston Co.; 1947: 835.
25. Ibid 839.
26. Ibid 83.
27. http://collectmedicalantiques.com/quotes (William Williams Keen quote) (accessed February 12, 2016)
28. Nuland SB. *Medicine. The Art of Healing*. New York: Hugh Lauter Levin Assoc., Inc.; 1992: 88.
29. Editorial. The struggle for better research in surgery. *Lancet* 2016; 387: 1970.
30. Mettler CC, *History of Medicine*. Philadelphia: Blakiston Co.; 1947: 321.
31. Zigrosser C. *Ars Medica*. Philadelphia: Philadelphia Museum of Art; 1959: 46.

32. Stewardson A, Pittet D. Ignác Semmelweis—celebrating a flawed pioneer of patient safety. *Lancet* 2011; 378: 22–23.

33. Mettler CC, *History of Medicine*. Philadelphia: Blakiston Co.; 1947: 976.

34. http://.muslimheritage.com/article/simurgh-symbol-holistic-medicine-middle-eastern-culture-in-history (accessed on January 17, 2017).

35. Reed H. *The Meaning of Art*. London: Faber and Faber; 1972: 114.

36. https://www.nlm.nih.gov/exhibition/cesarean/part1.html (accessed July 7, 2016).

37. Bordin G, D'Ambrosio LP. *Medicine in Art* (trans. Hyams J). Los Angeles: J. Paul Getty Museum; 2010: 179.

38. Mettler CC, *History of Medicine*. Philadelphia: Blakiston Co.; 1947: 807.

39. Ibid 852.

40. Ibid 1057.

41. Bordin G, D'Ambrosio LP. *Medicine in Art* (trans. Hyams J). Los Angeles: J. Paul Getty Museum; 2010: 202.

42. Aronson JK, Ramachandran M. The diagnosis of art: Dr Péan's operation. *J Roy Soc Med.* 2008; 101: 423–424.

43. Mettler CC, *History of Medicine*. Philadelphia: Blakiston Co.; 1947: 1060.

44. Ibid 1059.

45. Ibid 1062.

46. Roy PN, Mehra KS, Deshpande PJ. Cataract surgery performed before 800 B.C. *Brit J Ophthal.* 1975; 59: 171.

47. http://www.mrcophth.com/Historyofophthalmoloty/cataracthistory.htm (accessed January 3, 2017).

48. Mettler CC, *History of Medicine*. Philadelphia: Blakiston Co.; 1947: 813.

49. Ibid 864.

50. Anderson J, Barnes E, Shackleton. *The Art of Medicine*. Chicago: University of Chicago Press; 2011: 189.

51. Nuland SB. *Medicine. The Art of Healing*. New York: Hugh Lauter Levin Assoc., Inc.; 1992: 92.

52. Mettler CC, *History of Medicine*. Philadelphia: Blakiston Co.; 1947: 820.

53. White JY. The surrealist woman: the art of Remedios Varo. Syracuse University Honors Program Capstone Projects, Paper 744.

54. Nuland SB. *Medicine. The Art of Healing*. New York: Hugh Lauter Levin Assoc., Inc.; 1992: 32.

55. Watson CJE, Dark JH. Organ transplantation: historical perspective and current practice. *Br J Anaesthes.* 2012; 108 (S1): i29–i42.

56. Kmietowicz Z. UK becomes first country to allow mitochondrial donation. *BMJ.* 2015; 350: h1103.

Public Health

Historically, attention to the provision of clean water, proper sanitation, and a healthy environment has had a greater impact on life expectancy, disability, and quality of life than medical care (1). Although until the advent of modern sanitation in the mid-19th century C.E., cesspools and outdoor privies were the principal means of disposing human waste (2), some early societies appear to have had an inchoate appreciation for the relationship between proper sanitation and human health. At the Moenjodaro archeological site in the Sindh province of Pakistan (c. 4000–2000 B.C.E.), for example, as well as the palace of Knossos on Crete, which dates to c. 2000 B.C.E., there were magnificent bathing facilities and flush toilets. Water pipes installed at an even earlier period have been uncovered in private houses located among the ruins of Priene in Asia Minor; and in the Americas, vestiges of sophisticated sewage systems and baths have been found at sites occupied by the Incas (3).

WATER AND WASTE

Long before the birth of microbiology, ancient scholars anticipated the existence of pathogenic microorganisms with theories attributing the cause of infectious diseases to "seeds," "animaculae," and "worms" (4). However, there is no evidence that pre-modern peoples recognized the importance of human excreta as a source of such animaculae, or that sewage-contaminated drinking water was responsible for the deadly outbreaks of diarrhea and dysentery that have plagued human populations throughout history.

Cholera, the prototypical sewer-derived infection caused by the bacterium *Vibrio cholera*, induces watery diarrhea voluminous enough to drain the very life out of its victims (Figure 5.1). Ancient Greek and Sanskrit accounts of a disorder identical to modern-day cholera suggest that the infection has sickened and killed humans for thousands of years. However, for unclear reasons, documented accounts of cholera-like epidemics prior to the 17th century C.E. are rare. Since then, seven cholera pandemics have spread throughout the globe, with the most recent beginning in 1961 C.E. (5).

Until the work of John Snow and William Budd in the mid-1800s C.E., miasmas (gases arising from sewers) were thought to cause cholera, as well as many other illnesses. In a classic epidemiological investigation of the distribution of deaths from cholera in south London, Snow proved that cholera was water-borne, that is, transmitted by water from a contaminated source. Filippo Pacini (in 1854 C.E.) and Robert Koch (in 1883 C.E.) extended Snow's observations by isolating the bacterium responsible for the disorder (6). Their discovery enabled scientists to produce several cholera vaccines, none of which has, as yet, proved to be more than moderately effective (7).

For hundreds of years, another sewage-derived disorder, polio (Figure 5.2), terrorized humanity with attacks of paralysis and death occurring nearly every summer. The terror finally began to ease early in the 20th century C.E. and then all but ended—thanks to the

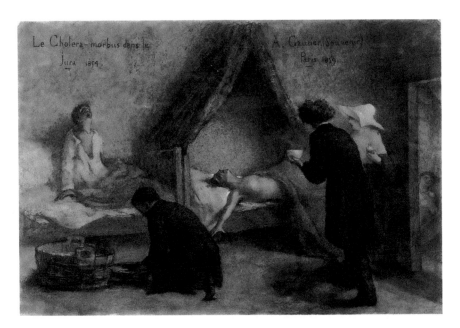

Figure 5.1. *Patients Suffering from Cholera in the Jura during the 1854 Epidemic*, pencil drawing, 1859 C.E. by Amand-Désiré Gautier, Wellcome Library, London, England. In this drawing, Paul Gachet (1828–1909 C.E.), most famous for having treated Vincent van Gogh during his final weeks at Auvers-sur-Oise, is shown tending to patients suffering from cholera somewhere in eastern France during the third cholera pandemic of 1851–1859 C.E. (5). The tub in the foreground likely was used to collect the voluminous watery diarrhea typical of the infection. Rehydration, the principal treatment for cholera even today, seems to be Dr. Gachet's intention, given what appears to be a bowl of broth he is about to offer the moribund-looking patient lying in front of him. The bottle in the nun's hand might have contained tincture of opium, castor oil, milk of magnesia, calomel, or any one of a long list of ineffective and potentially toxic medications used to treat gastroenteritis in the mid-19th century C.E.

development of *in vitro* viral propagation in tissue culture by John Enders, Frederick Robbins and Thomas Weller, and its application to polio virus by Thomas Francis, Jr., Jonas Salk and Albert Sabin, which resulted in two highly effective polio vaccines. Application of these vaccines in a global polio-eradication effort succeeded in reducing cases of polio from approximately 350,000 in 125 countries in 1988 C.E. to fewer than 100 cases in just two countries, Pakistan and Afghanistan, as of 2016 C.E. (9).

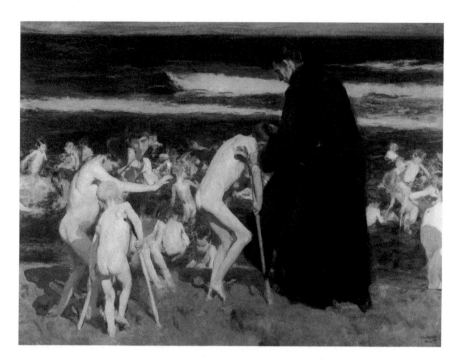

Figure 5.2. *Sad Inheritance*, oil on canvas, 1899 C.E. by Joaquín Sorolla, private
collection.
Sorolla has been called a "social realist" for having produced works that "captured the
immediacy of everyday life, warts and all" (8). The subject of this work is a party of
crippled children bathing in the sea at Valencia under the watchful eye of a monk. The
boys on crutches exhibit the tragic after-effects of an epidemic of polio that struck the
Valencia area in the late 19th century C.E.

THE ENVIRONMENT

Jacques Jouanna has suggested that one of the most important
achievements of Hippocratic scholars was to recognize the relationship
between the environment and health. The Romans regarded the rela-
tionship so important, that when considering a site for settlement, they
examined the livers of animals grazing there to determine its suitability
for human habitation. If the livers were greenish-yellow, the site was
deemed unhealthy and was avoided (10).

Swamps were considered especially unhealthy environments, owing
to their association with relapsing fevers (Figure 5.3). Putrid miasmas

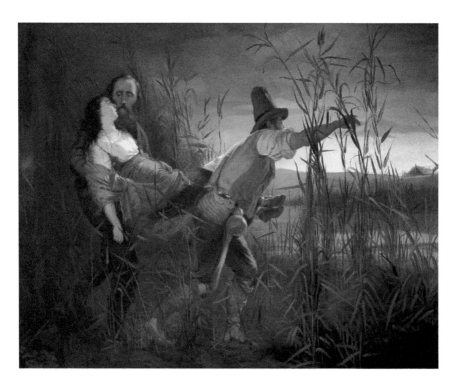

Figure 5.3. *Garibaldi Carrying His Dying Anita Through the Swamps of Comacchio*, oil on canvas, 19th century C.E. by Pietro Bauvier, Museo del Risorgimento, Brescia, Italy. Comacchio is situated on a lagoon just north of the mouth of the Reno River. Until its conversion into agricultural land in the mid-1800s C.E., Comacchio consisted primarily of wetlands in which malaria was prevalent (11). Anita Garibaldi, Giuseppe Garibaldi's Brazilian wife and comrade-in-arms, is reputed to have died of malaria, possibly contracted while campaigning in a swamp similar to the one depicted in this painting. Normally, she would have been protected from the lethal effects of malaria by immunity acquired in response to prior episodes of the infection during earlier campaigns with her husband in Brazil and Uruguay. However, she was pregnant at the time of her death, which would have heightened her risk of dying from the infection (12).

emanating from marshy environments were believed to be the cause of such fevers, giving rise to the name, *mala aria* (Italian for "bad air"), for one of the most important of these fevers. Not until Giovanni Maria Lancisi published *De noxiis paludum effluviis* ("On the noxious emanations of swamps") in 1717 C.E. did the connection between marshy areas, mosquitoes, and malaria begin to be appreciated (13). In time, Patrick

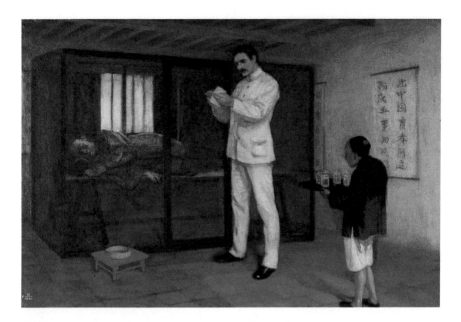

Figure 5.4. *Patrick Manson Experimenting with Filaria sangius-hominis on a Human subject in China*, oil on canvas, c. 1912 C.E. by Ernest Board, Wellcome Library, London, England.
Sir Patrick Manson was a Scottish physician who demonstrated the capacity of insects to serve as intermediate hosts for certain human infections. He accomplished this by persuading his gardener (the patient depicted in this painting) to allow himself to be bitten by mosquitoes, which when dissected revealed the presence of parasitic microfilaria (microscopic worms). Manson's discovery led to the theory of mosquito transmission of malaria, and established him as the father of modern tropical medicine (14, 15).

Manson (Figure 5.4) and Ronald Ross, building on the work of many other investigators, clarified the life-cycle of malaria parasites and linked their transmission to humans with mosquitoes (14, 15).

Transmission of a host of other human infections has since been connected with mosquitoes, including yellow fever, dengue, chikungunya, and West Nile fever. The Zika virus is a relatively recent addition to the list. First identified in the Zika forest of Uganda in 1947 C.E., the virus attracted little attention until shown to be the cause of an epidemic of microcephaly (Figure 5.5) and fetal death that began in Brazil in 2015 C.E. before spreading throughout the Americas (17).

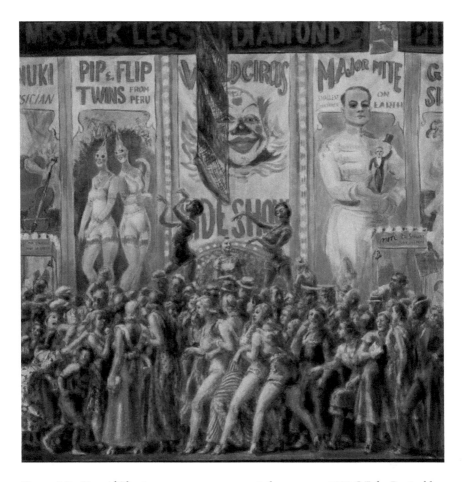

Figure 5.5. *Pip and Flip*, tempera on paper mounted on canvas, 1932 C.E. by Reginald Marsh, Terra Foundation for American Art, Chicago, Illinois, United States.

But for the title of Marsh's painting, the viewer's attention might be drawn to "Mite the Smallest Man on Earth," the other medical curiosity featured in this work. Although the microcephalic twins, Pip and Flip, were advertised as immigrants from the jungle region of Peru, they were actually from Hartwell, Georgia (16). If they had been born in Brazil in 2015 C.E., the Zika virus would have been a likely cause of their microcephaly (i.e., abnormally small heads). In the early 20th century C.E., the Zika virus had not yet been identified in the Americas. At that time, infection of the twins' mother during gestation by German measles, cytomegalovirus, toxoplasmosis, or chickenpox would have been a more likely cause of their microcephaly.

Figure 5.6. *They Do Have Faces*, watercolor, 2009 C.E. by Andrea Krook, artist's
collection.
Krook's water color features a family living in the Soweto slum near Nairobi, Kenya. As
of 2017 C.E., nearly a billion people worldwide were living under similarly unsanitary
conditions. Krook purposely painted her subjects without faces to reflect the tendency of
well-to-do citizens of first world countries to "look the other way," rather than confront
the plight of people living in urban slums like this one (19).

Today urban slums (Figure 5.6) represent one of the most challenging
environments with regard to public health. Many of them developed in
low- and middle-income countries during the latter half of the 20th cen-
tury C.E., when massive urbanization outpaced urban planning and infra-
structure. The inadequate sanitation and contaminated water supplies that
typify urban slums predispose inhabitants to diarrheal diseases and pro-
vide reservoirs for breeding of insect vectors of infections such as malaria,
dengue, and leishmaniasis. Overcrowding creates the additional burdens
of rampant tuberculosis, food insecurity, violence, and vulnerability to fire
and extreme weather (18).

PLAGUE

Although "plague" is a term commonly associated with bubonic plague, it is actually a generic term with roots based on epidemiological concepts first articulated in the Hippocratic Corpus. "Pandemic," a synonym for plague, is derived from *demo*, meaning "people" and *pan*, meaning "all" or "throughout." The prefixes *en* (within) and *epi* (upon) were used, and continue to be used, to distinguish disorders that smolder within populations (endemic) and those erupting suddenly upon communities (epidemics), from ones that sweep across the globe (pandemics; 20). In the 1990s C.E., the term "syndemics" was introduced to denote outbreaks in which two or more disease states act synergistically to accentuate the severity of each of the interacting disorders (e.g., the potentiating interaction between substance abuse, crime, and AIDS; 21).

Pandemics (or plagues) have had many causes throughout history. Two caused by *Yersinia pestis*, the bacterium responsible for bubonic plague, are widely regarded as having been the most catastrophic. The first, the Plague of Justinian, which raged between 541 and 542 C.E., killed an estimated 13% of the known world's population and contributed to the decline of the Eastern Roman (Byzantine) Empire. The second, The Black Death (Figure 5.7), was even more destructive, carrying off an estimated third of Europe's population during the 14th century C.E. and persisting in intermittent outbreaks for another 200 to 300 years thereafter (22).

Venice, with its enormous sea-trade to the east, was especially vulnerable to the ever-present threat of bubonic plague during the Middle Ages and the Renaissance. In 1127 C.E., the Venetian Republic responded to the threat by establishing the first official quarantine (Figure 5.8) as a preventive measure directed against ships arriving in their port with cases of suspected bubonic plague. The term "quarantine" is derived from *quarantenaria*, the 40-day period, which in the 13th and 14th centuries C.E. was thought to separate the acute phase of plague from its chronic phase (23).

Figure 5.7. *The Triumph of Death*, oil on panel, c. 1562 C.E. by Pieter Bruegel the Elder, Museo del Prado, Madrid, Spain.

There is nothing in the appearance of the ruck of dead and dying persons featured in Bruegel's depiction of hell-on-earth to indicate that they are victims of bubonic plague. They have no obvious buboes (enlarged lymph nodes) or evident hemorrhaging, two of the most prominent manifestations of the infection. However, what the painting lacks in clinical detail, it more than compensates for by conjuring up in the viewer's mind the horror, despair, and terror that accompanied the great wave of woe that rolled over Europe during the 14th century C.E. Although fantastical, Bruegel's work arouses a deep, vague, generalized sense of communion with the victims of the Black Death that might even be equated with scientific truth.

Leprosy was an equally terrifying plague of the Middle Ages. Although known to the ancient Hebrews, Greeks, and Romans, the infection was relatively rare until the 6th century C.E., when it began spreading throughout Europe. Leprosy had long smoldered among the poor. However, during the 13th and 14th centuries C.E., it increased in incidence throughout Western Europe, probably as a result of an influx of cases among Crusaders returning from the Middle East. The disease then gradually subsided for

Figure 5.8. *A Medical Officer Examining a Ship's Crew for Bubonic Plague on Arrival in the Thames*, watercolor drawing, 1905 C.E. by F. de Haanen after C. C. Eldred, Wellcome Library, London, England.
Buboes (enlarged, tender lymph nodes), particularly in the neck and axillae (armpits), are hallmarks of bubonic plague. The medical officer depicted in this work is about to palpate the axilla of the crew member with raised arms in search of such lymph nodes. If detected in any crew member, the ship and its entire crew would have been placed under quarantine.

unclear reasons until losing its significance as a public health threat in the 16th century C.E. (24).

During the Middle Ages, lepers (Figure 5.9), many of whom had dermatologic and musculoskeletal disorders other than leprosy, were ostracized more for esthetic than for public health reasons. Exclusion from the general population was stringently enforced by both secular and

Figure 5.9. *Leper Beggar in the Form of the Devil*, engraving, 15th century C.E. by
Hieronymus Bosch, Rijksmuseum, Amsterdam, the Netherlands.
This work by Bosch, a highly individualistic artist known for his deep insight into
humanity's desires and deepest fears, reflects the prevailing attitude toward leprosy
during the Middle Ages. Lepers were horrifying to people then, not just because of their
unsightly affliction, with its disfiguring destruction of skin, face, and limbs, but because
the disease was thought to be caused by sin, spiritual uncleanness, or, in other words, the
Devil's presence within the victim (24).

ecclesiastical authorities, much as had been done during Biblical times.
Lepers were required to wear distinctive clothing and, though segregated
from the public, were permitted to enter the city to beg at church
doors (25).

The "white plague," tuberculosis, is possibly mankind's oldest infec-
tion. According to one estimate, it emerged among humans as early as
70,000 years ago when ancient members of the species began migrating

Figure 5.10. *Cave Painting*, c. 8000 B.C.E. by an unknown artist, Tassili n' Ajjer, Algeria. The human figure at the far right of this cave painting appears emaciated, with spindly extremities and a simian head. From a clinical standpoint, however, the person's most striking feature is the gibbous deformity of his spine (i.e., his hunchback). In that distortion of some kind is a feature of all works of art (27), the person's abnormal spine might simply represent artistic distortion. If the person was real and accurately depicted, Pott disease—spinal tuberculosis—could explain both his abnormal spine and his emaciation.

out of Africa (Figure 5.10; 26). Evidence of the infection among the mummified remains of pre-Columbian, Native Americans suggests an even longer history of human affliction, one possibly predating separation of the Americas from the early continent of Gondwanaland by continental drift (28).

Ancient physicians were well aware of the existence of tuberculosis, although ignorant of its cause (29). Early theories attributed the disorder to a variety of factors, such as heredity, nutrition, the environment, and contagion. Robert Koch ended speculation as to its cause on March 24, 1882 C.E., when he announced to the Berlin Physiological Society that he had identified the bacterium responsible for tuberculosis—*Mycobacterium tuberculosis* (30).

The disease, tuberculosis, has been called "consumption" and "phthisis" (from a Greek verb meaning "to waste away"), reflecting the manner in which it seems to slowly destroy the body from within (31). The infection claimed the lives of roughly a billion people during the last two centuries of the 2nd millennium C.E. (26), and it entered the 21st century C.E. as the most common cause of death due to infection worldwide (32). Tuberculosis is the quintessential disease of poverty, although for a time it enjoyed a morbid reputation as the archetypical disorder of artists, aesthetes, and Romantics (31).

Of the plagues that raged during the 16th and 17th centuries C.E., none loomed larger than syphilis, "the great pox" (Figure 5.11). In 1495 C.E., the infection first appeared in Naples, then in Germany, France, and Switzerland. A year later, it spread to Holland and Greece. In 1497 C.E., syphilis reached England and Scotland and two years after that arrived in Hungary and Russia (35). Because the onset of the pandemic coincided with the return of Columbus from his first voyage of discovery, and because no such distinctive disorder had previously been seen in the Old World, syphilis is generally believed to be a New World infection transported to the Old World by Columbus's crew (36).

The name "syphilis" originated in an epic Latin poem, *Syphilis sive morbus gallicus*, published in 1530 C.E. by Girolamo Fracastoro, a physician, mathematician, and poet from Verona (37). The disorder waxed and waned globally until the end of the 2nd millennium C.E., when safer sexual behaviors prompted by the AIDS epidemic resulted in a decline in the incidence of syphilis that raised hope of its elimination through implementation of public health measures similar to those used against smallpox. However, by 2016 C.E., such hope faded as rates of syphilis trended steadily upward with the return of risky sexual behavior prompted by the advent of highly active anti-AIDS drugs (38).

Influenza is generally credited with causing the most devastating plague of modern times. The "Spanish" influenza pandemic of 1918–1919 C.E. (Figure 5.12), aided and abetted by the social upheaval of World War I, killed an estimated 20 to 50 million, mostly young, healthy persons in an astonishingly brief period (40).

Figure 5.11. *Syphilitic Man*, colored woodcut for a broadside (poster), 1496 C.E. by
Albrecht Dürer, Museen Preussischer Kulturbesitz, Berlin, Germany.
Dürer's woodcut is the earliest known illustration of syphilis. The sores visible on the
man's exposed skin were a conspicuous manifestation of the secondary stage of the in-
fection, which gave rise to "the great pox" as one of the earliest names for the infection.
The signs of the zodiac featured in the woodcut reflect the belief that the disease was a
product of unfavorable planetary alignment (33). The mysterious "1484" on the globe
above the patient's head might allude to the "grand junction" of Jupiter and Saturn that
occurred in 1484 C.E. (34) as the particular planetary alignment responsible for the ap-
pearance of syphilis less than a decade later.

The term "influenza" (Italian for "influence"), coined in the
mid-1700s C.E., ascribed the infection to unfavorable astrological
influences. Later, the term was modified to "influenza del freddo" ("in-
fluence of the cold"), reflecting the disorder's predilection for winter
months (41).

Figure 5.12. *Self-Portrait After Spanish Influenza*, oil on canvas, 1919 C.E. by Edvard Munch, Nasjonalmuseet, Oslo, Norway.
Munch was just one of millions who fell victim to the highly contagious and unusually virulent strain of influenza that circled the globe during the 1918–1919 C.E. pandemic. Medicine was then only beginning to understand the infection and had no effective treatment for it or its complications. Unlike so many young persons who died during the epidemic, Munch, who was fifty-six at the time, survived (39).

When influenza epidemics first appeared among humans is uncertain, due to the impossibility of differentiating outbreaks of influenza from illnesses caused by other respiratory viruses based on symptoms alone (42). The first creditable account of an influenza pandemic is generally regarded as one reported in 1510 C.E. (43). In the 500 years since, much has been learned about the infection. However, despite progress in managing outbreaks of influenza, including the advent of antiviral drugs

and moderately effective vaccines (44), given the astonishing ability of the virus to mutate, we are not much better able today to anticipate and prevent the emergence of pandemic influenza than we were 500 years ago (43).

The renowned American medical historian Cecilia C. Mettler (1909–1943 C.E.) argued that "it is doubtful that any particular etiologic agents of specific diseases have ever been completely absent [from the human race] . . . bearing in mind that simply because we can find no clear ancient description of a particular disease, this, in itself, is not adequate evidence that such a disease did not exist" (45). Several high-profile epidemics of the past century (e.g., legionellosis, severe acute respiratory syndrome [SARS], Middle East respiratory syndrome [MERS], AIDS and Ebola) might apply, although current evidence suggests that the pathogens responsible for the disorders have only recently emerged as major threats to public health.

Of these, in the current era, AIDS (acquired immune deficiency syndrome) (Figure 5.13) has had the greatest overall impact on public health. As of 2016 C.E., an estimated 75 million people worldwide were infected with the human immunodeficiency virus (HIV)—the virus responsible for the disorder—approximately 70% of whom resided in sub-Saharan Africa (46, 47). The source of the pandemic strain of HIV has been traced to the *Pan troglodytes troglodytes* chimpanzee of central African forests west and north of the Congo River. The earliest known AIDS case occurred in the capital of the Belgian Congo in the mid-1930s C.E. (48).

Pliny the Elder's quote—*ex Africa semper aliquid novi* ("from Africa always something new")—applies equally well to Ebola (Figure 5.14), one of mankind's most recent plagues. The first patient with Ebola was diagnosed in 1976 C.E. in the northwestern region of the Democratic Republic of the Congo. The filovirus responsible for the infection is named after the Ebola River, a tributary of the Congo River network, and is thought to have originated among fruit bats. A 2014–2016 C.E. Ebola outbreak involving 28,000 cases and 11,000 deaths galvanized the development of a highly immunogenic vaccine (50).

Figure 5.13. *Thomas—Galveston Hospital. "My family didn't want me for Christmas. They gave me paper plates and cups to eat off."* Drypoint, sheet (irregular), 1994 C.E. by Sue Coe, Whitney Museum of American Art, New York, United States.

Coe's poignant drypoint captures the hopelessness and fear of the early years of the AIDS epidemic, when patients were shunned much like the lepers of the Middle Ages. Until the cause and modes of transmission of the disorder were identified, many surgeons refused to operate on AIDS patients, some physicians and nurses avoided them, and the public kept its distance. During those early years, AIDS was nearly uniformly fatal. Today, thanks to the advent of a host of effective medications, the infection, though still not curable, has been converted into a manageable chronic disease.

Figure 5.14. *Ebola*, oil on wood, 2015 C.E. by Wim Carrotte, Saatchi Gallery, London, England.

In his account of the 5th century B.C.E. Plague of Athens, Thucydides wrote: "Neither were the physicians at first of any service, ignorant as they were of the proper way to treat it, but they died themselves the most quickly, as they visited the sick the most often" (49). These caregivers in yellow protective garments are not patients per se. However, like those who cared for victims of the Plague of Athens, their risk of becoming patients during the recent Ebola outbreak was substantial. Modern principles of protective isolation helped minimize but did not completely eliminate such risk.

IMMUNIZATION

Vaccines are frequently cited as one of the greatest successes in the history of public health. The term "vaccine," derived from *vacca* (Latin for "cow"), reflects the bovine source of the first modern vaccine—the one employed in the 18th century C.E. first by Benjamin Jesty and then by English physician Edward Jenner to protect against smallpox (Figure 5.15). Although "vaccine" is now applied broadly to immunizing agents, only the smallpox vaccine was derived directly from cows.

Figure 5.15. *Edward Jenner*, bronze statue, 1873 C.E. by Giulio Monteverde, Galleria Nazionale d'Arte Moderna, Rome, Italy.
Monteverde's sculpture captures the precise moment in 1796 C.E. when Jenner inoculated James Phipps with cowpox matter taken from the hand of milkmaid Sarah Nelms. Several weeks later, Jenner inoculated young James with smallpox, which failed to take. The experiment rendered James Phipps immune to smallpox and paved the way for the annihilation of one of the most dreaded scourges of the human race (51).

Smallpox epidemics likely began as early as the 5th century B.C.E., when the infection emerged out of Africa as the most likely cause of the Plague of Athens (52). Knowledge that an attack of smallpox almost always confers immunity against subsequent infection led to early immunization efforts involving the intentional inoculation

of smallpox matter from mild cases of the infection into the skin of non-immune persons. Although reasonably effective, the intervention (known as "variolation," after Variola, the scientific name for the smallpox virus) resulted in occasional outbreaks of severe, sometimes fatal, disease. Jenner's seminal contribution was to recognize that milkmaids previously infected with the cowpox virus (a different virus, though antigenically related to the smallpox virus) were immune to smallpox (53).

Jesty and Jenner raised the curtain on an age of immunization that produced effective vaccines against diphtheria (Figure 5.16), pertussis, tetanus (Figure 5.17), measles, polio, mumps, rubella, influenza, yellow fever, meningitis, pneumococci, papillomaviruses, and hepatitis (58). A strategic global immunization program employing Jenner's vaccine removed smallpox from the list of human plagues in 1980 C.E. Polio appears destined to a similar fate in the near future. However, effective vaccines against many other important human pathogens, such as *M. tuberculosis*, HIV, malaria, and dengue, remain to be developed (59).

ADDICTION

The crime and violence, abuse and neglect of children, lost productivity, and health care costs associated with alcohol and drug abuse have made addiction one of the most pressing public health problems of the 21st century C.E. Opioid addition (Figure 5.18) has been especially troublesome, given a 2016 C.E. estimate of 17 million people worldwide engaged in the use of heroin and other opioids. The cost of opioid abuse in terms of morbidity and mortality alone is enormous. In parts of North America and Europe, for example, overdose deaths have surpassed fatalities from motor vehicle crashes (61).

Opioid use probably began c. 3400 B.C.E. among the Sumerians, who cultivated the opium poppy for its euphoric effects. Hippocratic physicians

Figure 5.16. *Lazarillo and the Blind Man,* oil on canvas, 1819 C.E. by Francisco de Goya, private collection.

Because the man in Goya's painting appears to be examining the throat of a sick child, several art critics have suggested that the work is a depiction of diphtheria in which a "physician" is searching the child's throat for a pseudo-membrane, a dense gray layer of fibrous debris in the back of the throat that is a hallmark of diphtheria (54, 55). However, the man's clothes are not those of a physician. Moreover, he is blind and not looking into the boy's throat. According to "Lozarrillo de Tormes," the story on which the painting is based, the blind man is about to stuff his nose into the throat of the boy, Lazarillo, not in search of a pseudo-membrane, but a piece of sausage the starving child has just stolen (56).

Figure 5.17. *Opisthotonos*, oil on canvas, 1809 C.E. by Sir Charles Bell, Royal College of Surgeons, Edinburgh, Scotland.
Bell was a Scottish surgeon best known for the facial palsy (paralysis) which bears his name. This, his most famous painting, depicts "opisthonotonos," the generalized rigidity (i.e., tetany) of full-blown tetanus. The spastic arching of the head, neck, and spine is the work of a neurotoxin produced by the bacterium *Clostridium tetani*.
Bell's portrait is a composite of drawings of three soldiers treated for tetanus following their return from the Battle of Corunna in Northern Spain during the Napoleonic Wars (57).

were among the first to use the drug for medicinal purposes (62). Addiction to opioids, although likely to have been a problem throughout the drug's history, does not appear to have been a public health problem of any great magnitude until the 18th century C.E., when apothecaries and unscrupulous physicians began adulterating sodas, tonics, patent medicines, and even infant formulas with unregulated amounts of opium and cocaine (63). In the United States, addiction resulting from these practices finally began to be addressed in 1906 C.E. with enactment of the U.S. Pure Food and Drug Act (64).

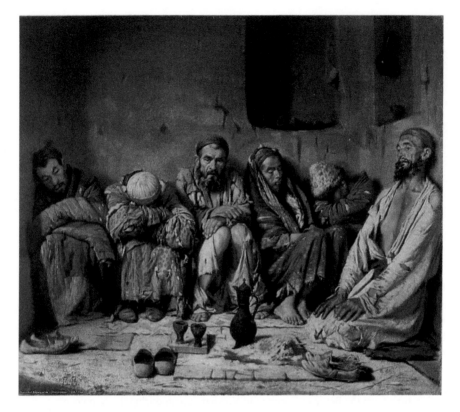

Figure 5.18. *Eaters of Opium*, oil on canvas, 1868 C.E. by Vasily Vereshchagin, Fine Arts Museum of Uzbekistan, Tashkent, Uzbekistan.
When Vereshchagin created this realistic depiction of Uzbeki opium addicts, addiction to the drug was rampant in Turkestan. The work was meant to convince the world that the Russian military was justified in suppressing the inhabitants of Central Asia in an effort to "civilize" them (60). The painting illustrates the power of art to render fascinating, even beautiful, some of society's saddest patients.

PRISONS

Nearly all societies throughout history have been guilty of forcing prisoners to live under appalling conditions (Figure 5.19). These conditions and the equally desperate environments from which inmates of prisons tend to originate have left prisoners prey to all manner of communicable diseases, many of which spill into communities at large after having matured and multiplied in prisons.

Until the 18th century C.E., neither medicine nor society took much notice of prison conditions or their effect on the health of inmates. Then in 1777 C.E., John Howard, the High Sheriff of Bedfordshire, published *State of the Prisons*, a report of his inquiries into the conditions of English prisons and his proposal for remedying the evils he had identified. His revelations regarding the relationship between jails and jail fever (typhus) anticipated the work of later sanitary reformers and galvanized English public opinion in support of efforts to improve the conditions of prisons in the United Kingdom (66).

Figure 5.19. *Prison Scene*, oil on tin plate, c. 1808 C.E. by Francisco de Goya, Bowes Museum, Barnard Castle, England.
Goya painted several prison scenes. Like Sheriff John Howard, he was outraged by the brutality then being meted out on prisoners. His dark prison scenes were indictments of such treatment and also reflections of the loneliness, fear, and social alienation he experienced after losing his hearing to a devastating illness in his mid-40s (see Chapter 10) (65).

The status of prisons in many, but not all, areas of the world has improved since 1777 C.E. However, prisoners remain a major source of communicable diseases. According to a 2014 C.E. survey, of the estimated 10.2 million people incarcerated worldwide on any given day, 329,000 (3.8%) are infected with HIV, 1,546,500 (15.1%) with hepatitis C, 491,500 (4.8%) with hepatitis B, and 286,000 (2.8%) with active tuberculosis (67).

REPRODUCTION

The earth's human population has grown steadily since the end of the Black Death of the 14th century C.E. The growth has been especially steep during the past century, thanks to increased agricultural productivity, abundant cheap energy, and advances in public health. In 2011 C.E., the United Nations Population Division projected a global population of 9 to 15 billion people by 2050 C.E., heightening concern that within this century, the earth's human carrying capacity will finally have been exceeded (68). In spite of such dire projections, except for communist China, no government has yet attempted to address head-on the thorny public health issues of birth control, abortion, sexuality, and maternal and child health (Figure 5.20) required to develop effective population control policies.

Aside from the profound economic, social, and political challenges posed by the burgeoning human population, there are the evolving public health-related crises of pollution and global warming. Air pollution alone (Figure 5.21) has emerged as a silent killer currently responsible for more deaths than AIDS, tuberculosis, and road injuries combined (70). The adverse effect of global warming on public health is potentially even more alarming. A recent World Health Organization report warned that climate change due to high levels of carbon dioxide emissions produced by the growing human population could cause an additional 250,000 deaths per year between 2030 and 2050 C.E., not taking into account factors such

Figure 5.20. *Desemparats (Maternité, Mère et enfant au fichu, Motherhood)*, pastel on paper, 1903 C.E. by Pablo Picasso, Museu Picasso, Barcelona, Spain.

Picasso produced this pastel during his Blue Period, one marked by relative poverty and instability (69). The work gives expression to the birth of a child as one of life's greatest blessings. The somber tones and mother's look of concern imply something more foreboding, possibly some vague acknowledgment that the birth of a child has also become one of the greatest threats to the health of the planet.

Figure 5.21. *Pollution*, watercolor and inks, 2012 C.E. by Catherine Hennessey, property of the author.
Hennessey's watercolor vividly demonstrates the relative importance of the objects depicted in a work of art (a pair of inflamed eyes, a barely visible nose, a disfiguring smudge) versus how the objects are treated in determining the work's impact on the viewer. Hennessy's image is arresting, shocking, yet strangely beautiful, like the vibrant colors of a sunset viewed through sickening urban smog.

as global warming's role in causing economic damage, major heat wave events, flooding, water scarcity, or human conflict. Moreover, as a result of rising temperatures worldwide, insect-borne diseases such as malaria, dengue, Zika, yellow fever, and the like are expected to spread into new regions as higher temperatures increase the range, replication, and biting rate of disease-transmitting insects (71).

REFERENCES

1. Wilensky G. Addressing social issues affecting health to improve US health outcomes. *JAMA*. 2016; 315: 1552–1553.
2. Rosen G. *A History of Public Health* (expanded ed.). Baltimore: Johns Hopkins U. Press; 1993: 234.
3. Ibid., 2–3.
4. Ibid., 271.
5. Lacey SW. Cholera: calamitous past, ominous future. *Clin Infect Dis*. 1995; 20: 1409–1419.
6. Rosen G. *A History of Public Health* (expanded ed.). Baltimore: Johns Hopkins U. Press; 1963: 262.
7. Qadri F, Wierzba TF, Ali M, et al. Efficacy of a single-dose, inactivated oral cholera vaccine in Bangladesh. *N Engl J Med*. 2016; 374: 1723–1730.
8. http://mydailyartdisplay.wordpress.com/2011/01/31/sad-inheritance-by-joaquin-sorolla/ (accessed May 6, 2016).
9. Patel M, Orenstein W. A world free of polio—the final steps. *N Engl J Med*. 2016; 501–503.
10. Rosen G. *A History of Public Health* (expanded ed.). Baltimore: Johns Hopkins U. Press; 1963: 18–19.
11. http://www.commune.comucchio.fe.it (accessed May 21, 2017).
12. http://searchingforbernini.files.wordpress.com/2013/07/garibaldi_carrying_his_dying_ani (accessed March 25, 2016).
13. Rosen G. *A History of Public Health* (expanded ed.). Baltimore: Johns Hopkins U. Press; 1963: 77.
14. Barnett R. Case histories. Malaria. *Lancet*. 2016; 387: 2495.
15. Grizzard M, Grizzard M. *On the cover*. *Clin Infect Dis*. I July 2015.
16. Southgate MT. *The Art of JAMA*, III, New York: Oxford U. Press; 2011: 105.
17. Samarasekera U, Triunfol M. Concern over Zika virus grips the world. *Lancet* 2016; 387: 521–524.
18. Editor. Health in slums: understanding the unseen. *Lancet* 2017; 389: 478.
19. http://www.visualnews.com/2013/03/06/andrea-krook-watercolor-artist/ (accessed February 16, 2017).
20. Mackowiak PA. *Post Mortem. Solving History's Great Medical Mysteries*. Philadelphia: ACP Press; 2007: 42.
21. Editorial. Syndemics: health in context. *Lancet* 2017; 389: 881.
22. Seifert L, Wiechmann L, Harbeck M, et al. Genotyping Yersinia pestis in historical plague. Evidence for long-term persistence of Y. pestis in Europe from the 14th to the 17th century. *PLoS ONE* 11: e0145194. doi: 10.1371/journal.pone.0145194.
23. Rosen G. *A History of Public Health* (expanded ed.). Baltimore: Johns Hopkins U. Press; 1963: 45.
24. Ibid 38–39.
25. Dequeker J, Fabry G, Vanopdenbosch L. Hieronymus Bosch (1450–1516): paleopathology of the medieval disabled and its relation to the bone and joint decade 2000-2010. *Med Archaeol*. 2001; 3: 864–871.

26. Dheda K, Barry 3rd CE, Maartens G. Tuberculosis. *Lancet* 2016; 387: 1211–1226.
27. Read H. *The Meaning of Art*. London: Faber and Faber; 1931: 29.
28. Mackowiak PA, Tiesler Blos V, Aguilar M, Treja D, Buikstra JA On the origin of American tuberculosis. *Clin Infect Dis*. 2005; 41: 515–518.
29. Mettler CC. *History of Medicine*. New York: The Classics of Medicine Library; 1986: 873.
30. Ibid., 263.
31. Barnett R. *The Sick Rose*. London: Thomas & Hudson Ltd.; 2014: 112–113.
32. Sotqiu G, Tiberi S, D'Ambrosio L, et al. WHO recommendations on shorter treatment of multidrug-resistant tuberculosis. *Lancet* 2016; 387: 2486–2487.
33. http://hfriedberg.web.wesleyan.edu/eng1205/wshakespeare/syphilitic.htm (accessed February 23, 2017).
34. http://www.esoteric.msu.edu/VolumeVI/Schoener.htm (accessed July 31, 2017)
35. Rosen G. *A History of Public Health* (expanded ed.). Baltimore: Johns Hopkins U. Press; 1963: 72.
36. Mackowiak PA. *Post Mortem. Solving History's Great Medical Mysteries*. Philadelphia: ACP Press; 2007: 237–238.
37. Grizzard M, Grizzard M. On the cover. *Clin Infect Dis*. 15 September 15, 2016.
38. Clement ME, Hicks CB. Syphilis on the rise. What went wrong? *JAMA*. 2016; 315: 281–283.
39. Faerna JM, Munch, Harry N. New York: Abrams; 1996: 146.
40. Trilla A, Trilla G, Daer C. The 1918 "Spanish flu" in Spain. *Clin Infect Dis*. 2008; 47: 668–673.
41. Online Etymology Dictionary. https://www.etymonlin.com/ (accessed February 17, 2017).
42. Mettler CC. *History of Medicine*. New York: The Classics of Medicine Library; 1986: 394.
43. Morens DM, Taubenberger JK, Folkers GK, Fauci AS. Pandemic influenza's 500th anniversary. *Clin Infect Dis*. 2010; 51: 1442–1444.
44. Pavia AT. Influenza vaccine effectiveness: mysteries, enigmas, and a few clues. *J Infect Dis*. 2016; 213: 1521–1522.
45. Mettler CC. *History of Medicine*. New York: The Classics of Medicine Library; 1986: 233.
46. Friedland G. Marking time in the global HIV/AIDS pandemic. *JAMA*. 2016; 316: 145–146.
47. Mayer KH, Shisana O, Beyer C. AIDS 2016: from aspiration to implementation. *Lancet* 2016; 387(10037): 2484–2485.
48. Hogan CA, Iles J, Frost EH, et al. Epidemic history and iatrogenic transmission of blood-borne viruses in mid-20th century Kinshasa. *J Infect Dis*. 2016; 214: 353–357.
49. Jouanna J. Hippocrates (trans. DeBevoise MB). Baltimore: Johns Hopkins U. Press; 1999: 208.
50. Regules JA, Beigel JH, Paolino KM, et al. A recombinant vesicular stomatitis virus Ebola vaccine. *N Engl J Med*. 2017; 376: 330–341.
51. Rosen G. *A History of Public Health* (expanded ed.). Baltimore: Johns Hopkins U. Press; 1963: 159–165.

52. Mackowiak PA. *Post Mortem. Solving History's Great Medical Mysteries.* Philadelphia: ACP Press; 2007: 27–57.
53. Mettler CC. *History of Medicine.* New York: The Classics of Medicine Library; 1986: 422–423.
54. Nuland SB. *Medicine. The Art of Healing.* New York: Hugh Lauter Levin Associates, Inc.; 1992: 74.
55. Bordin G, D'Ambrosio LP. *Medicine in Art.* (trans. Hyams J). Los Angeles: J. Paul Getty Museum; 2010: 249.
56. Cone TE, Jr. Goya's Lazarillo de Tormes. *JAMA.* 1967; 199: 222.
57. Grizzard M, Grizzard M. *On the cover.* Clin Infect Dis, 1 November 2012.
58. Kim DK, Bridges CB, Harriman KH. Advisory committee on immunization practices recommended immunization schedule for adults aged 19 or older: United States, 2016. *Ann Intern Med.* 2016; 164: 184–186.
59. Meissner HC. Immunization policy and the importance of sustainable vaccine pricing. *JAMA.* 2016; 315: 981–982.
60. http://www.sartle.com/artwork/eaters-of-opium-vasily-vereshchagin (accessed 4/27/2016).
61. Hadland SE, Wood E, Levy S. How the paediatric workforce can address the opioid crisis. *Lancet* 2016; 388(10051): 1260–1261.
62. http://www.pbs.org/wgbh/pages/frontline/shows/heroin/etc/history.html (accessed February 7, 2017).
63. Mettler CC. *History of Medicine.* New York: The Classics of Medicine Library; 1986: 212–213.
64. Leuver ME. Medicine and marijuana: a tangled history with an intoxicating weed. *Med Bull.* Winter 2016–2017: 16–17.
65. Mackowiak PA. *Diagnosing Giants. Solving the Medical Mysteries of Thirteen Patients Who Changed the World.* New York: Oxford U. Press; 2013: 82–96.
66. Rosen G. *A History of Public Health* (expanded ed.). Baltimore: Johns Hopkins U. Press; 1963: 119.
67. Dolan K, Wirtz AL, Moazen B, et al. HIV and related infections in prisoners 1. *Lancet* 2016; 388: 1089–1102.
68. Ehrlich PR, Ehrlich AH. Preface. *The Population Explosion.* London: Hutchinson & Co.; 1990: 39–40.
69. http://www.pablopicasso.org/blue-period.jsp (accessed February 17, 2017).
70. Editorial. Air pollution—crossing borders. *Lancet* 388: 103.
71. Levy K. Reducing health regrets in a changing climate. *J Infect Dis.* 2017; 215: 14–16.

Mental Health

In 2000 C.E., the editors of the *New England Journal of Medicine* looked back on the prior millennium and chose what they regarded as the most important medical developments of the preceding thousand years. "Each was a series of notable steps—some huge, some smaller—along a path that led to a crucial body of knowledge in a particular area" (1). None was selected from the area of mental health.

At the time the editors were making their choices, psychiatry had only recently attained the professional status of the other branches of the healing arts (2). The discipline had long been mired in problems of description dealing not with diseases, but with syndromes—constellations of symptoms—lacking identifiable causes, demonstrable anatomical pathology, specific diagnostic tests, or definitive treatments (3). Moreover, diagnostic boundaries based on psychiatry's syndromes have been stubbornly blurred and porous (Figure 6.1), with even the most distinctive symptoms, hallucinations for example, crossing boundaries between

Figure 6.1. *The Crazy Woman (La Pazza)*, oil on canvas, 1905 C.E. by Giacomo Balla, National Gallery of Modern Art, Rome, Italy.

Balla's portrait is an example of "divisionism," the characteristic style of the neo-impressionists, in which colors are separated into individual patches that interact optically. The subject, an *alien* (archaic term for a mental patient) is also typical of divisionists' penchant for social outcasts (4). This particular patient exemplifies the difficulty in diagnosing mental disorders. She is clearly disturbed. She is disheveled, posturing grotesquely, and apparently trying to communicate something . . . but what? Is she hallucinating, angry at the viewer, or trying to hush some inner voice? If we knew more about her, perhaps we could give her a diagnosis more informative (helpful?) than "a crazy woman". . . perhaps not.

different psychiatric diagnoses and between psychiatric patients and the population at large (5).

These limitations notwithstanding, progress has been made in the area of mental health over the course of many centuries. However, because psychiatry's history is an exceedingly complex one articulated in arcane hieroglyphs, the meanings of which have changed over time, the story of mental health's progress is distorted by misinterpretation, retrospective judgement, and generalization. Psychiatry has been disparaged for lagging behind the rest of medicine in understanding its disorders and developing effective treatments (6). However, it might be argued in the discipline's defense that the disorders of the rest of medicine are not nearly as complicated as those of mental health, because the brain is simultaneously the least accessible and the most complex organ of all.

MECHANISMS

Little is known for certain of the beliefs of primitive societies with regard to mental health. What scant information there is suggests that primitive peoples identified neuropsychiatric disorders with a "spirit principle" belonging not to the domain of the physician, but to that of the priest. The Babylo-Assyrians regarded the liver as the home of the spirit principle, whereas the ancient Egyptians were inclined to place it in the heart, which they believed controlled the function of the mind (7).

Many of the earliest Greek thinkers also accepted the idea that the liver and the heart influenced psychic phenomena. They extended the concept by positing that perturbations of thought occurred in the region of the diaphragm (the *phren*)—a structure separating the heart and the liver—giving rise to terms such as "phrenology," "frenetic," and "frenzy" (7). As noted in earlier chapters, the ancient Greeks also believed that one's health, mental as well as physical, is determined by the degree to which one or the other of the four corporal humors predominates (Figure 6.2).

Figure 6.2. *Galen's Four Humors*, color plate (illuminated manuscript), c. 1472 C.E. by an unknown artist, Zentralbibliothek, Zurich, Switzerland.

According to the humoral theory of the followers of Hippocrates, a person's basic temperament is determined by the degree to which one or another of the four corporal humors predominates. In warm, passionate (i.e., sanguine) persons [upper left panel] blood was believed to be the predominant humor; yellow bile in choleric persons prone to angry outbursts [upper right panel]; phlegm in dull, sluggish (i.e., phlegmatic) persons [lower left panel]; and black bile in persons having a melancholic disposition [lower right panel] (8).

Hippocratic scholars separated psychiatric disorders into just two major subdivisions: quiet and raving cases, which Roman and medieval scholars later denoted as *melancholia* and *mania* (9). The Romans added *insania* to the list of mental disorders for ravings we now call delirium and for the dotage of old age (10). They also began to regard the head (in concert with the *phren*) as the seat of some cases of madness (11). In Rome's waning days, Posidonius of Byzantium extended the concept by locating imagination in the front part of the brain, reason in the middle ventricle, and memory in the back of the brain (12).

The philosophical speculations of Persian scholars Rhazes and Avicenna had a profound influence on neuropsychiatric theory during the medieval period, though their concepts added little to those previously articulated by Hippocratic scholars. During that time, insight into the nature of mental illness continued to suffer the thought-arresting effects of both Galenic and Church dogma, the latter of which blamed mental illness on demonic forces forever in collision with the orderly functioning of the mind (13; Figure 6.3).

The Renaissance inaugurated an age of discovery during which physicians began to correlate disease with structure, although initially they were motivated more by logic than science (15). Autopsies performed on insane individuals found "morbid" conditions of the stomach and colon, leading to speculation that gastrointestinal and mental afflictions were somehow related (15), possibly via acrid vapors arising from the bowels (16). Those convinced that the brain was the seat of mental disorders argued over whether the ventricular system or the brain substance was responsible for such disorders (13). Superstition reaching back many generations attributed mental disturbances to "rocks in the head," which quacks were quick to use to their advantage (Figure 6.4). Lunar influences (the basis for the term "lunatic") also persisted as an explanation for mental illness (Figure 6.5), which Newton's later work gave credibility by offering alternations in gravity as the mechanism by which the moon exerted its mind-altering effect (19).

The advent of syphilis provided physicians with perhaps their earliest example of a medical disorder responsible for mental illness, insight

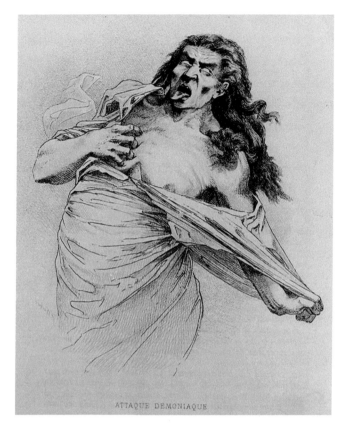

Figure 6.3. *Attaque Demoniaque*, metal engraving, 1843 C.E. by Adrien Delahaye and
Emil Lecrosnier, Etudes cliniques sur l'hystéro-épilepsie ou grande hystérie, Bibliothéque
Interuniversitaire de Médecine, Paris, France.
Anthropologists suspect that nearly all cultures have believed in spirits, and our own
culture is no exception. Certain extremely rare patients, such as the one illustrated in this
engraving, exhibit symptoms of mental derangement so fantastical (e.g., understanding
and speaking various foreign languages previously unknown to them; exhibiting enor-
mous strength; demonstrating hidden knowledge of others' secrets) that some of
today's physicians and clergy believe they can only be explained by attacks by demonic
spirits (14).

that much later led to recognition of congenital deficiencies, endocrine
disorders, malnutrition, poisonings, and the like as underlying causes of
mental dysfunction (3). However, until the mid-19th century C.E., most
physicians continued to subscribe to Galen's humoral theory of disease,
which called for treatment with purgatives, emetics, and bleeding.

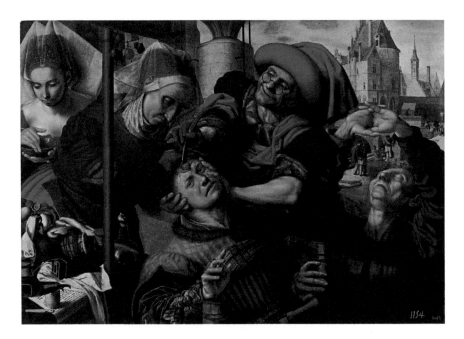

Figure 6.4. *The Surgeon (Extracting the Stone of Madness)*, oil on panel, c. 1550 C.E. by Jan Sanders van Hemessen, Museo del Prado, Madrid, Spain.
During the 16th and 17th centuries C.E., quacks took advantage of the superstitious belief that the mentally unbalanced person "had stones in his head." They did so by pretending to cure insanity with a superficial incision in the scalp, followed by feigned extraction of a small stone supplied by a confederate from behind. Van Hemessen's composition is a denunciation of the greed of surgeons who took advantage of such gullibility. Trephining skulls by prehistoric surgeons (see Figure 4.1) might have been genuine attempts to alleviate mental illnesses surgically by liberating malignant spirits from the cranium (17).

In the 19th century C.E., the new pseudoscience of phrenology claimed to be able to judge mental capacity by feeling the bumps on the surface of a person's skull. Two centuries later, a new cutting-edge technology, functional magnetic resonance imaging (MRI) enabled physicians to peer through the skull into the depths of the brain itself, providing a sort of internal phrenology that has as yet provided only limited insight into mechanisms involved in mental disorders (20).

At the turn of the 20th century C.E., Sigmund Freud proposed dysfunction based on conflict occurring between the superego and the id

Figure 6.5. *Lunacy*, watercolor and pencil on paper, 21st century C.E. by Yulia Kachan,
Saatchi Art, Los Angeles, California, United States.
Aristotle claimed that because the brain is the most moist organ in the body, it is the
most susceptible to pernicious influences of the moon. Although many people continue
to subscribe to the belief that the full moon has mystical powers capable of inducing
erratic behavior and all manner of strange events, the belief lacks scientific validation.
Nevertheless, it has been speculated that in ancient times, when people lived outside,
the bright light of a full moon might have triggered erratic behavior in patients with
disorders such as manic-depression by depriving them of sleep (18). Kachan's work gives
artistic expression to the theory in this image of the menacing effect of a full moon on a
patient with a morbidly depressed appearance.

and repression of libidinal experiences as causes of at least some mental
disorders (21). More recent scientific investigations concerned with the
influence of heredity (22), traumatic stress (23), brain anatomy (24, 25),
and environmental toxins (26) on mental health have carried the disci-
pline well beyond the ideas of Freud, Jung, Rank, Adler, and other early

psychotherapists, but not yet to the level of understanding enjoyed by the other branches of the healing arts.

DIAGNOSES

As already noted, Hippocratic physicians subdivided psychiatric disorders into just two categories—melancholia and mania. When Philippe Pinel became chief physician of Paris' Hospital de la Salpêtrière in 1795 C.E., he divided insane cases further into maniacs, melancholics, dements, and idiots (27). By 2013 C.E., the American Psychiatric Association had subdivided mental affections into hundreds of disorders, conditions, and problems ranging from "acculturation difficulty" to "wandering associated with a mental disorder" (28). The following are just a few of the most interesting psychiatric diagnoses from both a historical and artistic perspective:

Melancholia/Mania. The Greco-Roman characterizations of *melancholia* as quiet psychotic states and *mania* as excited psychotic states (10) aptly apply to the present-day diagnosis of bipolar disorder. The disorder affects more than 1% of people worldwide, irrespective of nationality, ethnic origin, or socioeconomic status. Accurate diagnosis is difficult because onset of the disorder most often involves a depressive episode (Figure 6.6) that is indistinguishable from unipolar depression (i.e., depression not alternating with manic episodes). Suicide among such patients is common, 20 times more common than among the general population. Treatments, including such things as mood stabilizers and antipsychotic drugs, electroconvulsive therapy, cognitive-behavioral therapy, supportive psychotherapy, and repetitive transcranial magnetic stimulations, are only moderately effective (29).

Retardation. Past diagnoses commonly given to persons born with intellectual capacities substantially below that of the general population (Figure 6.7) have included: "feeblemindedness "(30), "idiocy" (31), and "mental retardation." In the most recent edition of the American Psychiatric *Association's Diagnostic and Statistical Manual of Mental*

Figure 6.6. *Sorrowing Old Man (At Eternity's Gate)*, oil on canvas, 1890 C.E. by Vincent van Gogh, Kröller-Müller Museum, Otterlo, the Netherlands.
Oscar Wilde once ruminated: "Every portrait that is painted with feeling is a portrait of the artist not the sitter." When penning these words, Wilde might well have had in mind this portrait, painted by van Gogh two months before suicide carried him to "eternity's gate." God's gift of laughter appears to have gone out of the old man, never to return, just as it did for the artist who was repeatedly tormented by episodes of both melancholia and mania (see Chapter 10).

Disorders (edition 5, DSM 5) (28), "mental retardation" has been replaced by "intellectual disability" or "intellectual development disorder" in a move toward less stigmatizing diagnostic terms. The degree of disability required of the diagnosis is vague. In the past, the diagnosis was applied to an adult lacking "the intelligence of a child of fourteen" (31). The DSM-5 definition stipulates an intellectual disability two or more standard

Figure 6.7. *The Beggars (The Cripples)*, oil on panel, 1568 C.E. by Pieter Bruegel the Elder, the Louvre, Paris, France.
The title of this work suggests that these poor creatures had been forced into a life of beggary by a crippling disorder of their legs. A close examination of their faces, however, reveals the gaze of persons capable of seeing more than they understand, leading to the conclusion that their primary deficit was not physical but mental—mental retardation. No physical illness could have caused symmetrical destruction of the lower legs of beggars of that era without having taken their lives as well. More than likely their lower legs were amputated not as a consequence of disease, but in an effort to enhance their effectiveness as beggars by attracting pity.

deviations below the mean of the general population, or an intelligence quotient (IQ) of 70 or below.

Dementia. Today nearly 50 million people worldwide suffer with dementia, one of the most feared disorders of old age (32). Although the condition has long been a source of both speculation and investigation, little is known about why it develops. In the 4th century C.E.,

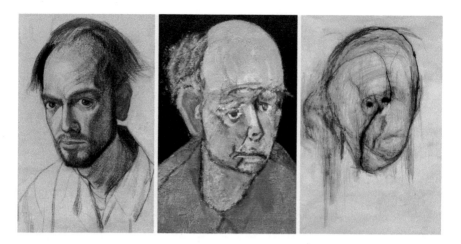

Figure 6.8. *Self Portraits*, mixed media on paper, 1967 C.E. [left], oil on canvas, 1997 C.E. [center], pencil on paper, 2000 C.E. [right] by William Utermohlen, private collections and New York Academy of Medicine, New York, United States.
Utermohlen was 62 in 1995 C.E. when diagnosed with Alzheimer's disease. He decided then to document the course of the disease and its effect on his mind in self-portraits until no longer able to do so because of the disease's effects. His wife, an art historian, said of his portraits: "In these pictures we see with heart-breaking intensity, William's efforts to explain his altered self, his fears and his sadness" (33).

Oribasius of Pergamum wrote of a condition he called "cerebral atrophy." Exhibiting surprisingly modern insight, he postulated that as a person grows old, the brain becomes atrophic and the nerves become dry, causing paralysis and dullness of sensations (12). Modern technology has expanded our knowledge of the anatomical abnormalities associated with senile dementia, although it has provided little insight into its causes. In the case of Alzheimer's dementia (Figure 6.8), the most common form of dementia diagnosed today, autopsy studies have identified peculiar protein *plaques* and *tangles* as anatomical hallmarks of the disorder (34).

Lycantropy. Paul of Aegina, a later Byzantine writer, gave a vivid description of "lycantropy," a fantastical mental disorder upon which the werewolf myth is based (Figure 6.9), and which had considerable currency well into the 16th century C.E. According to Paul: "Those laboring

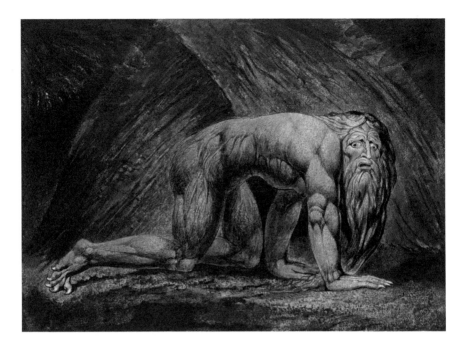

Figure 6.9. *Nebuchadnezzar,* copper engraving colored with pen, ink and watercolor, 1795 C.E. by William Blake, Tate Gallery, London, England.
According to Daniel 4:33 of the Old Testament, Nebuchadnezzar, Babylonia's greatest king, suffered a bout of insanity during which "he was driven away from the people and ate grass like cattle. His body was drenched with dew of heaven until his hair grew like the feathers of an eagle and his nails the claws of a bird." The biblical description of the king's illness suggests the possibility of a variant of lycantropy, which Blake reinforced by giving him a wolf-like appearance.

under lycanthropia go out during the night imitating wolves in all things, and lingering about sepulchers until morning" (35).

Hysteria. Hysteria (exaggerated or uncontrollable emotion or excitement) is the first mental disorder diagnosed in women for which an accurate description exists. In the Kahun Medical Papyrus (c. 1900 B.C.E.), the ancient Egyptians identified the cause of hysterical disorders as spontaneous movement of the uterus within the female body (36). In the 3rd century C.E., Aretaeus of Cappadocia, one of the most celebrated Greek physicians of the Roman era, advanced the concept by characterizing the *hystera* (Greek for "uterus") as a sessile animal capable of throttling the host into hysterical fits (37). In the 19th century C.E., Jean-Martin

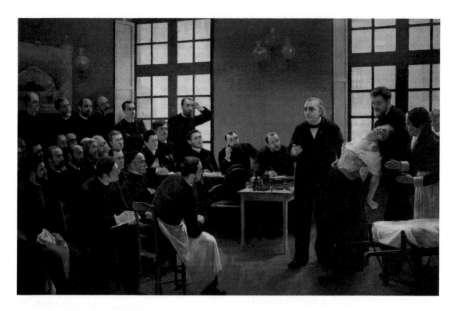

Figure 6.10. *Charcot Giving a Lesson in Hysteria at the Salpêtrière,* oil on canvas, 1885
C.E. by Pierre-Audré Brouillet, Musée d'Histoire de la Medécine, Paris, France.
When Jean-Martin Charcot, the "father of modern neurology," became the chief clinician
at the Salpêtriére in 1862 C.E., he reconceptualized psychiatric disorders as neurological
problems. He was especially interested in cases of hysteria, which he displayed in weekly
public performances such as the one depicted in Brouillet's painting. During these,
patients re-enacted their symptoms for the gatherings of onlookers. Charcot employed
numerous treatments ranging from hypnosis to electrotherapy in attempts to cure hys-
teria with little success (38).

Charcot proved during repeated theatrical demonstrations that hysteria is
an affection of the mind rather than of the body (Figure 6.10).

Schizophrenia. Compared to melancholia, mania, and generic "insanity,"
all recognized since antiquity, schizophrenia (Figure 6.11) is a relatively re-
cent disease concept. In the late 19th century C.E., Emil Kraepelin, Arnold
Peck, and Benedict Morel proposed "dementia praecox" (dementia of ad-
olescence) as a name for this diverse group of diseases defined by sub-
jective experiences (symptoms), behavioral impairment, and variable
courses. Later, Eugen Bleuler coined the term "schizophrenia [derived
from the Greek words *schizo* (split) and *phren* (mind)]. After more than a
century of intensive investigation, while much is known in general about

Figure 6.11. *The Fairy Feller's Master-Stroke*, oil on canvas, 1864 C.E. by Richard Dadd, Tate Gallery, London, England.
This painting features not a patient, but a glimpse into the troubled mind of a patient with paranoid schizophrenia. On August 28, 1843 C.E., Richard Dadd, one of the most promising artists of his generation, stabbed his father to death in the belief that he had been ordered to do so by Osiris, the ancient Egyptian god of the underworld (39). Hallucinations (in Dadd's case, secret communications from Osiris) constitute one of the five symptom domains of psychotic disorders in DSM-5, though they are experienced by an estimated 8% of the public at large (5).

this highly variable disorder, the specifics as related to the etiology and pathophysiology of individual cases have yet to be identified (40).

Other disease entities. Disruptive mood dysregulation disorder (Figure 6.12), eating disorders (Figures 6.13 and 6.14), body dysmorphic syndrome (Figure 6.15), homosexuality (previously considered a mental

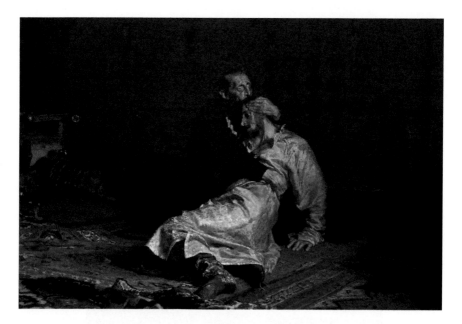

Figure 6.12. *Ivan the Terrible and His Son Ivan on November 16, 1581*, oil on canvas, 1885 C.E. by Ilya Repin, Tretyakov Gallery, Moscow, Russia.
Clinical diagnoses of historical figures are necessarily tentative due to limitations of medical information included in the historical record. This is especially true of psychiatric diagnoses. Many have wondered as to the mental health of Ivan IV ("the Terrible"), Great Duke of Moscow and All Russia from 1547 to 1584 C.E. Although intelligent and devout, he was given to fits of rage, during one of which, he murdered his son and chosen heir (41). Given Ivan's extraordinarily destructive outbursts, such as the one depicted in Repin's painting, one of the many diagnoses that might be given to him is the Disruptive Mood Dysregulation Disorder, which appeared for the first time in DSM-5.

disorder, but no longer) (Figure 6.16), and gender dysmorphia (Figure 6.17) are examples of other mental disease concepts portrayed in notable works of art for which little is known regarding their cause.

TREATMENT

Although the effects of various drugs on the course of mental health disorders have provided insights into the pathophysiology of some disorders, the specific mechanisms responsible for most have yet to

Figure 6.13. *Yamai no soshi—Obesity,* ink and color on paper, late 12th century C.E. by an unknown artist, private collection, Kyoto, Japan.
The money lender depicted in this Japanese Disease Scroll is so obese she is unable to stand without assistance. Such extreme obesity was considered a disease in 12th century C.E. Japan (42), just as it is in DSM-5, where it is listed as a "binge eating disorder."

be identified. As a result, treatments have had to focus on alleviating symptoms rather than preventing or curing the disorders themselves. The nature of treatments given to patients with mental health disorders has varied over time under the influence of both pathophysiological concepts and a modest number of technological advances.

In that loss of restraint has probably always been considered one of the defining characteristics of "madness" (47), restraining patients with mental illnesses has been a fundamental component of treatment since ancient times (Figure 6.18). In the 7th century C.E., Paul of Aegina advised that with *phrenetics,* "a state of quietude is to be maintained as much as possible: and if they be rich, they are to be restrained by their servants; but if not, they are to be bound with ligatures" (49). Not until the 17th century C.E., in the Low Countries of Europe, were public institutions created for restraining such patients (50). These allowed for the mentally ill to be removed from the streets, at least initially, not to be made well but to limit the damage they might cause to their neighbors and betters.

Figure 6.14. *Olympia*, oil on canvas, 1863 C.E. by Édouard Manet, Musée d'Orsay, Paris, France [upper image]; *After Manet, Olympia*, oil on canvas, 2009 C.E. by Remus Grecu, Städel Museum, Frankfurt, Germany [lower image].

Grecu produced his revised portrait of Manet's *Olympia* for the German Eating Disorder Aid Foundation. The plaque next to the painting in the Strädel Museum reads as follows: "Beauty ideals change. Today, the media and cosmetics industries all promote body measurements that are unattainable for people with healthy eating behaviors, effectively turning [DSM-5] disorders like anorexia and bulimia into trends" (43).

Figure 6.15. *Michael Jackson (Green)*, synthetic polymer on canvas, 1984 C.E. by Andy Warhol, National Portrait Gallery, Washington, D.C., United States.

Michael Jackson, ultra-talented music producer, dancer, song writer, and singer, was addicted to plastic surgery. Between the late 1970s C.E. and his death in 2009 C.E., he underwent dozens of operations, including rhinoplasty, cheek implants, lip augmentation, and remodeling of his jaw, until his original facial features were nearly obliterated. Jackson did so, he once explained, because he didn't want to look like his father (44). Jackson's obsessive preoccupation with his appearance and the exceptional measures he took to alter it are characteristic of a relatively new psychiatric diagnosis known as the "body dysmorphic disorder."

Figure 6.16. *Boys in Love*, silver point drawing, 1929 C.E. by Christian Schad, Museen der Stadt, Aschaffenburg, Germany.
Societal attitudes toward homosexuality have varied both over time and between societies. In ancient Greece, for example, the homosexual impulse was recognized, even idealized. A man could be both an openly homosexual lover and an honored citizen (45). In America in 1952 C.E., DSM-1 diagnosed homosexuals as sexual deviants with socio-pathic personalities. In DSM-5, lesbian, gay, and bisexual persons are no longer regarded as abnormal.

They were places of incarceration rather than for cure (48). Restraint was accomplished through the use of physical violence, chains, wrist cuffs, and leg irons. Later, mind-numbing drugs were applied as pharmacological restraints.

When "mad houses" in Europe and North America were finally scrutinized by reformers during the late 18th century C.E., the restraint and neglect being meted out on inmates became national scandals.

Figure 6.17. *Lili Elbe,* water color, c. 1928 C.E. by Gerda Wegener, Wellcome Library, London, England.
According to DSM-5, gender dysmorphia (formerly known as gender identity disorder) is a diagnosis applied to people "whose gender at birth is contrary to the one they iden- tify with," *and* the discrepancy is a source of "clinically significant distress." Lili Elbe was born a male named Einar Wegener. After marrying Gerda, the artist responsible for this work, he began questioning his gender identity, changed his sex and became Lili Elbe. During the course of a fifth operation to reconfigure her genital organs, Lili died (46).

Philippe Pinel at the Bicêtre and Salpêtrière hospitals in Paris (Figure 6.19) and William Tuke and his Quaker colleagues of the foundation of the York Retreat in England are credited with orchestrating a turning point in psy- chiatric care by offering patients less restraint along with moral therapy based on human interaction (49). Unfortunately, their efforts have had only a limited global impact.

Figure 6.18. *James William Norris*, colored etching, 1815 C.E. by George Arnald,
Wellcome Library, London, England.
James Norris was an American sailor confined for 10 years in isolation in the Bethlem
Royal Hospital (Bedlam) before being discovered by English reformers in 1814
C.E., shackled and (contrary to his appearance in this etching) in extremely poor
health. When Norris was admitted to Bedlam in 1804 C.E., the hospital was severely
overcrowded due to increased numbers of military patients returning from the war be-
tween Britain and France. Norris' case was instrumental in bringing about reform of
conditions in British mental institutions (48).

In many countries throughout the world today, large numbers of
patients with serious mental illnesses, such as schizophrenia, bipolar, and
major depressive disorders, are either homeless street denizens or are con-
fined to prisons and jails, rather than psychiatric facilities. In the United
States, for example, an estimated 10 to 20% of jailed inmates awaiting trial
and 25% of prison inmates have serious mental illnesses for which proper
care is rarely provided (52).

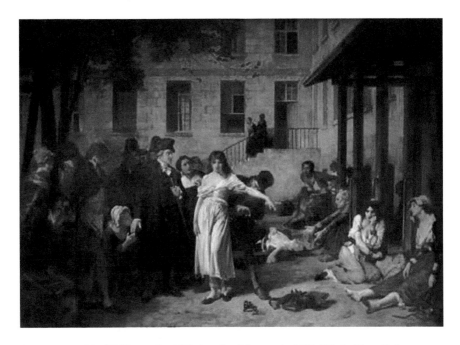

Figure 6.19. *Pinel Délivrant les Aliénés,* color lithograph, 1878 C.E. by Tony Robert-Fleury, Bibliotheque des Arts Decoratifs, Paris, France.
Jean Baptiste Pussin, Pinel's predecessor as governor of the ward for the insane at Bicêtre, inspired *le gest de Pinel,* shown in this touching scene by earlier introducing gentle but firm and psychologically sensitive treatment of the insane. Robert-Fleury, a specialist in history and genre scenes, painted Pinel freeing the disturbed women of Salpêtrière from their chains in a heroic posture reminiscent of Napoleon's in *Napoleon's Visit to the Plague House in Jaffra* by Antoine-Jean Gros (51).

Other mental health interventions have varied greatly throughout history. Under the persistent influence of Galen's humoral theory of disease, physicians used phlebotomy, purging, and cauterization in efforts to relieve the symptoms of mental illnesses. Drugs such as opium, hellebore, wormwood, and mandragora used by ancient physicians gave way to modern pharmaceuticals capable of alleviating, though not eradicating, the mental distress of most psychiatric patients. Therapies involving message, music, exercise, and light have each been used with limited success in patients with various mental disorders. Technological advances in engineering have given rise to the use of electricity and magnetism in the treatment of depression, and for a time, advances in concepts regarding the role of the brain in psychiatric disorders led to the use of prefrontal

Figure 6.20. *Der Würgeengel*, crayon on paper, 1909 C.E. by Franz Karl Bühler, reproduced from Hans Prinzhorn, Artistry of the Mentally Ill, Frontispiece, Verlag von Julius Springer, Berlin, Germany, 1922.

Bühler created *Der Würgengel* ("The Choking Angel") while confined for 40 years in a mental hospital with schizophrenia. The work, which is thought to have conveyed the artist's paranoid terror, is now lost and presumed to have been destroyed by the Nazis as "degenerate art." Bühler too was destroyed, like the "patient" being strangled by der Würgengel in his drawing. In accordance with Germany's 1933 C.E. law for the Prevention of Genetically Diseased Offspring, Bühler was transported to a killing center in Grafeneck, Germany, gassed. and cremated. Schizophrenics, manic-depressives, the mentally retarded, homosexuals, and severe alcoholics were deemed unworthy of life during Germany's experiment with National Socialism. Hospital beds freed by killing such incurables were needed to care for Germany's war-wounded (54).

lobotomy for the "relief of mental pain" (53). In the early 20th century C.E., the eugenics movement attempted to eliminate mental illness altogether by removing the genes of those afflicted with such illnesses from the human gene pool by murder and sterilization (Figure 6.20).

REFERENCES

1. The Editors. Looking back on the millennium in medicine, *N Engl J Med.* 2000; 342: 42–49.
2. Zigrosser C. *Ars Medica.* Philadelphia: Philadelphia Museum of Art; 1959: 42.
3. Mettler CC, *History of Medicine.* New York: The Classics of Medicine Library; 1986:. 597.
4. http://www.italy24.ilsole24ore.com/art/arts-and-leisure/2017-01-06/futurist-giacomo-balla- (accessed March 15, 2017).
5. Owen MJ, Sawa A, Mortensen PB. Schizophrenia. *Lancet* 2016; 388: 86–94.
6. Harrison PJ, Cader MZ, Geddes JR. Reprogramming psychiatry: stem cells and bipolar disorder. *Lancet* 2016; 387: 823–824.
7. Mettler CC, *History of Medicine.* New York: The Classics of Medicine Library; 1986: 488–489.
8. Nuland SB. Medicine. *The Art of Healing*, New York: Hugh Lauter Levin Associates, Inc.: 1992: 24.
9. Mettler CC, *History of Medicine.* New York: The Classics of Medicine Library; 1986: 494.
10. Ibid 501–2.
11. Ibid 517.
12. Ibid 527.
13. Ibid 542.
14. Gallagher R. As a psychiatrist, I diagnose mental illness. Also, I help spot demonic possession. *The Washington Post*; July 1, 2016.
15. Mettler CC, *History of Medicine.* New York: The Classics of Medicine Library; 1986: 539, 569.
16. Ibid 547.
17. Zigrosser C. *Ars Medica.* Philadelphia: Philadelphia Museum of Art; 1959: 38.
18. Arkowitz H, Lilienfeld SO. Lunacy and the full moon. *Scientific American;* February 1, 2009.
19. Mettler CC, *History of Medicine.* New York: The Classics of Medicine Library; 1986: 558.
20. Rose S. Brainocentrism? *Lancet* 2017; 389: 898.
21. Sullivan E. The art of medicine. Melancholy, medicine, and the arts. *Lancet* 2008; 372: 884–885.

22. Saunders JB. The nature of addictive disorders. https://blog.oup.com/2017/02/nature-of-addictive-disorders/ (accessed March 10, 2017).

23. Okkels N, Trabjerg B, Arendt M, Pedersen CB. Traumatic stress disorders and risk of subsequent schizophrenia spectrum disorder of bipolar disorder: a nationwide cohort study. *Schizophrenia Bull.* 2017; 43: 180–186.

24. Ekman CJ, Petrovic P, Johansson AGM, et al. A history of psychosis in bipolar disorder is associated with gray matter volume reduction. *Schizophrenia Bull.* 2017; 43: 99–107.

25. Morch-Johnsen L, Nesvåg R, Jørgensen KN, et al. Auditory cortex characteristics in schizophrenia: Associations with auditory hallucinations. *Schizophrenia Bull.* 2017; 43: 75–83.

26. Abbasi J. Call to action on neurotoxin exposure in pregnant women and children. *JAMA.* 2016; 316: 1436–7.

27. Mettler CC, *History of Medicine.* New York: The Classics of Medicine Library; 1986: 562.

28. Diagnostic and Statistical Manual of Mental Disorders, 5th ed. (DSM-5). Arlington, VA: American Psychiatric Association, 2016.

29. Grande I, Berk M, Birmaher B, Vieta E. Bipolar disorder. *Lancet* 2016; 387: 1561–1572.

30. Mettler CC, *History of Medicine.* New York: The Classics of Medicine Library; 1986: 541.

31. Ibid 549.

32. Frankish H, Horton R. Prevention and management of dementia: a priority for public health. *Lancet* 2017; 390: 2614–2615.

33. http://art-sheep.com/an-artist-with-alzheimers-drew-a-series-of-self-portraits-documenting-t (accessed February 5, 2016).

34. http://www.alz.org/alzheimers_disease_what_is_alzheimers.asp (accessed March 22, 2017).

35. Mettler CC, *History of Medicine.* New York: The Classics of Medicine Library; 1986: 535.

36. Tasca C, Rapetti M, Carta MG, Fradda B. Women and hysteria in the history of mental health. *Clin Pract Epidemiol Ment Health* 2012; 8: 110–119.

37. Mettler CC, *History of Medicine.* New York: The Classics of Medicine Library; 1986: 518.

38. https://convosatiate.wordpress.com/ (accessed October 17, 2016).

39. Harris JC. The fairy feller's master-stroke. *Arch Gen Psychiatry* 2004; 61: 541–542.

40. Jablensky A. The diagnostic concept of schizophrenia: its history, evolution, and future prospects. *Dialogues Clin Neurosci.* 2010; 12: 271–287.

41. http://www.abcgallery.com/R/repin/repin74.html (accessed February 29, 2016).

42. Shinoda T. The handicapped as depicted in the art of Japan, in Yabe K, Kusano K, Nakata H (eds.), *Adapted Physical Activity.* Tokyo: Springer; 1994: 53–55.

43. http://osocio.org/message/contemporary-beauty-ideals/ (accessed March 31, 2016).

44. http://www.telegraph.co.uk/culture/music/michael-jackson/5650647/Michael-Jackson-the(accessed March 23, 2017).

45. Fisher K, Funke J. The art of medicine. Sexual science beyond the medical. *Lancet* 2016; 387: 840–841.
46. http://www.theweek.co.uk/65324/lili-elbe-the-transgender-artist-behind-the-danish-girl (accessed March 6, 2017).
47. Bynum B, Bynum H. Object lessons. The straitjacket. Lancet 2016; 387: 1607.
48. Anderson J, Barnes E, Shackleton. *The Art of Medicine.* Chicago: University of Chicago Press; 2011: 211.
49. Mettler CC, *History of Medicine.* New York: The Classics of Medicine Library; 1986: 498.
50. Ibid 549.
51. Harris JC. Pinel delivering the insane. *Arch Gen Psychiatry* 2003; 60: 552.
52. Hirschtritt ME, Binder RL. Interrupting the mental illness-incarceration-recidivism cycle. *JAMA.* 2017; 317: 695–696.
53. Freeman W, Watts JW. Prefrontal lobotomy. The surgical relief of mental pain. *Bull NY Acad Sci.* 1942; 18: 794–812.
54. Harris JC. The würgengel. *Arch Gen Psychiatry* 2006; 63: 1066–1067.

Military Medicine

During times of war, humanity's capacity for maiming and killing has always exceeded its ability to rehabilitate or to cure (1). Even so, war, with its abundance of casualties, has been a pragmatic training field for physicians, especially surgeons (Figure 7.1; 2), as well as a giant field trial for testing and refining medical advances developed during peacetime. Trauma surgery, emergency care, and control of infections have each leapt forward during wars, just as attention to the care of troops since the time of imperial Rome has yielded a strategic advantage to armies by preserving warriors' fighting capacity in the face of accidents and wounds.

FIRST AID

Roman emperor Augustus is credited with forming the earliest medical corps in the 1st century B.C.E. (4). By the time of Trajan (98–128 C.E.),

Figure 7.1. *Achilles Scrapes Rust from His Spear into the Wound of Telephus*, marble relief, 1st century B.C.E. by an unknown artist, House of the Telephus Relief, Herculaneum, Italy.

According to Greek mythology, Telephus, an ally of the Trojans, received a thigh wound from the spear of Achilles that would not heal until treated by rust scraped from the spear that had caused the wound. Achilles is shown performing the treatment in this marble relief in return for Telephus' help in locating Troy (3). *The Iliad* (Book XI, lines 946–950) describes a more rational treatment for such wounds: "Extract the spear tip, wash with warm water, and apply crushed pain-killing root." The identity of the "pain-killing root" is not given, though it could have been the bitter mandrake root (mandragora), which was used in antiquity as an analgesic (see Chapter 4).

every legion and Roman vessel was assigned a surgeon having a rank equivalent to a non-commissioned officer and excused from combat and routine camp duties. The services of these surgeons helped maintain the combat readiness of armed forces, as well as the morale of fighting men by assuring them that their wounds would be cared for (Figure 7.2; 1).

For nearly two millennia, military surgeons performed similar services in moments of crisis, gradually identifying new ways of managing

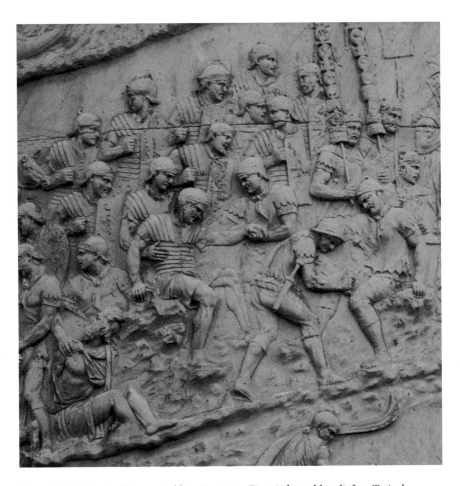

Figure 7.2. *Wounded Roman Soldiers Receiving First Aid*, marble relief on Trajan's column, 113 C.E. by an unknown artist, Rome, Italy.

The complete frieze on this column celebrates victories of Emperor Trajan in two campaigns against the Dacians, who inhabited an area that is now part of Romania (5). Three injured soldiers are depicted in this scene. One on the right appears to have thigh wounds that are being bandaged. The seated soldier near the center being supported by two comrades has no obvious wound but is missing his helmet, suggesting that he might have suffered a concussion following a blow to his head. A third soldier in the lower left corner of the relief is being restrained rather than treated. Given his beard and dress, most likely he is a Dacian captive.

Figure 7.3. *Japanese Red Cross Near the Yalu River*, color lithograph print, 1904 C.E by an unknown artist, United States Library of Congress, Washington, D.C., United States. This print features a Japanese advanced dressing station near the border between present-day North Korea and China during the Russo-Japanese War. Both Russian and Japanese casualties are being urgently treated and triaged by Red Cross personnel a short distance from the front, indicated by an explosion in the left background.

injuries inflicted in the crucible of combat, while discarding others shown by trial and error to be unhelpful. Recognizing that many soldiers died before reaching a surgeon, physicians began to consider what could be taught to non-physicians, and in the late 19th century, concepts of "first aid" began to emerge. In the early 20th century C.E., administration of first aid to wounded soldiers was facilitated by the creation of advanced dressing stations (Figure 7.3) and then by specially equipped forward hospitals within a short distance of the front lines of battle (Figure 7.4).

Figure 7.4. *French Underground Hospital at Verdun*, oil on board, 1917 C.E. by Ugo Matania, Wellcome Library, London, England.
Matania likely painted this scene of a French front-line hospital from pencil sketches made on the spot, rather than a photograph, since the poor light and frantic activity taking place would have made photography impossible. The number and condition of the injured soldiers depicted in the painting give only vague expression to the terrible carnage inflicted by German and French forces on each other during the battle of Verdun, which lasted eleven months and produced over 750,000 casualties (6).

TRANSPORT

Today's trauma victims owe much to Dominique Jean Larrey and Jonathan Letterman. During the Napoleonic wars, Larrey introduced horse-drawn wagons known as "flying ambulances," which were used to rush wounded French soldiers from the field of battle to the rear for emergency care. Fifty years later and an ocean away, Letterman created a similar ambulance corps for the Army of the Potomac during the American Civil War (Figure 7.5; 4). By the time of the Korean War in the mid-20th century C.E., helicopters had become the modern equivalent of Larrey's "flying

Figure 7.5. *Island of Mercy: The Pry Mill at Antietam*, oil on linen, 21st century C.E. by Keith Rocco, National Museum of Civil War Medicine, Frederick, Maryland, United States.

At the Battle of Antietam, the bloodiest single day of the American Civil War, Surgeon Jonathan Letterman began reorganizing the medical corps of the Union Army of the Potomac as its new director (7). One of his most important innovations, transportation of wounded soldiers from the field of battle to dressing stations in the rear, is reflected in the horse-drawn ambulances featured in this painting. Letterman is shown on horseback giving instructions to two surgeons in the foreground.

ambulances," charged with transporting casualties to mobile army surgical hospital (MASH) units as quickly as possible. Capitalizing on lessons learned while caring for wounded Americans in Korea, Dr. R. Adams Cowley created the first statewide air transport system for civilian trauma victims in Maryland and the world's first shock trauma center at the University of Maryland School of Medicine in Baltimore (8).

HEMORRHAGE

As early as Roman times, military surgeons controlled blood loss from wounds with tourniquets and ligatures (4, 9). However, the value of these

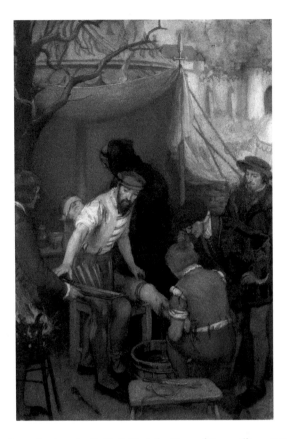

Figure 7.6. *Ambrose Paré on the Battlefield at the Siege of Bramvilliers, 1552,* oil on canvas, c. 1912 C.E. by Ernest Board, Wellcome Library, London, England. Board's idealized painting depicts Paré at work as a military surgeon using a tourniquet to control bleeding as he prepares to amputate the lower leg of a wounded soldier. In contrast to many surgeons of the 16th century C.E., Paré used ligatures to close bleeding vessels during surgery (10).

interventions was largely forgotten in the aftermath of the fall of Rome until rediscovered by Ambrose Paré in the 16th century C.E. (Figure 7.6). Paré, a French barber-surgeon who served four kings—Henry II, Francis II, Charles IX, and Henry III—is credited with demonstrating that amputation sites healed better when bleeding was controlled with ligatures than when sealed with a red hot iron or boiling oil (4).

Blood replacement, such a fundamental component of trauma care today (Figure 7.7), began in 1795 C.E., when Philadelphia physician, Philip Syng

Figure 7.7. *Blood Transfusion in a Desert Dressing Station*, pencil wash, c. 1941–1943 C.E. by Peter McIntyre, National Collection of War Art, Wellington, New Zealand. McIntyre produced this work as New Zealand's official war artist during the Allied North African campaign of World War II (11). The soldier being transfused in this work has what appears to be a bulky bandage covering his lower chest. Prior to the surgical advances of World War I, serious chest wounds would have been uniformly fatal. The blood being transfused into the patient is contained in a glass bottle rather than a plastic bag, which would not be available until after the war (12).

Physick performed the first human blood transfusion on an obstetric patient. However, because he didn't publish his work, nothing more is known of his novel intervention, and credit for the first successful transfusion of human blood into a patient has been given to James Blundell, a British obstetrician, who in 1818 C.E., transfused a hemorrhaging woman with four ounces of blood taken from her husband. Blundell published the results of his intervention along with ten more transfusions performed between 1825 and 1830 C.E., five of which he claimed were beneficial. Until 1900 C.E., when blood-typing became available as a result of the work of Austrian physician, Karl Landsteiner, potentially fatal transfusion reactions would have been an all too common complication of such interventions (12).

In 1918 C.E., Oswald Robertson, an American Army officer, created the first blood depot, which proved to be critically important in managing bleeding in World War I casualties. During World War II, Dr. Charles R. Drew, an African-American surgeon and medical researcher, was instrumental in developing large-scale blood banks that helped save the lives of thousands of Allied soldiers. Drew is also remembered for protesting against the practice of racial segregation in the donation of blood, which the Red Cross maintained until 1950 C.E. That same year durable plastic bags replaced breakable glass bottles as blood containers in one of the most influential advances in blood banking after that of the typing and crossing of donated units of blood (12).

CONTAGION

The Roman military devoted considerable thought and energy to maintaining the health of its fighting men. Roman soldiers were expected to bathe regularly, even when on campaign. Swamps were avoided when selecting sites for encampments, and wounds were cleaned with vinegar or wine to prevent putrefaction (13, 14). Although these measures helped to limit infections among Roman military forces, until the 20th century C.E., more combatants died of infections than battle wounds (4).

The Crimean War was a public health disaster that proved to be a turning point in military medicine's effort to control contagion. Between June and August 1854 C.E., 20% of the British expeditionary force involved in the campaign was hospitalized with cholera, dysentery, and other infections, with nearly a thousand lives lost before the first shot was fired. During the height of the disaster, the British sustained 42.7 deaths per 1,000 soldiers due to infection, many of which were directly related to unsanitary conditions of the wards on which British troops were hospitalized (Figure 7.8). Florence Nightingale played a pivotal role in reorganizing the wards, during which she developed principles of sanitation that proved

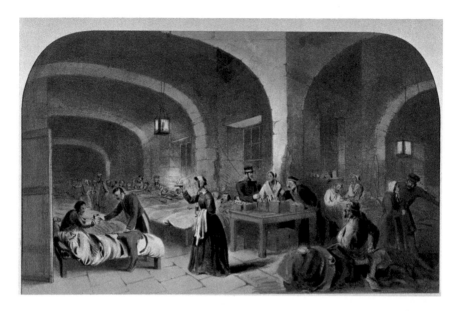

Figure 7.8. *Florence Nightingale in the Military Hospital at Scutari,* colored lithograph, c. 1855 C.E. by Joseph-Austin Benwell, National Army Museum, London, England. When a Sanitary Commission arrived in the Crimea to investigate the thousands of British troops dying not of wounds, but of dysentery, diarrhea, and other diseases, they discovered that the water supply of the General Hospital was being contaminated by open privies and a clogged sewer line beneath the hospital. They also found hundreds of desperately ill soldiers crammed into beds not 18 inches apart (15). Nightingale is shown here making her nightly inspection of the cramped wards prior to implementing the sanitary improvements that ended the epidemic.

critical in minimizing contagious morbidity and mortality in subsequent military operations (15).

Improvements in sanitation and advances in microbiology eventually led to a decrease in deaths due to infectious diseases among combatants, so that by World War I, mortality from communicable diseases no longer surpassed mortality from battle injuries. World War I was the first war in history in which this was the case (at least until November 1918 C.E., when the Spanish flu swept across the globe killing as many as 50 million people), thanks to advances in water purification, waste disposal,

Figure 7.9. *"Little Pinch,"* watercolor, c. 1941 C.E. by Angelo Gepponi, U. S. Army Heritage and Education Center, Carlisle, Pennsylvania, United States.
In 1777 C.E., American General George Washington ordered mandatory inoculation of all soldiers in his continental Army against smallpox after an outbreak of the infection had devastated the army during the Quebec campaign. Washington's was the first organized military program to prevent smallpox (17). During World War II, tetanus immunization was the principal "little pinch" used to protect combatants against death from contagion. Today immunization of military recruits includes a host of agents directed against infections ranging from influenza to meningitis (18).

and field sanitation in general, combined with an early method of wound disinfection (16). During World War II, immunizations (Figure 7.9) and antibiotics (Figure 7.10) helped drive down deaths due to infection even further.

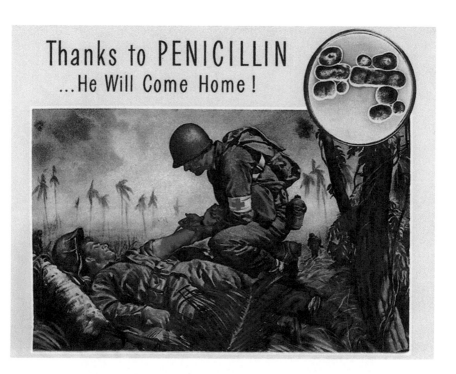

Figure 7.10. *Advertisement for penicillin in Life Magazine* by an unknown artist, *August 14, 1944 C.E. issue.*

Alexander Fleming made his momentous discovery (inhibition of bacteria around colonies of the mold depicted in the upper right corner of this ad) during peacetime. However, war provided the necessary impetus and resources to mass-produce penicillin, the antibiotic derived from the bacteria-inhibiting mold. By the end of World War II, American pharmaceutical companies were producing 650 billion units of penicillin a month, the majority of which were being used to treat injured soldiers (19). Indiscriminate use of myriad subsequent antibiotics has led to the emergence of strains of bacteria able to resist the inhibitory effects of all currently available antibiotics. Administration of antibiotics as prophylaxis (i.e., given to prevent rather than to treat infections), an example of which is featured in this ad, is one of the many inappropriate uses of antibiotics causing the emergence of these highly resistant strains of bacteria.

REHABILITATION

In the United States, rehabilitation medicine was incorporated into the military's health care system during World War I, primarily as a means of radically overhauling the country's veterans' welfare system. By 1916 C.E., the year before America declared war on Germany, the United States had spent more than $5 billion on disability payments to Civil War veterans since the end of the conflict in 1865 C.E., an amount exceeding the cost of the war itself. Initially, rehabilitation of injured veterans was viewed as a new form of medical welfarism designed to assist and to oblige disabled veterans to recover from their war injuries so that they might reenter the workforce and avoid becoming wards of the state (20).

Although the principles of reconstructive surgery for disabled soldiers were developed in Germany ten years before the outbreak of World War I, the discipline expanded greatly during the war (Figure 7.11; 16) and, along with the newly formed professions of physical therapy and occupational therapy, has continued to evolve ever since (20).

RESEARCH

Throughout history, wars have acted as giant clinical trials in which medical theories and interventions have been tested, initially by trial and error, then in the modern era, by scientific methods. These investigations produced advances in sanitary engineering, wound care, vaccine development, trauma and emergency care, reconstructive surgery, and robotics that have benefitted the general public as much as the military. Peacetime investigations by the military have been equally productive, generating knowledge critical to the control of such globally important infections as yellow fever (Figure 7.12), malaria, shigellosis, meningitis, influenza, and pneumonia (4, 16, 23).

Figure 7.11. *The Skat Players—Card Playing War Invalids*, oil and collage on canvas, 1920 C.E. by Otto Dix, Nationalgalerie, Staatliche Museen, Berlin, Germany.
Dix's service during World War I revealed to him the consequences of war in all their naked ghastliness. This work teams with irreverent sarcasm directed at the Weimar Republic for its suppressed memory of the blind heroism, misery and death of war, and for dealing with its wartime defeat and financial catastrophe with non-stop revelry. Even the noble efforts of reconstructive surgeons to "bring back, refashion, and restore to wholeness the features which nature gave but [war] destroyed" (21) are distorted and disparaged. Dix, like many post-World War I artists, rejected the impulse of earlier generations of artists to disguise the horrors of war in works of art.

Figure 7.12. *Conquerors of Yellow Fever*, oil on canvas, c. 1940 C.E. by Dean Cornwell, The Philip S. Hench Yellow Fever Collection, University of Virginia, Charlottesville, Virginia, United States.

Cornwell created a series of works commemorating great moments in medicine for Wyeth and Brother of Philadelphia. This one features Cuban physician Dr. Carlos Finley (left, in civilian clothes), U S surgeon Dr. Walter Reed (center), and others observing Dr. Jesse Lazear inoculate Dr. James Carroll with yellow fever virus in Cuba following the Spanish-American War. In fact, Reed was not present when Lazear placed the tube containing a yellow fever-infected mosquito on Carroll's forearm. He was at the War Department in Washington, D.C. Carroll suffered a severe, but fortunately non-fatal, attack of yellow fever as the first experimentally infected case in history. Through this experiment and others, he, Lazear and Dr. Aristides Agramonte, under Reed's direction, proved that the *Aedes aegypti* mosquito is the natural vector of yellow fever (22).

MENTAL HEALTH

War's devastation is not limited to the physical world of buildings and bodies. It also damages the psyche (24). Susceptibility to the adverse psychological effects of trauma varies, with some people endowed with substantially less psychic resilience than others. During America's mobilization for World War I, psychological examination of draftees was used for the first time in an attempt to weed out less resilient "mental defectives" and to ensure that the nation's soldiers possessed an "active mind as well as body" (16). The program proved to be of limited value. In response to the seemingly endless trauma of World War I, thousands of combatants on both sides collapsed psychologically. Those who did were given a diagnosis of "shell shock." Although newly recognized, the disorder and its more recent, chronic counterpart, post-traumatic stress disorder (PTSD), have probably always plagued warriors (Figure 7.13), as well as civilians (25).

WAR CRIMES

War is a hell in which killing is a patriotic duty, humanistic instincts are made felonies, and peacetime crimes become virtues. Until recently, no method used to destroy an enemy was considered unacceptable. Wells have been poisoned (by the Greeks in 300 B.C.E.), diseased bodies catapulted into walled cities (in the 1422 C.E. siege of Bohemian city of Carolstein), smallpox used as a biological weapon (by the British against disaffected Indians during the French and Indian War), and poisonous gases sprayed on the enemy (by both sides during World War I; Figure 7.14; 27). Public outrage over the intense suffering of victims of chemical weapons used during World War I finally led to the signing of the Geneva Protocol in 1925 C.E. and adoption of the Chemical Weapons Convention in 1997 C.E., which made the use of chemical weapons a crime against humanity (30). The use of biological weapons was made

Figure 7.13. *Battle of Issus*, mosaic, c. 100 B.C.E. by an unknown artist, Museo Nazionale, Naples, Italy.
When Alexander (shown in this mosaic attacking Darius III of Persia) returned from India after his men refused to march further, he was not the same man who crossed the Hellespont to become Lord of Asia. A decade of the trauma of uninterrupted conquest had reduced him to a state of chronic paranoia and alcohol abuse seen in many of today's victims of post-traumatic stress disorder (25). The artist responsible for this mosaic gave Alexander a wide-eyed look of suppressed terror (insert), as if to suggest that even at the moment of his greatest victory, he had begun to perceive that "as a warrior marshals from within himself the predatory energies that his role requires, he becomes himself a beast and always potential prey to another" (26).

a crime in 1972 C.E., with the signing of the Biological Weapons Convention (31).

Crimes against humanity, at least among members of the medical profession, reached a level of cruelty and cynical disregard for the basic principles of medical ethics during World War II never before witnessed among civilized societies. Atrocities committed by German and Japanese physicians on prisoners [and likely also by Stalinist physicians (32)] reflected "a utilitarian ethos that justified using living bodies to gain scientific knowledge that was deemed critical for national survival . . .that if soldiers were giving their lives on the battlefield, ordinary citizens should also be expected to make . . . sacrifices" (33). In Ravensbrück, Dachau,

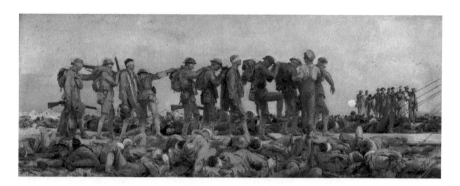

Figure 7.14. *Gassed*, oil on canvas, 1919 C.E. by John Singer Sargent, Imperial War Museum, London, England.
Picasso once reflected that "art has neither a past nor a future," that in effect, it is eternal (28). He was referring to his own work but might just as well have had this painting in mind. No work depicts better the toll taken on society's young men than this one of blind soldiers being led in file along a duck board by a medical orderly juxtaposed upon a group of barely visible, robust, young soccer players in the background. Sargent was commissioned by the British government to produce a painting based on the theme of Anglo-American cooperation for a Hall of Remembrance for World War I. Unable to find suitable matter on the subject, he chose this scene instead, which he had witnessed in 1918 C.E. in the aftermath of a mustard gas attack on the Western Front (29).

Buchenwald, and Auschwitz, these "sacrifices" included dying of hunger, thirst, and cold; drowning; amputation of limbs, suffocation; and vivisection (Figure 7.15) (32). In Japan's infamous Unit 731, thousands of human subjects were infected with anthrax, cholera, dysentery, tetanus, plague, salmonella, tuberculosis, and typhoid, all of whom either died or were killed (35). In the United States, additional thousands were unknowingly exposed to radiation between 1944 and 1974 C.E. in an effort to learn the effects of radiation and its treatment should atomic warfare become a reality. "Societal values, scientific zeal, ideological beliefs and desire for personal achievement" all converged in causing otherwise ordinary physicians to do evil things. (33).

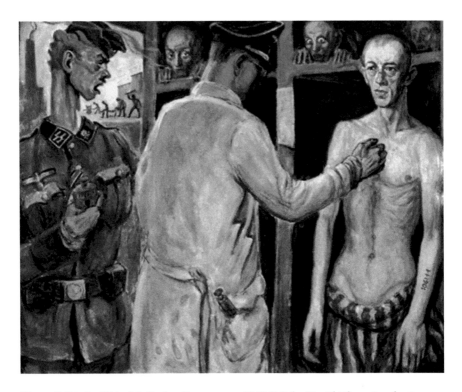

Figure 7.15. *La Visite Medicale*, oil on canvas, 1945 C.E. by David Olere, Auschwitz-Birkenau Memorial and Museum, Oświęcim, Poland.

Olere was deported from Drancy to Auschwitz in 1943 C.E., which gave him first-hand knowledge of life in the German concentration camps of World War II. In this work, the nature of the "experimental drug" being held by the SS guard and about to be injected into the half-naked prisoner by the infamous Dr. Josef Mengele can only be imagined. It might have been a suspension of any one of a number of deadly bacteria that were studied by death-camp physicians like Mengele, or phenol, which was used to terminate the lives of hopeless cases once they were of no further use to the Third Reich. All was done in the name of patriotism, which gave license to murder, lie and torture for the sake of the fatherland (34).

REFERENCES

1. McCallum JE, *Military Medicine: From Ancient times to the 21st Century*. Santa Barbara: ABC-Clio; 2008: xv, xxi.
2. Zigrosser C. *Ars Medica*. Philadelphia: Edward Stern & Co. 1955: 22.
3. Parsifal and Greek myth: Telephus and Prometheus, http://www.monsalvat.no/grkmyths.htm (accessed April 11, 2017).
4. Connell C. Is war good for medicine? War's medical legacy, http://sm.stanford.edu/archive/stanmed/2007summer/main.html. (accessed February 16, 2016).
5. Bordin G, D'Ambrosio LP. *Medicine in Art* (trans. Hyams J). Los Angeles: J. Paul Getty Museum; 2010: 180.
6. https://artuk.org/discover/artworks/first-world-war-1-french-underground-hospital-at-verdu (accessed April 11, 2017).
7. http://www.mnwelldir.org/docs/history/civil_war.htm (accessed April 5, 2016).
8. Mackowiak PA. *Diagnosing Giants. Solving the Medical Mysteries of Thirteen Patients Who Changed the World*. New York: Oxford U. Press; 2013: 128–144.
9. Science Museum. Brought to life: exploring the history of medicine. Medical innovations and war, http://www.sciencemuseum.org.uk/broughttolife/themes/war/innovations (accessed April 4, 2017).
10. Anderson J, Barnes E, Shackleton E. *The Art of Medicine*. Chicago: U. Press Chicago; 2011: 191.
11. http://warart.archives.govt.nz/PeterMcIntyre (accessed April 5, 2016)
12. Highlights of transfusion medicine history, http://www.aabb.org/tm/Pages/highlights.aspx (accessed April 9, 2017).
13. Gabriel RA. *Man and Wound in the Ancient World*. Washington, DC: Commonwealth Fund Publications; 2012: 161–184.
14. Crosby WH. *A History of Military Medicine* (book review). *N Engl J Med*. 1993; 328: 1427–1428.
15. Mackowiak PA. *Post Mortem. Solving History's Great Medical Mysteries*. Philadelphia: ACP Press; 2007: 277–304.
16. Ireland MW. The achievement of the Army Medical Department in the world war in the light of general medical progress. *JAMA*. 1921; 76: 763–769.
17. https://www.historyofvaccines.org/content/articles/us-military-and-vaccine-history (accessed April 13, 2017).
18. https://www.thebalance.com/military-vaccinations-4058318 (accessed April 13, 2017).
19. https://www.getscience.com/content/penicillin-wwii-poster-gallery (accessed April 15, 2017).
20. Linker B. The Great War and modern health care. *N Engl J Med*. 2016; 374: 1907–1909.
21. Keil G. The history of plastic surgery. *Laryngol Rhinol Otol*. 1978; 57: 581–591.
22. Woodward TE, Beisel WR, Faulkner RD. Marylanders defeat Philadelphia yellow fever updated. *Trans Am Clin Climatol Assoc*. 1976; 87: 69–101.

23. Bennett JDC. Medical advances consequent to the Great War 1914–1918. *J Roy Soc Med*. 1990; 83: 738–742.

24. Boyce N. Exhibition. Something else. *Lancet* 2017; 389: 1091.

25. Mackowiak PA. *Post Mortem. Solving History's Great Medical Mysteries.* Philadelphia: ACP Press; 2007: 59–82.

26. Homer. The Iliad (trans. Rees E, notes by King B), New York: Barnes & Noble Inc.; 2005: 480.

27. Poupard JA, Miller LA. History of biological warfare: catapults to capsomeres. *Ann NY Acad Sci*. 1992; 666: 9–20.

28. Read H. The Meaning of Art. London: Faber and Faber; 1972: 215.

29. http://www.iwm.org.uk/collections/item/object/23722 (accessed April 12, 2017).

30. https://www.un.org/disarmament/wmd/chemical/ (accessed April 11, 2017).

31. http://www.unog.ch/bwc (accessed April 11, 2017).

32. Wiesel E. Without conscience. *N Engl J Med*. 2005; 352: 1511–1513.

33. Lerner BH, Caplan AL. Judging the past: how history should inform bioethics. *Ann Intern Med*. 2016; 164: 553–557.

34. Huxley A. *Eyeless in Gaza*. Harmodsworth: Penguin Books, Ltd.; 1971: 150.

35. Harris S. Japanese biological warfare research on humans: a case study of microbiology and ethics. *Ann NY Acad Sci*. 1992: 666: 21–52.

Genetics

Nearly 3000 years ago, Homer mused in the *Iliad* that "the gods give wonderful gifts no man can choose for himself," though for some they "spin a web of miserable existence." Thanks to the advent of clinical genetics, we now know that one's genetic code determines to a considerable degree whether the gifts from God are wonderful, a mixed blessing, or "a web of miserable existence."

The history of modern genetics covers less than two centuries. The science traces its origin to the work of Gregor Mendel, an Augustinian monk and later abbot, who lived and worked in a monastery in Brno, Czech Republic. In carefully performed cross-breeding experiments with garden peas published in 1866 C.E., Mendel uncovered the basic nature of inheritance and conceived the concept of dominant versus recessive traits—that is, inherited traits requiring genetic input from just one parent versus both parents to be passed on from one generation to the next (1, 2). Over the course of the next century and a half, chromosomes were identified and accurately enumerated; James Watson, Francis Crick, and Rosalind

Franklin determined DNA's unique structure; and teams of investigators led by Francis Collins, and Craig Venter succeeded in sequencing the entire human genome (2).

CHROMOSOMES

The term "chromosome" [derived from *chromo* (Greek for "color") and *soma* (Greek for "body")], was introduced by Waldeyer in 1888 C.E. to reflect chromosomes' affinity for certain colorful dyes used in research. Not until 1956 C.E. was the correct number of human chromosomes identified as 46, or more precisely, 23 pairs of chromosomes composed of a chromosome from each parent (1).

One pair of chromosomes, the sex chromosomes, determines an offspring's gender. The other 22 pairs of chromosomes are called "autosomes." When the pair of sex chromosomes consists of two female (or "X") chromosomes (resulting in an "XX genotype"), the offspring develops into a female. When the pair is composed of an X-chromosome and a male (or "Y") chromosome (resulting in an "XY-genotype"), the offspring develops male morphological characteristics.

Genetic disorders can develop as a result of abnormalities of both the number of chromosomes and their composition. Down syndrome (Figure 8.1) is a disorder belonging to the former category. In 1959 C.E., Jerome Lejeune identified the presence of an extra chromosome number 21 as the cause of the syndrome's cognitive impairment and myriad anatomical malformations (3).

Klinefelter syndrome (Figure 8.2) is another example of a genetic disorder caused by an excess number of chromosomes—in this case an extra X-chromosome in a male. The XXY-genotype produces a variable array of physical abnormalities, including absent or delayed puberty, small testes, long, spindly legs, broad hips, enlarged breasts and decreased facial and body hair (6).

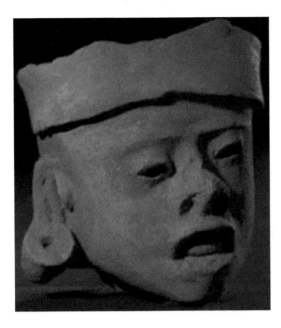

Figure 8.1. *Tolteca Figurine* (Down syndrome), terra-cotta, c. 500 C.E. by an unknown
artist, www.interscience.wiley.com.
This figurine's oblique eyes, flat nasal bridge and small mouth with protruding tongue
are classic facial features of Down syndrome. The syndrome is also characterized by
cognitive impairment, heart defects, and a host of other abnormalities (3). Although
throughout history, persons with such disabilities have often been scorned, ridiculed,
and rejected as evil, the artist responsible for this figurine would seem to have seen
beauty rather than abomination in this patient.

There are "intersex" conditions in which individuals express either
ambiguous external or internal genitalia or characteristics of both sexes
(Figure 8.3). "Hermaphroditism" and "pseudo-hermaphroditism" are
two examples. Patients with male pseudo-hermaphroditism inherit two
different cell lines, one with a normal male XY-sex chromosome pattern
and the other with a single X chromosome or XO-pattern. This mixed (or
mosaic) chromosomal pattern induces the development of ambiguous in-
ternal and external genitalia and, in some cases, testicular feminization, in
which a genetic male exhibits all of the external features and psychosexual
orientation of a female (8).

Figure 8.2. *John Randolph of Roanoke*, oil on canvas, 1804–1805 C.E. by Gilbert Stuart, National Gallery of Art, Washington, D.C., United States. (a); *John Randolph in England,* pen and ink, 1844 C.E.by William Henry Brown, Metropolitan Museum of Art, New York, NY, United States (b).

John Randolph was a congressman and later senator from Virginia, personal friend of Francis Scott Key, and one of the most outspoken opponents of America's involvement in the War of 1812. He was 32 when Gilbert Stuart painted his portrait (4). Randolph's remarkably youthful appearance for his age, absent facial hair, spindly legs, and tall angular physique (in the caricature) are typical of Klinefelter syndrome. The diagnosis is further suggested by the fact that Randolph's post mortem examination revealed a "scrotum . . . scarcely at all developed" with a right testicle "the size of a small bean" (5).

GENES

Although Mendel is credited with having inaugurated the science of genetics, prior to his work, others had already recognized the existence of the X-linked inheritance pattern of hemophilia (Figure 8.4); that is, a mutation on the X-chromosome causing expression of the defect predominantly in males due to their possessing a single X-chromosome (1).

Figure 8.3. *Night* (as portrayed on the tomb of Guiliano Medici), marble sculpture,
c. 1525 C.E. by Michelangelo, Chapel of San Lorenzo, Florence, Italy.
The muscular body of Michelangelo's *Night* figure reflects the artist's use of a male model
when creating many of his female nude figures (7). In the absence of such information,
the ambiguous physique of the figure might lead one to consider a diagnosis of male
pseudo-hermaphroditism.

Sir Archibald Garrod was the first person to connect a human dis-
order to Mendel's laws of inheritance. In the 1920s C.E., he introduced
the concept of "inborn errors of metabolism"—genetic disorders
resulting from failed production of enzymes critical to certain key met-
abolic functions (10). In one such disorder, oculocutaneous albinism
(Figure 8.5), the defective gene is the one responsible for the forma-
tion of tyrosinase, an enzyme critical to the generation of skin and eye
pigment (1).

Figure 8.4. *Love-romanov: Death of the Empire*, oil on canvas, c. 1990 CE. By Yuri Karpenko, private collection.
In Karpenko's allegorical painting of the end of the Romanov dynasty, Nicolas II, the last Russian Tsar, holds his limp son, who was one of history's most famous victims of hemophilia. Although rumors persisted for decades that the young Tsarovich had somehow escaped the massacre of his family by the Communists in July 1918 C.E., DNA testing of the Romanov remains in 2008 C.E. confirmed his death with the rest of his family (9).

In the late 1940s C.E., Linus Pauling used electrophoresis to determine that the devastating consequences of sickle cell anemia (Figure 8.6; i.e., hemolysis, anemia, ischemia, inflammation, susceptibility to infection, painful crises, and vital organ injury) all result from an abnormal structure of the hemoglobin molecule of red blood cells. By 1956 C.E., Vernon Ingram narrowed the abnormality to a single peptide, and by 1957

Figure 8.5. *Albinos*, oil on canvas, c. 2017 C.E. by Antoinette Kelly, private collection, Saatchi Gallery, London, U.K.
Although lacking formal training in either medicine or genetics, Kelly has captured the cardinal features of oculocutaneous albinism in this sensitive portrait of a young girl with the genetic disorder. The girl's white hair (and also that of the rabbits) and pale skin are the result of a genetic defect that limits the production of melanin pigment. Her downward gaze reflects the visual disturbance related to an abnormally developed retina, which results in photosensitivity and occasional blindness (11).

C.E., to a single amino acid difference in the β-globin gene of sickle cell patients (1, 12).

Of all the disorders now known to have a genetic etiology, none has appeared more often in works of art than achondroplasia (Figures 8.7 and 8.8). The abnormal gene responsible for this particular form of dwarfism (a mutation of the *FGR3* gene), is inherited in an autosomal dominant

Figure 8.6. *Ten Redefined*, oil on canvas, 2015 C.E. by Hertz Nasaire, property of the artist.
Nazaire, himself a victim of sickle cell anemia (13), used bold strokes and unshaded colors to reveal the pitiless facts of the "web of miserable existence" spun by this genetic disorder. In a figurative sense, Nazaire "painted with his blood" the intense pain of a sickle cell crisis, which is a hallmark of the disorder. The odd title of the portrait likely alludes to the current clinical practice of rating the intensity of pain on a scale of 1 to 10, which Nazaire seems to imply is too narrow to adequately convey the intensity of the pain caused by sickle cell crises.

manner (i.e., only one of the pair of autosomal chromosomes containing the gene has to be defective to produce the abnormality). The mutation produces a number of distinctive abnormalities, including short arms, legs, and fingers; bow legs; exaggerated curvature of the lower spine (lordosis); a large head with prominent forehead; and a depressed nasal bridge (3).

Figure 8.7. *Dwarf Djeho*, carved lid of a granite sarcophagus, c. 360–343 B.C.E. by an unknown artist, Cairo Museum, Egypt.

According to the Roman philosopher, Seneca, "All art is but imitation of Nature." The artist responsible for Djeho's image on the lid of this sarcophagus far exceeded Seneca's pronouncement by offering a near photographic depiction of the physical characteristics of achondroplasia. The short figure (measuring just 124 cm or 4 feet in height) has the characteristic prominent forehead, depressed nasal ridge and enlarged anterior-posterior skull diameter of achondroplasia. His short arms and legs and slightly exaggerated curvature of the lower spine (lordosis) are also typical of achondroplastic dwarfism (14).

Although the role of genetic factors in common disorders such as hypertension, diabetes, and mental illness is gradually being elucidated, full understanding is lacking, owing in part to the influence of many interacting genes on such disorders. Whereas the list of disorders caused by a single gene mutation is long, the disorders themselves are exceedingly

Figure 8.8. *El Bufón don Sebastián de Morra*, oil on canvas, 1645 C.E. by Diego
Rodriquez de Silva y Velázquez, Museo del Prado, Madrid, Spain.
Dwarfs were often kept as curiosities in royal courts and were, therefore, frequently
subjects of the works of court painters. Velázquez painted several such portraits, of
which this is his most famous. Although Sebastián de Morra had a close and amicable
relationship with young Prince Baltasar Carlos, he was also the subject of ridicule and
mistreatment by nobles at Philip's court (3). In this portrait Velázquez has captured a
defiant court jester ("bufón") revealing in his expression, perhaps just for an instant, his
true feelings regarding his status in the royal court.

Figure 8.9. *Woodie Guthrie*, Giclée print, 2014 by Tyler Lukey, property of the artist. Singer, song-writer, and political activist, Woodie Guthrie was Huntington disease's most famous victim. The disease is caused by a single defective gene, which produces progressive degeneration of the brain. In time, the defect induces disordered movement and impaired cognition, sometimes manifesting as frank psychosis (15). In this print, Lukey gives symbolic expression to the destruction of Woodie's music and brain by Huntington disease before taking his life at age 55 (16).

rare (1). Several have captured the attention of artists, either because they victimized a famous person, as, for example, Woodie Guthrie, who suffered with Huntington disease (Figure 8.9), or they have distinctive physical features. Marfan syndrome (Figure 8.10), the most common of the latter type of disorder, develops as a result of a mutation of the *FBN1* gene, which leads to the production of abnormal connective tissue throughout the body (17). Cri-du-chat syndrome (Figure 8.11) and Angelman syndrome (Figure 8.12) are two other extremely rare disorders caused by a single gene mutation that are featured in works of art.

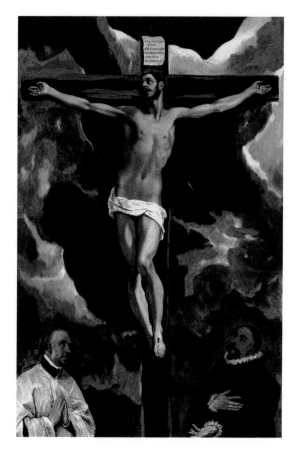

Figure 8.10. *Christ on the Cross*, oil on canvas, c. 1600–1610 C.E. by Domenkos Theotokpoulos (El Greco), Getty Museum, Los Angeles, California, U.S.A.

For reasons known only to the artist, El Greco incorporated many of Marfan syndrome's distinctive physical features into this idiosyncratic rendition of Christ. The figure's slender build, disproportionately long arms and legs, concave breast bone and subtle curvature of the spine, while not diagnostic of Marfan syndrome, are suspicious enough that such a patient would warrant examination for one of the mutations of the *FBN1* gene responsible for the syndrome (17).

Figure 8.11. *Cri Du Chat 1*, oil on canvas, 2015 C.E. by Claudiu Lazar Melian, private collection.

Cri-du-chat syndrome, first described by Jérôme Lejeune in 1963 C.E., is caused by the loss of multiple genes from chromosome number 5. Affected children have intellectual disability, delayed development, small heads (microcephaly), low birth weight, and poor muscle tone (hypotonia). They also have distinctive facial features, such as widely set eyes (hypertelorism), a small jaw and rounded face. One of their most striking characteristics is a high-pitched, cat-like cry as infants, which gave rise to the name of this rare genetic disorder. Melian's cat-like portrait, which calls to mind Munch's *The Scream* (see Chapter 10), mirrors several of the classic features of the disorder (18).

Figure 8.12. *Portrait of a Child with a Drawing,* oil on canvas, c. 1520 C.E. by Giovanni Francesco Caroto, Castelvecchio Museum, Verona, Italy.

Angelman syndrome, a rare genetic disorder resulting from mutations of the *UBE3A* gene, is named after Dr. Harry Angelman, who first described the disorder in 1965 C.E. (19). In his report, Angelman described three children with intellectual and developmental disabilities, sleep disturbances, and seizures. Their most distinctive characteristic, however, was an odd propensity for smiling, laughing, and jerking movements. According to Angelman, he was inspired to report the three cases after seeing Caroto's painting. The boy's rictus smile and puppet drawing brought to mind his three patients and gave him the idea to write his article, which he titled, "Puppet Children" (3).

INBREEDING

Throughout history, royal families have endeavored to preserve their heritage and power within the family bloodline by marrying close relatives. In doing so, some paid a heavy price for their consanguinity in genetic defects (Figures 8.13 and 8.14). Reproduction involving close relatives, such as first cousins and, in particular, first degree relatives (brother-sister, father-daughter, and mother-son) is especially dangerous (22, 23). As the amount of inbreeding increases, so do the frequency and the complexity of congenital malformations (24). This is because the genes responsible for birth defects are largely recessive genes, which tend to produce their deleterious effects only when inherited from both parents. Fortunately, such genes are rare and, therefore, unlikely to be carried by both parents unless they are close relatives (20).

CANCER

The chromosomal theory of cancer, first clearly enunciated by Theodor Boveri in 1914 C.E., is now the basis for both our understanding of the pathogenesis of cancer and some of today's most innovative cancer therapies. Studies of the genetics of cancer cells have demonstrated the existence of chromosomal abnormalities in virtually all cancer cells, many of which are targets of current therapeutic regimens (1). Of the myriad malignant cells studied to date, none has been subjected to more intensive investigation than the HeLa cell, a cell line originally isolated from the cervical carcinoma of a now famous patient by the name of Henrietta Lacks (Figure 8.15; 25).

The edifying picture given to us by genetic investigations, especially by the Human Genome Project, has considerably enlarged and diversified our knowledge of the human condition and our capacity to improve it with increasingly effective treatments. Even so, to suggest that we will ever fully understand the *sui generis* of any individual or perfect the health of

Figure 8.13. *Akhenaten, Nefertiti, and their Children Blessed by Aten (the Solar Disk),* limestone relief, c. 1350 B.C.E. by an unknown artist, Ägyptisches Museum, Berlin, Germany.

Whereas in Western Europe, artistic style evolved nearly continuously throughout history, prior to the reign of Akhenaten, 2000 years passed in ancient Egypt without bringing any obvious change in artistic style. The realism of Akhenaten's "Amarna art," of which this is an example, represented a radical departure from the stylized art of prior dynasties. The bizarre appearance of Akhenaten and his family in this relief reflects generations of inbreeding among Egypt's 18th dynasty, the adverse consequences of which were especially severe in the children of Akhenaten and Nefertiti, who were brother and sister. Their son, Tutankhamun, developed at least four genetic defects as a result of his extensively inbred heritage, which likely were responsible for his sudden death when barely 20 years of age (20).

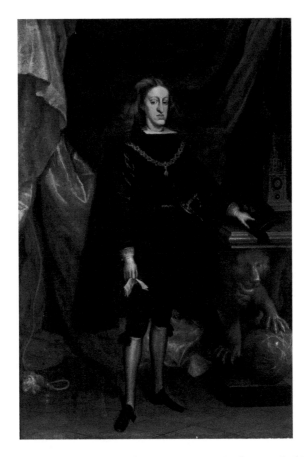

Figure 8.14. *King Charles II of Spain*, oil on canvas, 1685 C.E. by Juan de Miranda
Carreno, Kunsthistorisches Museum, Vienna, Austria.

In seeking to consolidate their power within the family by frequent consanguineous
marriages, the Habsburgs fell victim to numerous genetic defects, the least disabling
of which was the protruding "Habsburg jaw" exhibited by Charles II in this portrait.
Charles II, the last Habsburg king, was a product of generations of inbreeding,
which included a first cousin as his mother. His highly inbred heritage left him sterile,
unable to stand until nearly 6 years of age, mentally slow, and dead before his 39th
birthday (21).

Figure 8.15. *Henrietta Lacks,* watercolor with composite gold leaf, 2015 by C. Bridget Cimino, property of the artist.

Henrietta Lacks died of metastatic cancer of the cervix at age 31 in 1951 C.E. The chromosomal abnormality responsible for her cancer produced a highly aggressive malignant cell that killed Henrietta within eight months of her diagnosis and enabled her cancer to survive in cell culture indefinitely (1). The continuously replicating cell line (HeLa cells) derived from cancerous cervical cells harvested from Lacks without her knowledge gave rise to a multi-billion dollar biotech industry responsible for such major therapeutic advances as the polio vaccine and in vitro fertilization (26).

humans through gene editing, based on the belief that "what we are is a direct and inevitable consequence of our genome" (1), will likely forever remain "a roost of false dreams" (27).

REFERENCES

1. McKusick VA. History of medical genetics, in *Emory and Rimoin's Principles and Practice of Medical Genetics*, 5th ed., Rimoin DL, Connor JM, Pyeritz RE, Korf BR (eds.). Philadelphia: Churchill Livingston; 2007: 3–32.
2. Rimoin DL, Hirschhorn K. A history of medical genetics in pediatrics. *Pediatr Res.* 2004; 56: 150–158.
3. Bukiv N, Elling JW. Genetics in the art and art in genetics. *Gene*; 2014. http://dx.doi.org/10.1016/j.gene.2014.07.073 (accessed April 23, 2017).
4. http://allenbrowne.blogspot.com/2016/01/john-randolph-of-roanoke.html (accessed April 25, 2017).
5. Dr. Francis West's reminiscences of the last moments of the honorable John Randolph of Roanoke. John Randolph of Roanoke Papers, University of Virginia (courtesy of Dr. Munsey S. Wheby).
6. Graham GE, Allanson JE, Gerritsen JA. Sex chromosome abnormalities, in *Emory and Rimoin's Principles and Practice of Medical Genetics*, 5th ed., Rimoin DL, Connor JM, Pyeritz RE, Korf BR (eds.). Philadelphia: Churchill Livingston; 2007: 1044–1047.
7. Libranome H. Michelangelo's women (https://www.haaretz.com/israel-news/culture/leisure/michelangelo-s-women-1.36095) (accessed October 26, 2017)
8. Imperato-McGinley J, Peterson RE. Male pseudohermaphroditism: the complexities of phenotypic development. *Am J Med.* 1976; 61: 251–272.
9. http://historyofrussia.org/alexei-romanov/ (accessed May 6, 2017).
10. Garrod A. The lessons of rare diseases. *Lancet* 1928; 1: 1055–1060.
11. King RA, Oetting WS, Summers CG, et al. Abnormalities of pigmentation, in *Emory and Rimoin's Principles and Practice of Medical Genetics*, 5th ed., Rimoin DL, Connor JM, Pyeritz RE, Korf BR (eds.). Philadelphia: Churchill Livingston; 2007: 3400–3407.
12. Lettre G, Bauer DE. Fetal haemoglobin in sickle-cell disease: from genetic epidemiology to new therapeutic strategies *Lancet* 2016; 387: 254–262.
13. http://nazaire.info/artist.html (accessed May 6, 2017).
14. Unger S, Lachman RS, Rimoin DL. Chondrodysplasias, in *Emory and Rimoin's Principles and Practice of Medical Genetics*, 5th ed., Rimoin DL, Connor JM, Pyeritz RE, Korf BR (eds.). Philadelphia: Churchill Livingston; 2007: 3109–3153).
15. Richardson EP, Jr, Adams RD. Degenerative diseases of the nervous system, in Thorn GW, Adams RD, Braunwald, et al. (eds.), *Harrison's Principles of Internal Medicine*, 8th ed. New York: McGraw-Hill Book Co.; 1977: 1922–1923.
16. http://www.woodyguthrie.org/biography/biography8.htm (accessed May 7, 2017).

17. https://ghr.nlm.nih.gov/condition/marfan-syncrome (accessed May 4, 2017).
18. https://ghr.nlm.nih.gov/condition/cri-du-chat-syndrome (accessed May 8, 2017).
19. Angelman H. "Puppet" children: a report of three cases, *Dev Med Child Neurol.* 1965; 7: 681–688.
20. Mackowiak PA. *Diagnosing Giants. Solving the Medical Mysteries of Thirteen Patients Who Changed the World.* New York: Oxford U. Press; 2013: 1–17.
21. Hodge GP. A medical history of the Spanish Habsburgs as traced in portraits. *JAMA.* 1977; 238: 1169–1174.
22. Bittles AH, Neel JV. The costs of human inbreeding and their implications for variations at the DNA level. *Nature Genet.* 1994; 8: 117–121.
23. Seemanova E. A study of children of incestuous matings. *Human Heredity* 1971; 21: 108–128.
24. Schull WJ. Empirical risks in consanguineous marriages: sex ratio, malformations, and viability. *Am J Hum Genet.* 1958; 10: 294–343.
25. Skloot R. *The Immortal Life of Henrietta Lacks.* New York: Crown Publishing Group; 2010. 381 pp.
26. Friedman L, Jones T. Medicine on the big and small screen: The immortal life of Henrietta Lacks. *The Pharos* 2017: Summer 47–49.
27. Vergil, *The Aeneid*, book 6, lines 283–284.

Death and Dying

Humans have long speculated as to what happens in death's aftermath. For nearly 4000 years, Hindus have maintained that after death, the soul is reborn (reincarnated) in a new body again and again, until it becomes perfect and reunites with its source (1). The ancient Egyptians regarded death, with all its awesome significance, as simply a temporary interruption of life (2), leading them to surround their noble dead with priceless artifacts they expected to be used in the next life (Figure 9.1). The ancient Greeks imagined their dead as being delivered to an everlasting afterlife in the house of Hades (4) by the gods of both death and sleep (Figure 9.2). And to this day, Christians perceive death not as an end of life, but the beginning of a new one in either heaven or hell, depending on a person's conduct and faith during this life.

Medical science has revealed much about the process of dying. However, in spite of many thousand years of speculation, nothing is known, or can ever be known, by the living of what lies beyond the grave.

Figure 9.1. *Funeral Mask of Tutankhamun,* sculpture of gold and semi-precious stones, 14th century B.C.E. by an unknown artist, Egyptian Museum Cairo, Egypt. Tutankhamun's death mask and other exquisite artifacts, discovered in his nearly intact tomb by Howard Carter in 1922, C.E., were affirmations of life and its continuation, even in the presence of death. This idealized image of one of the last pharaohs of Egypt's 18th dynasty gives no hint of the numerous congenital abnormalities almost certainly responsible of the king's untimely death at barely 20 years of age (3).

All that we know for certain is that each of us has an ineluctable obligation to die, generally at a time and of a cause not of our choosing (Figure 9.3). We have no way of discerning what lies in store for us after we are dead. Only death's effects on those left behind can ever be known (Figure 9.4).

Figure 9.2. *Laid to Rest by Sleep and Death*, white-ground oil container, c. 435–425
B.C.E., attributed to the Thanatos Painter, British Museum, London, England.
This vessel containing an offering of oil was found at the Ampelokepoi Tomb near
Athens. On it are depicted two winged figures who have collected a warrior from the bat-
tlefield and are gently laying him to rest in a tomb. The figure on the left represents death
(*Thanatos*). His younger companion on the right represents sleep (*Hypnos*) (5).

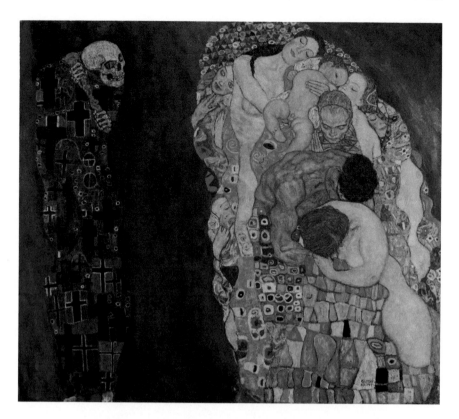

Figure 9.3. *Death and Life*, oil on canvas, 1916 C.E. by Gustav Klimt, Dr. Rudolf Leopold Collection, Vienna, Austria.

In this glittering example of Viennese Art Nouveau, Klimt envisions pale death's capacity to dictate the fate of all of us "ephemeral mortals, poor wretches who flame with life for a little while like flourishing leaves that draw their food from the earth, then wither and die forever" (6). All the stages of life represented in the tangled mass of birth, motherhood, intimacy, and love are being eyed greedily by death opulently covered in religious symbols echoing tombstones (7).

GROWING OLD

Until the late 18th century C.E., average human life expectancy at birth was less than 30 years, and had not increased much since hunter-gatherer times (10). This meager average lifespan (i.e., the total number of years lived by a population of humans divided by the number of humans in the population) was due in large part to a high mortality rate among

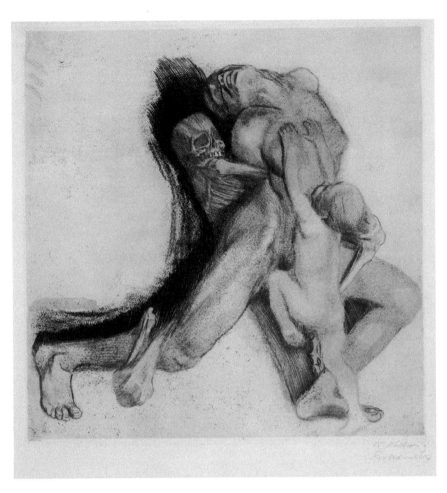

Figure 9.4. *Tod und Frau (Death and Woman),* lithograph, 1910 C.E. by Käthe Kollwitz, Kunstsammlung Akademie, Berlin, Germany.

According to Herbert Read (8), the expressionists tried "to depict not objective facts of nature [or] any abstract notion based on those facts, but the subjective feelings of the artist." This work is typical of such art. The source of the feelings motivating Kollwitz's powerful depiction of the dance of death as an agonizing struggle between black-pinioned death and a soon-to-be motherless child might have been the deaths of several siblings during the artist's childhood (9).

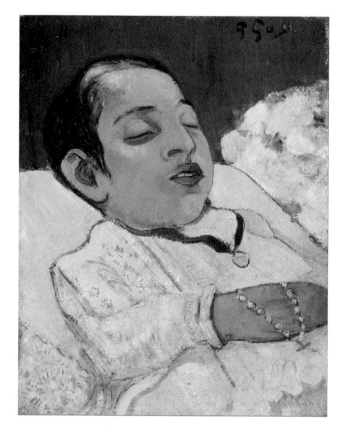

Figure 9.5. *Atiti*, oil on canvas, 1892 C.E. by Paul Gauguin, Kröller-Müller Museum, Otterlo, the Netherlands.
Aristide "Atiti" Suhas was a year and a half old when he died suddenly on March 5, 1892 C.E. Gauguin's serene portrait offers not a trace of the cause of the child's untimely death (11). In Tahiti in 1892 C.E., such deaths would not have been unusual. At that time, infections such as measles, whooping cough, diphtheria, and influenza carried off many children, owing to the lack of effective immunizations against such infections.

infants and children (Figure 9.5). In the mid-19th century C.E., this grim statistic began to improve as a result of advances in standards of living, medicine, and public health, so that by 1980 C.E., male children in developed countries such as the United States had an expected average lifespan of 71 years and female children 78 years (12). In most developed countries, life expectancy has increased since then by at least 2 years each decade. Unfortunately, disability trends have not shown a similar clear

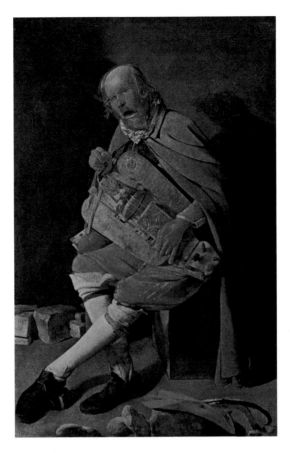

Figure 9.6. *The Hurdy-Gurdy Player*, oil on canvas, c. 1631 C.E. by Georges de La Tour, Musée d'Arts de Nantes, Nantes, France.
The old man featured in this painting, so gray and so far along in his pilgrimage of life, appears only feebly alive. He is unkempt and almost certainly blind. His contorted facial expression as he sings while playing his hurdy-gurdy, suggests the lingering effects of a prior right-sided stroke. Although based on the man's appearance most viewers would rate his quality of life as horrible, a survey of such patients in 1991 C.E. found that others, including primary care physicians, tended to consider older patients' quality of life worse than did the patients themselves (15).

improvement (13), raising concern that the cost of the recent increases in life expectancy is the burden of disabilities that in the past might otherwise have been fatal (14; Figure 9.6).

Throughout history, the longing for longevity without decrepitude has stimulated repeated efforts to find a means by which youth might be

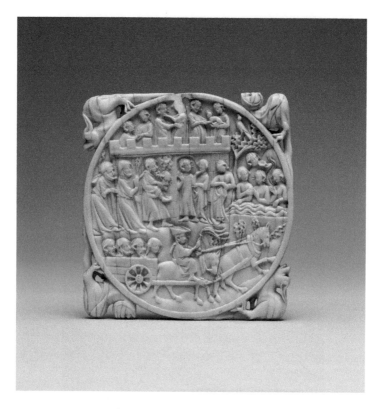

Figure 9.7. *Mirror Cover with the Fountain of Youth*, ivory plaque, c. 1330–1340 C.E. by
an unknown artist, Walters Art Museum, Baltimore, United States.
This carved scene of the Fountain of Youth features frail, elderly men and women
walking, being carried and traveling by cart to the mythical fountain at the top
right. After bathing, they reemerge as vivacious young couples seen above the castle
battlements at the top center of the carving.

restored, or a youthful mind and body might at least be maintained as long
as possible. Tales of a fountain containing waters having such power have
been recounted in various cultures since at least the time of Herodotus
(5th century B.C.E.) (16) (Figure 9.7).

Medical science's current contribution to the quest for longevity without
decrepitude has been to focus attention on preventing "avoidable" mor-
tality (due to disorders such as cancer and cardiovascular disease) and on
increasing as much as possible the number of years lived without disa-
bility. To this end, medicine has targeted risk factors known to predispose

Figure 9.8. *A Woman with Parkinson's Disease*, plaster figure, 1895 C.E. by Paul Marie Louis Pierre Richer, Lyon Musée d' Histoire de la Médecine et de la Pharmacie, Lyon, France.

Richer was an assistant to Jean-Martin Charcot (see Figure 6.10) at the Salpêtrière Hospital and later chair of artistic anatomy at the École des Beaux-Arts (18). His plaster figure, with masked facies (expressionless face) and hands in a "pill-rolling" position, gives nearly perfect artistic expression to the condition first described by James Parkinson in 1817 C.E. Of one such case, Parkinson wrote: "He was entirely unable to walk; the body being so bowed, and the head thrown so forward as to oblige him to go on a continued run . . . and to employ his stick every five or six steps to force him more into an upright posture" (19). Parkinson's disease, which affects 2–3% of persons aged 65 years and older, is currently the second most common neurodegenerative disorder world-wide (20).

to disability (e.g., physical inactivity, high alcohol intake, smoking, obesity, and hypertension) (17). Unfortunately, modifiable risk factors for many of the disorders responsible for the decrepitude of old age have yet to be identified. For some of these disorders (Figure 9.8), the "ragged hand of time" is the principal risk factor and cannot be modified.

DEFYING DEATH

Prior to the 20th century C.E., medicine had little capacity to prevent or cure fatal diseases or to assist in the recovery from serious injuries. Resisting death was rarely possible and, therefore, accepted as a part of human condition (Figure 9.9). Modern advances in medical science have enabled physicians to defy death (Figure 9.10), at least temporarily, by

Figure 9.9. *Death Comes to the Doctor*, from the Dance of Death Series, woodcut, 1523–1526 C.E. by Hans Holbein the Younger, Kunstmuseum Basil, Switzerland.
Like many of Holbein's works, this one is satirical and replete with layers of symbolism, allusions, and paradox (21). Death, with an old man in tow, hands the doctor the sample of urine on which the doctor will base his diagnosis (see Chapter 2). The work was as a mocking repudiation of medicine's capacity to defy death its chosen victim.

Figure 9.10. *Ars Moriendi*, aquatint and dry etching, 2000 C.E. by Marcos Carrasquer, property of the artist.
Ars moriendi, Latin for "art of dying," is a body of literature that originated in Europe in the 15th century C.E. on the heels of the Black Death. It outlined prayers and protocols that served as a practical framework for preparing a person for death, while emphasizing the limits of life on earth (22). Carrasquer's etching reflects man's recent capacity to defy death, the ruler of all mankind, if only briefly, thanks to recent advances in medical science.

prolonging the lives of patients with illnesses that in earlier times would have been rapidly fatal. Whereas past generations of physicians had little more to offer patients than tentative prognoses, compassionate understanding, and crude attempts to assist the healing power of nature, science and the scientific method have empowered today's clinicians with what many believe is an unlimited capacity to resist death indefinitely. Moreover, whereas in the past, raising the dead was the mythical province of the Church (Figure 9.11), the advent of cardiopulmonary resuscitation (Figure 9.12), has created an increasingly blurred boundary between concepts of life and death (27).

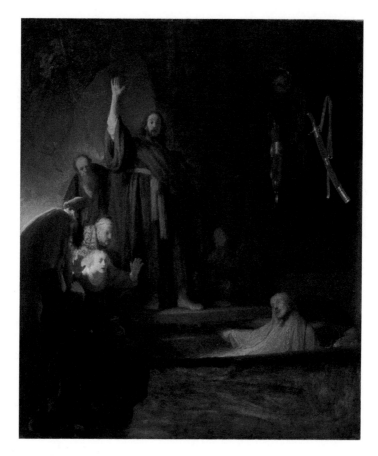

Figure 9.11. *The Raising of Lazarus,* oil on canvas, c. 1630 C.E. by Rembrandt van Rijn, Los Angeles County Museum of Art, Los Angeles, United States.

If Jesus did bring Lazarus of Bethany back to life after he had been dead for four days as reported in the Gospel of John, only a miracle could have been responsible. Medical science would have no better explanation, other than the possibility that Lazarus was not dead when summoned from his coffin, only appearing to be dead because of a temporary paralysis due to some unknown toxin or psychiatric disorder. Rembrandt's odd portrayal of Jesus looking more like a startled magician than a triumphant savior (23), suggests that the artist doubted the former explanation.

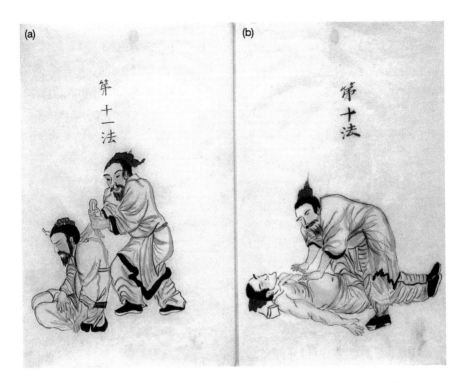

(a) 第十一法

(b) 第十法

Figure 9.12. *A Man Who Has Hanged Himself* (a), *A Man Who Has Drowned Being Resuscitated* (b), block prints, 1905 C.E. by an unknown artist, Wellcome Library, London, England.

These images appeared in a Japanese manuscript detailing techniques for resuscitating persons who drowned, hanged themselves, collapsed, or lost consciousness (24). The closed chest massage being performed on the patient in the right panel was first used by German physician Dr. Friedrich Maass in 1891 C.E. to resuscitate a patient who had suffered a cardiac arrest following inhalation of chloroform (25). The first written report of cardiopulmonary resuscitation, however, might be the following one in the Old Testament, which describes the prophet Elisha breathing life back into a child: "And [Elisha] went up, and lay upon the [dead] child, and put his mouth upon his mouth, and his eyes upon his eyes, and his hands upon his hands; and stretched himself upon the child; and the flesh of the child waxed warm" (26).

THE GOOD DEATH

Ask Americans today how they would like to die, and the answer will almost invariably be some version of "late and sudden" (28). In all probability, people have always wished for such a death—a quick, painless one, at the end of a long and honorable life (Figure 9.13). Today most would

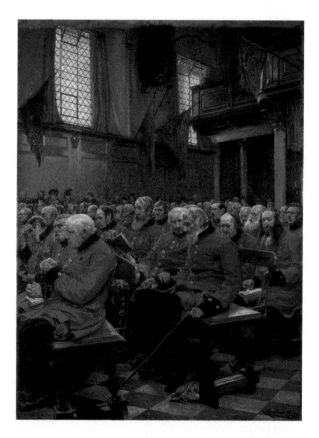

Figure 9.13. *The Last Muster: Sunday at the Chelsea Hospital,* oil and canvas, 1875 C.E. by Hubert von Herkomer, Lady Lever Art Gallery, Port Sunlight, England. Von Herkomer presents these "pensioners" in an ennobling and dignified light at what appears to be the end of a long life of service to country. The central figure, slumped forward with bowed head as his neighbor feels his pulse, seems to be answering the "last muster" suddenly and peacefully. Whereas his apparent death is one most people would hope for, his lot was less ennobling than the painting suggests. He and the other pensioners featured in the work were residents of a home for veteran soldiers unable to support themselves after leaving the army (29).

also prefer to spend their final days at home among family and friends (30) (Figure 9.14), which until the 20th century C.E., was the usual place to die (32). A shift to institutionalized death began in the mid-1900s C.E. with the emergence of hospitals as the locus of scientific medicine. By the 1980s C.E., for example, only 15% of deaths were occurring at home in the United States. Since then, a movement to separate death and dying from hospitals and other health care facilities has created a cultural shift toward dying at home. The shift is reflected not just in terms of preferences expressed in polls, but also in practice. However, although patients strongly prefer to die at home, they are often reluctant to do so until given the benefit of the most advanced medical technologies.

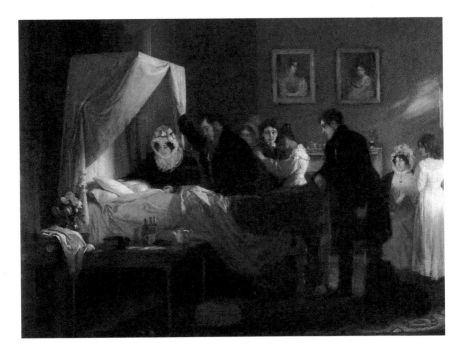

Figure 9.14. *Sarah Dillwyn's Deathbed*, oil on canvas, 1829 C.E. by Charles Robert Leslie, Swansea Museum, Wales, England.
All that can be seen of poor Sarah Dillwyn is the top of her tiny head peeking out from under a snowy white shroud. She was 10 years old and died of rheumatic fever (31), which in 1829 C.E. carried off many children, even those of well-to-do families, such as the one featured in Leslie's painting.

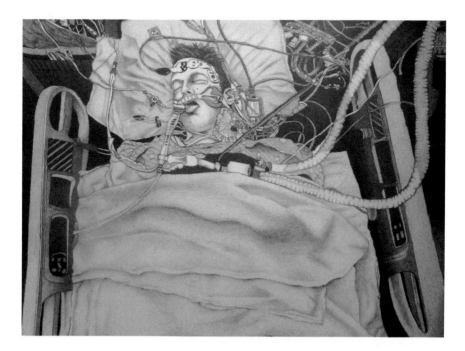

Figure 9.15. *Sleeping Man*, graphite on paper, 2012 C.E. by Michael Bise, property of the artist.

This is one of a series of autobiographical drawings focusing on the artist's hospitalization for a heart transplant. In this one, he appears suspended in a kind of purgatory between life and death, while helplessly ensnared in a web of tubes and wires. The dystopic character of the image raises questions in the viewer's mind as to whether the tubes and wires are keeping the patient alive or siphoning the life out of him (33).

Consequently, in developed countries such as the United States, a substantial number of patients die in intensive care units in search of extraordinary interventions that might allow them to extend their lives, if only a bit longer (32) (Figure 9.15).

GLORIFYING DEATH

According to the popular writer on Classics, Edith Hamilton, "There is nothing more romantic than heroism and great deeds in battle and a glorious death" (34)—an attitude embraced by Virgil, who wrote that ancient

Rome's vision of the way "to glorious death [was] through storms of wounds over and over . . . for Rome's sake to die and [become] immortal forever" (35). The ancient Greeks had a different attitude. They saw too clearly the agony of death (Figure 9.16) to be inclined to glorify it, even in battle (37).

During its period of imperial conquests, Britain emulated Rome in glorifying death in battle in literature as well as art (38) (Figure 9.17). The "Great War" radically altered Britain's view, as it did that of many other nations. During World War I, so many soldiers "filled up their measure of fate and journeyed down to the house of Hades" (39), that dying *pro patria* lost its luster (Figure 9.18).

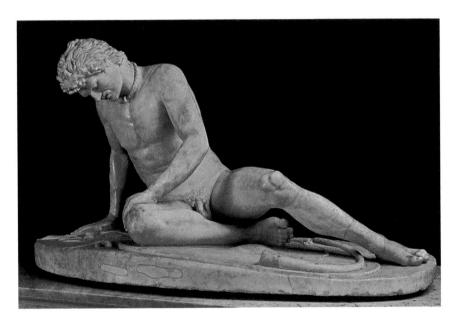

Figure 9.16. *The Dying Gaul,* marble sculpture, 2nd century B.C.E. by an unknown artist, Capitoline Museums, Rome, Italy.
This marble Roman copy of a lost bronze sculpture created by the great Hellenistic artist Epigonos features a dying enemy of ancient Greece (36). He lies naked on the ground supporting himself with one arm, the other resting weakly on his flexed right leg. His head is bent downward. A broken sword lies useless next to him, as blood flows from a chest wound. The image is powerful, full of pathos, pain, and sadness . . . beautiful, though hardly a glorification of death.

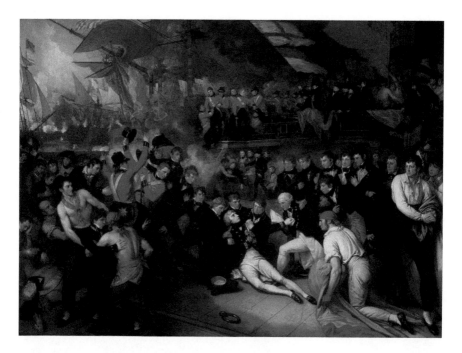

Figure 9.17. *The Death of Nelson*, oil on canvas, 1806 C.E. by Benjamin West, Walter Art Gallery, Liverpool, England.
In this rendition of the climax of the battle of Trafalgar, West presents to the viewer not so much the death of Nelson as an image of the glory of Britannia. The scene bowdlerizes the carnage of warfare. Even Nelson shows no outward evidence of his mortal wound, only a face as white as alabaster that seems to utter, "There is no way to convince one of our kind but to kill us."

ASSISTED DYING

Everyone dies. Nearly 60,000,000 people now do so each year (41). Some take their own lives for reasons only they fully understand (Figure 9.19). For many others, dying involves a period of protracted illness, disability, and intense suffering. In some cases, the suffering is so severe and unremitting, that steps taken to prolong life are torture, and the sufferers long to die. A few find relief in suicide, others through palliative care.

Cultural attitudes toward suicide have varied over time and among societies. No archeologic evidence of suicide exists in ancient Egypt,

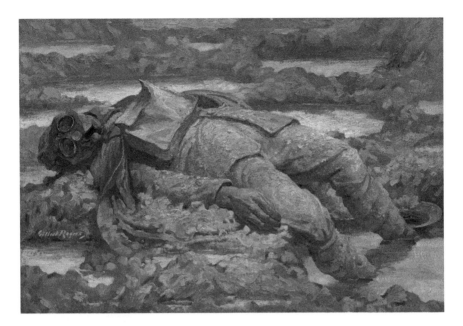

Figure 9.18. *Gassed: "In arduis fidelis,"* oil on canvas, c. 1919 C.E. by Gilbert Rogers, Imperial War Museums, London, England.
Rogers was an officer in the Royal Army Medical Corps commissioned to document the activities of medical personnel during World War I (40). Although the subject of this painting is a single dead stretcher-bearer who has given his all while "faithful in hardship" (*in arduis fidelis*), the work transports the viewer directly into the horror of the vast fields of dead and dying that was the "Great War."

or of discrimination against those who died by their own hand (43). The ancient Greeks condoned the practice, but only when justified, as, for example, a means of capital punishment (Figure 9.20), or to relieve the intolerable suffering of a painful and incurable illness. In ancient Rome, there was no general prohibition against suicide. Only slaves and soldiers were forbidden to take their own lives—for economic reasons in the former case and for patriotic reasons in the latter. Aside from the sixth commandment, which states, "Thou shall not kill," the Bible contains no explicit condemnation of suicide. However, when suicide among early Christians threatened the Church's existence in the 4th century C.E., the practice was made a mortal sin (45). In the 12th century C.E., Japan's ancient warrior class introduced a unique form of

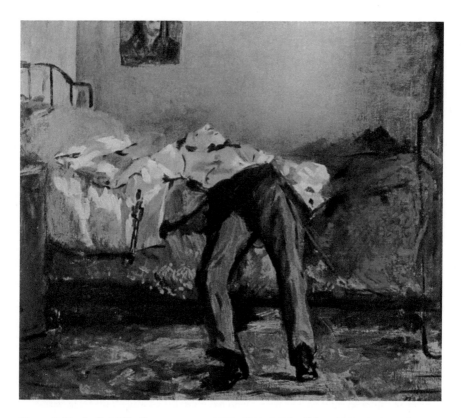

Figure 9.19. *Le Suicidé*, oil on canvas, c. 1877–1881 C.E. by Éduard Manet, Foundation
E.G. Bührle, Zurich, Switzerland.
Manet's grim work, with its blood puddled on the floor beside the bed and seeping
through the white shirt of the victim holding a large revolver in his right hand, is an
image of the act of suicide so realistic, it seems to be unfolding right before the viewer's
eyes. We have no way of knowing if the painting was based on an actual suicide, which
most critics doubt, since Manet left no information concerning either the identity of
the victim featured in his work or the circumstances surrounding the man's desperate
act (42).

ritual suicide, not as a means of relieving intolerable suffering, but as
a way for Samurai to achieve an honorable death (46). In the United
States, suicide is currently the 10th leading cause of death for all ages,
with an annual incidence of 13 per 100,000 persons (47).

Recently physicians have begun to "assist" patients seeking suicide as
a means of ending unbearable suffering. The intervention has generated

Figure 9.20. *The Death of Socrates*, oil on canvas, 1787 C.E. by Jacques Louis David, Metropolitan Museum of Art, New York, United States.
When the Athenian government offered Socrates the choice of renouncing his beliefs or death, he chose the latter. His method was to be suicide. In David's portrait, Socrates is being "assisted" by a pupil, who is handing him a cup of hemlock. Plato, who was a young man at the time, not the elderly one shown in profile at the foot of the bed, was ill and not present when Socrates took his own life (44).

considerable controversy and a host of conflicting labels ranging from "euthanasia" (from the Greek *eu*, for "well" or "good" and *Thanatos* for "death") to "mercy killing" (48). As of the end of 2016 C.E., physician-assisted dying could be performed legally in the Netherlands, Belgium, Luxembourg, Colombia, Canada, Switzerland, and five states in the United States (49).

Palliative care is now promoted as an alternative to assisted death in relieving the intolerable suffering of terminal patients (Figure 9.21). The term "palliative" is derived from *pallium* (Latin for cloak), which in the 1st century C.E. referred to the lamb's-wool cloak worn by bishops of the ancient church in memory of Christ as the Good Shepherd (52). Such care is designed to improve the quality of life of patients nearing death, as well

Figure 9.21. *The Dying Valentine Godé-Darel*, oil on canvas, 1915 C.E. by Ferdinand Hodler, Kunstmuseum, Basel, Switzerland.

This is the last of a series of Hodler's works documenting the slow, painful death from cancer of his once beautiful companion (50). In this portrait, completed a day after Valentine died, she has a *facies Hippocraticus*—the classic facial features of a chronically ill patient on the verge of death. Twenty-five hundred years ago Hippocrates delineated those features—"sharp nose, eyes hollow, temples sunken . . . the skin about the face hard and tense and parched, the color of the face as a whole being yellow or black" (51).

as that of their families, through the prevention and the relief of suffering by means of early identification and treatment of pain and other physical, psychological, and spiritual problems (53).

REFERENCES

1. Jayaram V. Hinduism and the belief in rebirth (http://www.hinduwebsite.com/re-incarnation.asp).
2. Robinson A. Designs upon death in ancient Egypt. *Lancet.* 2016; 387: 1806.
3. Mackowiak PA. *Diagnosing Giants. Solving the Medical Mysteries of Thirteen Patients Who Changed the World.* New York: Oxford U. Press; 2013: 17.
4. *The Iliad,* XI: 95–96.

5. Jenkins I, Farge C, Turner V. *Defining Beauty. The Body in Ancient Greek Art.* London: The British Museum Press; 2015: 168.
6. *The Iliad*, XXI: 15–18.
7. Buchholz EL, Bühler G, Hille K, Kaeppele S, Stotland I. *Art. A World History.* New York: Abrams; 2007: 401.
8. Read H. *The Meaning of Art.* London: Faber and Faber, 1931: 223.
9. Bittner H. *Kathe Kollwitz Drawings.* New York: Thomas Yoseloff, Ltd.; 1959: 1–2.
10. Woodward A, Blakely T. Nobody on the face of the globe lived longer. *Lancet* 2016; 387: 1049.
11. www.krollermuller.no/paul-gauguin-atiti-1 (accessed February 16, 2016).
12. Ludwig DS. Lifespan weighed down by diet. *JAMA* 2016; 315: 2269–2270.
13. Jagger C, Matthews FE, Wohland P, et al. A comparison of health expectancies over two decades in England: results of the cognitive function and ageing study I and II. *Lancet* 2016: 387: 779–786.
14. Zeng Y, Feng Q, Hesketh T, et al. Survival, disabilities in activities of daily living, and physical and cognitive functioning among the oldest-old in China: a cohort study. *Lancet* 2017; 389: 1619–1629.
15. Uhlmann RF, Pearlman RA. Perceived quality of life and preferences for life-sustaining treatment in older adults. *Arch Intern Med.* 1991; 151: 495–497.
16. Herodotus, *Histories*, Book III: 23.
17. Tobias M. Social rank: a risk factor whose time has come? *Lancet* 2017; 389: 1172–1174.
18. Ringrose H (ed.). *The International Who's Who.* London: The International Who's Who Publishing Co.; 1910: 693.
19. Hurwitz B. Parkinson's disease: what's in the name? *Lancet* 2017; 389: 2098–2099.
20. Poewe W, Seppi K. Insulin signaling: new target for Parkinson's treatments? *Lancet* 2017; 390: 1628–1630.
21. Waterhous E. *Painting in Britain.* 1530-1790. London: Penguin; 1978. ISBN 0-14-056101-3.
22. McKenzie K. A modern *ars moriendi. N Engl J Med.* 2016; 374: 2107–2109.
23. *Sister Wendy's American Collection*, LACMA, VHS. Boston, MA: WGBH/Spire Films, 2003.
24. http://wellcomeimages.org/ (accessed February 16, 2016).
25. Figl M, Pelinka LE, Mauritz W. Franz Koenig and Friedrich Maass. *Resuscitation* 2006; 70: 6–9.
26. II *Kings* 4: 32–34.
27. Mackowiak PA. President's Address. Mary Shelly, Frankenstein and the dark side of medical science. *Trans Am Clin Climatol Assoc.* 2014; 125: 1–15.
28. Fitzgerald F. Dying in America. *The Pharos* 1997; Spring: 29–31.
29. http://www.liverpoolmuseums.org.uk/ladylever/collections/paintings/gallery2/thelastmuste (accessed May 24, 2017).
30. Groff AC, Colla CH, Lee TH. Days spent at home—a patient-centered goal and outcome. *N Engl J Med.* 2016; 375: 1610–1612.
31. https://artuk.org/discover/artworks/sarah-dillwyns-deathbed-224867 (accessed June 7, 2017).

32. Rothman DJ. Where we die. *N Engl J Med.* 2014; 370: 2457–2460.

33. http://glasstire.com/2013/09/21/the-kingdom-of-the-sick/ (accessed June 20, 2017).

34. Hamilton E. *The Roman Way.* New York: Avon Books; 1932: 178.

35. Ibid., 179, 182.

36. http://www.vulture.com/2016/07/dying-gaul-is-a-world-masterpiece-about-death.html/ (accessed June 8, 2017).

37. Hamilton E. *The Roman Way.* New York: Avon Books; 1932: 181.

38. Ibid., 180.

39. *The Iliad*, IX: 5–6.

40. http://www.sc-ems.com/ems/NuclearBiologicalChemical/MedicalAspectsofNBC/chapters/... (accessed January 18, 2016).

41. Bauchner H, Fontanarosa PB. Death, dying and end of life. *JAMA* 2016; 315: 270–271.

42. http://www.reshafim.org.il/ad/egypt/people/suicide.htm (accessed June 2, 2017).

43. http://www.manet.org/le-suicide.jsp (accessed November 14, 2017).

44. Taylor CCW. *Socrates. A Very Short Introduction.* New York: Oxford U. Press; 1998: 15.

45. McNamara G. A brief history of suicide (http://www.soars.org.uk/index.php/about/2014-06-06-18-57-53) (accessed June 2, 2017).

46. http://www.history.com/news/ask-history/what-is-seppuku (accessed June 2, 2017).

47. Boilini H, Baldwin M, Lamvu G. Is ketamine the new wonder drug for treating suicide? *Federal Practitioner* 2017; 34(9):12–16.

48. Chochinov HM. Physician-assisted death in Canada. *JAMA* 2016; 315: 253–254.

49. Emanuel EJ, Onwuteaka-Philipsen BD, Urwin JW, Cohen J. Attitudes and practices of euthanasia and physician-assisted suicide in the United States, Canada, and Europe. *JAMA* 2016; 316: 79–90.

50. Buchholz EL, Bühler G, Hille K, Kaeppele S, Stotland I. *Art. A World History.* New York: Abrams; 2007: 399.

51. Joanna J. Hippocrates (trans. DeBevoise MB). Baltimore: Johns Hopkins U. Press; 1999: 293.

52. Bordin G, D'Ambrosio LP. *Medicine in Art* (trans. Hyams J). Los Angeles: J. Paul Getty Museum; 2010: 369.

53. Angus DC, Truog RD. Toward better ICU use at the end of life. *JAMA* 2016; 315: 255–256.

Artists as Patients

According to Havelock Ellis, a late 19th, early 20th century C.E. physician and progressive intellectual, "Every artist writes his own autobiography." Although artists do reveal much about themselves in their works, rarely do they give even a glimpse into their medical histories. The following self-portraits are notable exceptions. They reflect the disorders with which eleven artists struggled yet only vaguely understood. Each portrait arouses a host of deep, vague, generalized reminiscences of what it means to be a patient, and how tenuous one's hold on health is, regardless of one's accomplishments.

ALBRECHT DÜRER (1471–1528 C.E.)

Almost nothing is known of the medical history of Dürer, the renowned German printmaker, designer, and father of a new artistic language of over half a millennium ago. What is known is that sometime between 1509 and

1521 C.E., he created an intriguing half-length self-portrait (Figure 10.1) he hoped would enable an out-of-town physician to diagnose a lingering illness (1). It is not known if the portrait was accompanied by a letter, if it was received, opened, or if the portrait elicited a response. All that is known is that in the spring of 1521 C.E., when the portrait was likely

Figure 10.1. *The Sick Dürer*, pen and watercolor, c. 1521 C.E. by Albrecht Dürer, Kunsthalle, Bremen, Germany.

A translation of the inscription at the top of the work states: "Where the yellow spot is and where I am pointing with my finger, that is where it hurts" (1). Without a detailed history and physical examination, the cause of the pain cannot be determined. The spleen, lower left lung, diaphragm, stomach, duodenum, tail of the pancreas and left kidney are only some of the anatomical structures lying beneath the area indicated by the yellow circle. Given Dürer's reported episodes of "hot fever," an inflamed spleen due to malaria would have been a likely cause of his pain "where the yellow spot is."

created, Dürer wrote in his diary that he had been seriously ill the previous year with periodic "hot fever, great weakness, nausea, and headache (2)." Whatever the cause of the illness, Dürer weathered it well enough to live another seven years.

REMBRANDT VAN RIJN

(1606–1669 C.E.)

Although Rembrandt lived for 63 years, *Allecto*, "bringer of grief," denied him an old age that was either flourishing or green. By the age of 53, Rembrandt had lost his wife and three of his five children. His wealth, art collection, and grand house in Sint-Anthonisbreestrat were gone. Several law suits had left him insolvent, and lacking new contracts, he was producing little (3). One of Rembrandt's few works then was a self-portrait reflecting both the generalized effects of aging and subtle manifestations of two, possibly three, disorders (Figure 10.2).

FRANCISCO GOYA

(1746–1828 C.E.)

Francisco José de Goya y Lucientes was a Vesuvius of artistic experimentation and production forever in eruption and one of the greatest portraitists of modern times. During his long career, he produced over 1800 works. Many attacked corruption, superstition, and vice in high and low places as mirrors in which Spain's confusion, misery, and repression during the artist's lifetime are clearly reflected. When Goya was 46, a strange, nearly fatal illness left him permanently "deaf as a stump." He produced no artistic record of that illness. However, when he was 73, he again became seriously ill (4). This time he commemorated the illness and the physician who cared for him in a poignant self-portrait (Figure 10.3).

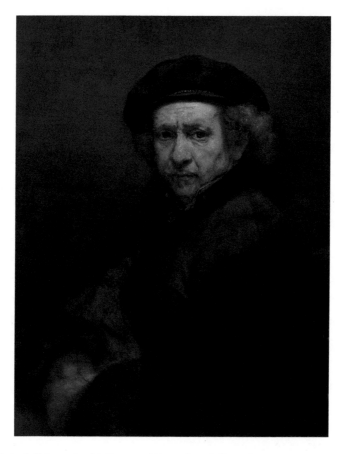

Figure 10.2. *Self-Portrait with Beret and Turned up Collar*, oil on canvas, 1659 C.E. by Rembrandt van Rijn, National Gallery of Art, Washington, D.C., United States. Several subtle details of this self-portrait suggest that at only 53 years old, Rembrandt was already victimized by a number of disorders associated with old age (3). There are cream-colored streaks just below both eyes having the appearance of lipid deposits known as "xanthelasma," a skin condition associated with arteriosclerosis. The coarse, red, bulbous nose is typical of another age-related condition known as "rhinophyma;" and the barely-visible nodular deformity of the vessel peeking out in front of the hair in the upper left forehead is sometimes seen in cases of temporal arteritis. Although intriguing, without additional information concerning Rembrandt's medical history, the significance of these subtle details is open to debate.

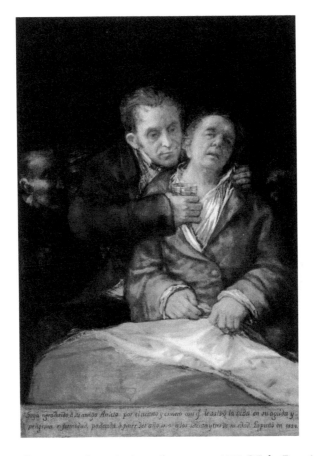

Figure 10.3. *Self-Portrait with Dr. Arrieta*, oil on canvas, 1820 C.E. by Francisco Goya, Minneapolis Institute of Arts, Minneapolis, United States.

This is the last of Goya's roughly 40 self-portraits. The work depicts Dr. Arrieta administering medication along with a healing touch to his patient. The significance of the two gloomy faces on the left is uncertain. The one on the right, death's face, indicates the seriousness of the illness, from which Goya fortunately recovered. Beneath the painting is written: "Goya in gratitude to his friend Arrieta for the skill and great care with which he saved his life in his acute and dangerous illness, suffered at the end of 1819, at the age of 73 years. He painted this in 1829" (5).

VINCENT VAN GOGH (1853–1890 C.E.)

Today van Gogh's works are some of the most prized of any artist who put paint to canvas. However, while he was alive, van Gogh was a wonder in our midst we were too dull to see. His life was cut short by a fit of insanity (a self-inflicted gunshot to the chest) that was the result of just one of many psychotic episodes that began in his third decade. The episodes involved auditory and visual hallucinations, delusions, hyper-excitation with confusional states, incoherent speech, and self-mutilation (6) (Figure 10.4). Their cause is an unsolved mystery, although bipolar disorder, temporal lobe epilepsy, syphilis, and schizophrenia have each been proposed as van Gogh's diagnosis (7). Of the diagnoses that have been put forth, an inherited metabolic disorder known as acute intermittent porphyria, the purported diagnosis of King George III of Great Britain, accounts for more of the signs and symptoms of van Gogh's complicated illness than any yet proposed (6).

EDVARD MUNCH (1863–1944 C.E.)

Munch was one of the most controversial and renowned expressionist/symbolist artists of the late 19th, early 20th century C.E. His intensely colorful and mysterious works reflect a chronic anxiety and morbid preoccupation with death that were rooted in traumatic experiences of his childhood. When he was only five, his mother died of tuberculosis, followed shortly thereafter by the death of his favorite sister, also of tuberculosis. His father, a fundamentalist Christian, responded to the tragedies with depression, anger, and quasi-spiritual visions of the events as God's punishment (9). Young Edvard found a refuge of sorts from his father's ravings in drawing and painting, producing works that linked his own small disturbed pulse with the tumultuous beatings of the world's mighty heart (Figure 10.5).

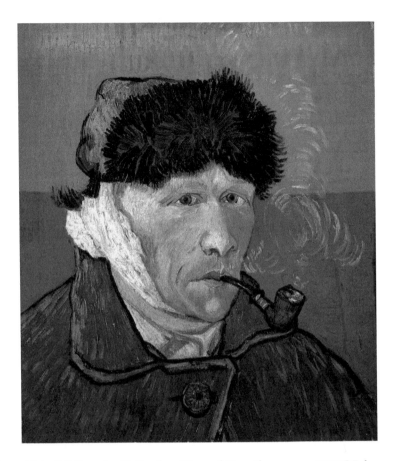

Figure 10.4. *Self-Portrait with Bandaged Ear and Pipe*, oil on canvas, 1889 C.E. by Vincent van Gogh, private collection, Chicago, United States.

At 11:30 PM on December 23, 1888 C.E, van Gogh crossed the courtyard from the yellow house he shared with Paul Gauguin to La Maison de Tolérance brothel, asked for Rachel, and gave her part of his right ear wrapped in paper, telling her to "Guard this article carefully" (8). He had no recollection of what he had done, nor did he recall many of his prior psychotic episodes (6).

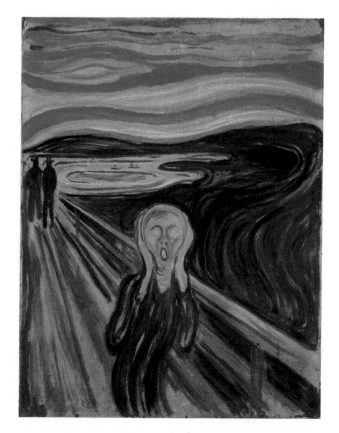

Figure 10.5. *The Scream*, waxed crayon and tempera on paper, 1893 C.E. by Edvard
Munch, National Gallery, Oslo, Norway.
Although not a self-portrait, per se, *The Scream*, nevertheless, is autobiographical.
The idea for the work apparently came to Munch during a visit to the mental hospital
in Oslo, where his sister Laura Catherine was a patient. According to Munch: "I was
walking down the road with two friends while the sun set; suddenly, the sky turned
as red as blood. I stopped and leaned against the fence . . . shivering with fear. Then
I heard the enormous infinite scream of nature" (9). Whether the scream came from an
actual person or was one echoing from traumatic events experienced during Munch's
childhood is not known.

HENRI DE TOULOUSE-LAUTREC (1864–1901 C.E.)

Toulouse-Lautrec was an acclaimed artist, an alcoholic, and a self-fashioned
bohemian best known for his posters and paintings of cabaret performers
in Paris nightclubs of the late 19th century C.E. He was also a medical

Figure 10.6. *Self-Portrait Caricature, Signed "Lost,"* charcoal on paper, c. 1882 by Henri de Toulouse-Lautrec, Musee Toulouse-Lautrec, Albi, France.
Toulouse-Lautrec used his art to satirize his deformities and to attack any patronizing sentimentality directed toward him. Therefore, the protruding lips, enlarged nose and receding chin, all of which support a diagnosis of pycnodysostosis, cannot be regarded as objective clinical evidence. Whatever his diagnosis, one might argue that had it not been for his crippling genetic disorder, Toulouse-Lautrec might not have been driven to the outskirts of Paris for inspiration in its gritty nightlife (10).

curiosity with a peculiar form of dwarfism that rendered him short-statured and crippled (Figure 10.6). In that his parents were first cousins (his grandmothers were sisters), his odd congenital disorder was likely the result of excessive inbreeding. Although "pycnodysostosis" (a rare form of dwarfism characterized by brittle bones, short stature, a large beaked nose and various other physical abnormalities) is the diagnosis most often given for his disorder, his actual diagnosis remains a mystery (10).

PAUL KLEE (1879–1940 C.E.)

Klee was a Swiss-born artist whose nearly 10,000 works combine elements of expressionism, cubism, surrealism, and orientalism. He was a distinguished and popular professor at the Academy of Arts in Düsseldorf until 1933 C.E., when dismissed by Germany's National Socialists for being Jewish and producing art they slandered as morally inferior and "degenerate." In 1935, at the age of 56, he began having symptoms of a rapidly progressive disorder that ended his life in just 5 years (11). The character of the disorder was typical of a systemic sclerosing condition known as "scleroderma." Ironically, a self-portrait created 24 years before the disorder first came to Klee's attention exhibits several of the classic features of scleroderma (Figure 10.7).

DICK KET (1902–1940 C.E.)

Ket was a Dutch magic/realist painter noted for his still-lifes and self-portraits. Of his 140 works, 40 are self-portraits, notable for their depiction of progressive manifestations of a congenital heart defect thought to have been tetralogy of Fallot with dextrocardia (Figure 10.8). The disorder was likely responsible for his death at only 37 years of age (13).

FRIDA KAHLO (1907–1954 C.E.)

Magdalena Carmen Frida Kahlo y Calderón had intended to be a doctor. However, at the age of 18, she was seriously injured in a collision between a trolley car and a bus on which she was a passenger. The accident left her with fractures of her lumbar spine, pelvis, right leg, and clavicle, along with a dislocated shoulder and crushed right foot. During her long and excruciatingly painful convalescence, Kahlo turned from

Figure 10.7. *Junger Mann, ausruhend (Young Man, Resting), a* self-portrait, ink on paper, 1911 C.E. by Paul Klee, private collection.
Manifestations of scleroderma first noted by Klee in 1935 C.E. included tensing of the skin of his face and neck causing pointing of his nose and thinning of his lips. Eventually, his face became mask-like (11). According to one source (12), though contradicted by another (11), similar changes developed in his fingers, making it difficult for him to paint. In this portrait, created over two decades before the onset of Klee's symptoms, the nose, mouth, fingers and face give the viewer an eerie glimpse of the fatal disorder lying in store for the artist. Not depicted are the effects of scleroderma on Klee's esophagus and lungs, which caused progressive difficulty in swallowing and increasing shortness of breath before carrying him to his grave (12).

medicine to painting. Permanently scarred by the trauma and a bout of polio at age 6, which had caused permanent atrophy of her right leg, Kahlo devoted her art to bold, colorful, symbolic studies of the nature of ineffable suffering and her own capacity to endure and to carry on (14) (Figure 10.9).

Figure 10.8. *Self-Portrait*, oil on canvas, 1932 C.E. by Dick Ket, Museum Bojmans Van Beunigen, Rotterdam, the Netherlands.
Ket's health was deteriorating when he painted this portrait (13). The club-shaped fingernails with their cyanotic (blue) hue, dilated neck veins, plethoric face, and the faint bulge in Ket's exposed left chest all support a diagnosis of congenital heart disease.

JOHN BELLANY (1942–2013 C.E.)

Although generally not included among history's great artists, Bellany produced a series of works during his tumultuous life that now grace the walls of such museums as the Tate, London's National Portrait Gallery, and New York's Museum of Modern Art. His works combine expressionism and religious symbolism reflecting personal tragedy, heavy drinking, and

Figure 10.9. *Broken Column*, oil on canvas mounted on Masonite, 1944 C.E. by Frida Kahlo, Museo Dolores Olmedo, Xochimilco, Mexico City, Mexico.

Kahlo's intention in works like this one was to create a new type of art for her native Mexico, distinct from the traditions of Europe and the United States (14). This one, like many of her others, is intensely personal and disturbing. In it, Kahlo reveals the physical and emotional consequences of her injuries with a direct view into some of the darkest areas of her inner self. When she painted this portrait in 1944 C.E., Kahlo's condition had deteriorated to the point that for five months, a steel corset was needed to support her spine. In this painting, the straps of the corset seem to be all Kahlo has to hold her broken body together. The tears and the nails piercing her face and body symbolize her unremitting pain, her steady gaze, her determination to carry on in spite of the pain (15).

illness. After separating from his first wife and their three children at age
28, Bellany began drinking heavily (16), and once having tasted the cup of
dissipation, would not turn away from it until his liver was a wreck and a
ruin. One of his most arresting works features his experience as a patient
recovering from surgery to replace his dead liver (Figure 10.10).

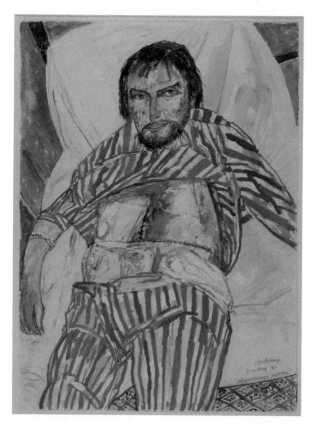

Figure 10.10. *Self-Portrait in Hospital*, watercolor on paper, 1988 C.E. by John Bellany,
Tate Gallery, London, England.
In 1988 C.E., Bellany not only survived a pioneering liver transplant, he recovered
so quickly, his surgeon remarked that he was the only patient he had ever seen who
returned to work the day after his operation (16). In this portrait, painted only hours
after Bellany had undergone surgery, the artist's wry smirk adumbrates a quote he later
gave to the Guardian: "If you have that guiding light, you will survive whatever comes
your way, as I have done—a transplant, pneumonia, three heart attacks, two strokes, all
these things" (16).

MUHAMMAD ASIM KHAN (1944 C.E. –)

Khan, a devoted physician, researcher, and rheumatologist at Case Western University in Cleveland, is also an artist. At the age of 12, he began suffering with a form of arthritis, since diagnosed as "ankylosing spondylitis."

Figure 10.11. *Self-Portrait,* oil on canvas, 1987 C.E. by Muhammad Asim Khan, artist's collection.

Kahn's painting is organized as a triptych, in which each of three vertical elements depict the letters of his middle name, "Asim," as well as the initials of "ankylosing spondylitis in Muhammad." To the right, Asim is written in Arabic letters, the first of which is embedded in the flag of Pakistan where Khan was born. On the left, Asim is written in Roman letters. The American flag is a nod to Khan's current life and culture in the United States (17). The rigid neck and distorted spine and hips in the middle image represent some of the most common, but by no means only, abnormalities created by ankylosing spondylitis.

He has only a limited number of oeuvres to his credit, including this abstract one, which features just some of the destructive effects of his rheumatologic disorder on joints and other tissues throughout his body (17) (Figure 10.11).

REFERENCES

1. Schott GD. *The Sick Dürer:* a Renaissance prototype pain map. *Br. Med J.* 2004; 329: 1492.
2. Hutchison JC. *Albrecht Dürer. A Biography.* Princeton: Princeton U. Press; 1990: 162.
3. Espinel CH. A medical evaluation of Rembrandt. His self-portrait: ageing, disease, and the language of the skin. *Lancet* 1997; 350: 1835–1837.
4. Mackowiak PA. *Diagnosing Giants. Solving the Medical Mysteries of Thirteen Patients Who Changed the World.* Oxford: Oxford U. Press; 2013: 82–96.
5. Mathiasen H. Emphatic art: Goya and Dr. Arrieta. *Am J Med.* 2008; 121: 355–356.
6. Arnold WN. The illness of Vincent van Gogh. *J History Neurosci.* 2004; 22–43.
7. Siegal N. What ailed van Gogh? Doctors weigh in. http://nytimes.com/2016/09/16/arts/design/vincent-van-gogh-doctors-history-weigh-in-a. (accessed September, 29, 2016).
8. Harris JC. The Cover. *JAMA.* 2010; 303: 1892.
9. Edvard Munch. http://www.theartstory.org/artist-munch-edvard.htm (accessed June 29, 2017).
10. Hodder A, Huntley C, Aronson JK, Ramachandran M. Pycnodysostosis and the making of an artist. *Gene;* 2014 http://dx.doi.org/10.1016/j.gene.2014.09.055 (accessed September 26, 2016).
11. Suter H. Paul Klee's illness (systemic sclerosis) and artistic transfiguration, in BogousslavskyJ, Hennerici MG, Bassetti C (eds.). *Neurological Disorders in Famous Artists. Part 3. Front Neurol Neurosci.* 2010; 27: 11–28.
12. Aronson JK, Ramachandran M. The diagnosis of art: scleroderma in Paul Klee— and Rembrandt's scholar? *J R Soc Med.* 2010; 103: 70–71.
13. Loch S, Last JM, Dunea G (eds.), *The Oxford Illustrated Companion to Medicine,* New York: Oxford U. Press; 2001: 66.
14. Cole TB. Portrait of Virginia. Frida Kahlo. *JAMA.* 2016; 316: 1136.
15. http://www.fridakahlofans.com/c0480.html (accessed February 1, 2016).
16. http://www.telegraph.co.uk/news/obituaries/10274525/John-Bellany.html (accessed June 26, 2017).
17. Boonen A, van der Heude D, van der Linden. Muhammad Asim Khan. Portrait of a rheumatologist as a great artist. *J Rheumatol.* 2001; 28: 843–844.

EPILOGUE

History is a story that changes constantly as facts materialize (or are invented) and are recorded, forgotten, rediscovered, and ignored in attempts to impose order on a fundamentally chaotic process. When told by artists, the story is intensely personal. Their works summon life experiences that expand our perception of persons and events that enable us to transcend our own time and traditions to become more open to the past, as well as the future. They encourage self-doubt, which frees us from the bonds of allegiance to certainty that blind us to the limitations of the historical record. Works of art, such as those presented here, are intellectual tools that provide context vital to understanding how we happen to know what we know; why we do what we do; and where we are likely to be in the future.

The images featured in this book, although limited in number, reveal many of the tragic and beautiful and wondrous aspects of the ever-evolving medical landscape. Like all great works of art, they are trans-historical as well as trans-cultural; they are as alive today as when they were created,

in some cases thousands of years ago, and will remain so until the end of days. Together, they represent a pictorial review of the history of medicine that draws attention to the patient more than to the heroic physicians or epic events of the past. No other medium preserves so poignantly the essence of medical progress as revealed through the experiences of patients and their physicians or bolsters the idea that clinical medicine is as rightly ranked with the humanities as it is with the natural sciences.

INDEX

Page references to figures are indicated by *f*'s.